Moore

HENRY MOORE

I would like my work
to be thought of as a
celebration of life
and nature

CHRONICLE BOOKS

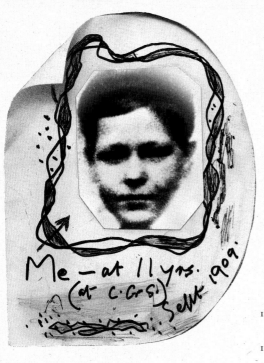

Me — at 11 yrs.
(at C. G. S.) Sept. 1909

1898 Born at Castleford, Yorkshire, 30th July.
1910 Won scholarship to Castleford Grammar School.
1917 Joined 15th London Regiment (Civil Service Rifles). Gassed at Cambrai. Sent back to England, December.
1919 Demobilised in February. Entered Leeds School of Art.
1921 Won Royal Exhibition Scholarship in Sculpture. Entered Royal College of Art.
1924 Awarded Royal College of Art travelling scholarship, but on completing third year as student, appointed instructor in the sculpture school for seven years.
1928 First one-man exhibition at Warren Gallery. Received first public commission — a relief for the facade of the new Underground Building, St James's, London.
1929 Married Irina Radetzsky.

1932 Moved to Chelsea School of Art to establish department of sculpture.
1940 Began shelter drawings. Appointed official War artist. After studio damaged by bombing in October took house at Much Hadham, Hertfordshire, where he has lived ever since.
1941 Appointed a Trustee of Tate Gallery for seven years.
1943 Madonna and Child commissioned for St Matthew's Church, Northampton.
1946 Birth of his daughter, Mary. Visited New York for first major retrospective exhibition at Museum of Modern Art.
1948 Awarded International Sculpture prize, 24th Venice Biennale.
1949 Reappointed a Trustee of Tate Gallery for a further seven years.
1953 Awarded International Prize for sculpture, 2nd Sao Paulo Biennale. Visited Brazil and Mexico.
1955 Elected Honorary Member of American Academy of Arts and Sciences. Appointed a Trustee of National Gallery. Appointed

member of the Order of the Companions of Honour.
1958 Created Honorary Doctor of Arts by Harvard University. Awarded second Sculpture Prize, Carnegie International, Pittsburgh.
1959 Created Honorary Doctor of Laws by University of Cambridge. Awarded International Sculpture Prize, Tokyo Biennale.
1961 Elected Honorary Member of American Academy of Arts and Letters. Created Honorary Doctor of Literature by University of Oxford. Elected a Member of the Academie der Kunste, Berlin.
1962 Created Honorary Doctor of Engineering by Technische Hochschule, Berlin. Made Honorary Freeman of the Borough of Castleford, Yorkshire. Sculpture commissioned for Lincoln Center, New York. Elected Honorary Fellow of Lincoln College, Oxford.
1963 Awarded Antonio Feltrinelli Prize for Sculpture by Accademia dei Lincei, Rome. Appointed Member of the Order of Merit.
1964 Awarded Fine Arts Medal by Institute of Architects for the United States. Appointed Member of Arts Council of Great Britain.
1965 Elected Honorary Fellow of Churchill College, Cambridge.
1966 Created Honorary Doctor of Fine Arts by Yale University. Elected a Fellow of British Academy.
1967 Created Honorary Doctor of Laws by St Andrews University, Scotland. Created Honorary Doctor of Arts by Royal College of Art, London.
1969 Created Honorary Doctor of Laws by the University of Manchester. Created Honorary Doctor of Letters by the University of Warwick. Elected

Honorary Member of the Vienna Secession.

1970 Created Honorary Doctor of Literature by the University of Durham.

1971 Elected Honorary Fellow of the Royal Institute of British Architects. Created Honorary Doctor of Letters by the University of Leicester.

1972 Created Honorary Doctor of Letters by York University, Toronto. Awarded medal of the Royal Canadian Academy of Arts. Created Cavallere di Gran Croce dell'Ordine al Merito della Repubblica Italiana by President Leone of Italy. Awarded the Premio internazionale 'Le Muse', Florence. Awarded the Premio Ibico Reggino Arti Figurative per la Scultura, Reggio Calabria. Created Foreign Member of the Orden Pour le Mérite für Wissenschaften und Künste, Federal Republic of Germany. Major exhibition at the Forte di Belvedere, Florence, visited by over 350,000 people.

1973 Elected Member of the French Académie des Beaux-Arts. Awarded the Premio Umberto Biancamano, Milan.

1974 Opening of the Henry Moore Sculpture Centre at the Art Gallery of Ontario, Toronto. Created Honorary Doctor of Humane Letters, Columbia University, New York. Elected Honorary member of the Royal Scottish Academy of Painting, Sculpture and Architecture, Edinburgh.

1975 Created Honorary Member of the Akademie der Bildenden Kunste, Vienna. Elected Membre de l'Institut, Académie des Beaux-Arts, Paris. Awarded the Kaiserring der Stadt Goslar, West Germany. Created Associate of the Académie Royale des Sciences, des Lettres et des Beaux-Arts of Belgique.

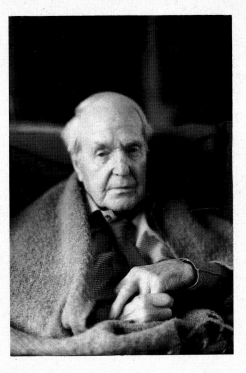

1977 Formed The Henry Moore Foundation. Elected Member of the Serbian Academy of Sciences and Arts. Tate Gallery, London: The Drawings of Henry Moore retrospective exhibition.

1978 Major donation of sculptures to the Tate Gallery, London. 80th birthday exhibitions at the Serpentine Gallery and in Kensington Gardens, London and the City Art Gallery Bradford. Awarded the Grosse Goldene Ehrenzeichen by the City of Vienna. Awarded the Austrian Medal for Science and Art.

1979 Created Honorary Doctor of Letters, University of Bradford.

1980 Donation of Large Arch to the Department of the Environment for permanent siting in Kensington Gardens. Presented by Chancellor Schmidt with the Grand Cross of the Order of Merit of the Federal German Republic.

1981 Elected Full Member of Académie Européenne des Sciences des Arts et des Lettres, Paris. Major retrospective exhibition in Retiro Park, Palacio Velazquez and Palacio Cristal, Madrid; Gulbenkian Foundation, Lisbon; Miro

Foundation, Barcelona. Created Honorary Freeman of the City of Leeds.

1982 Large retrospective exhibition in Museo de Arte Moderno, Mexico City and simultaneous smaller exhibition in Monterrey (Mexico). Opening of new extension to Leeds City Art Gallery—the Henry Moore Centre for the Study of Sculpture.

1983 Major exhibitions in Venezuela and USA—'Henry Moore—60 years of his art', Metropolitan Museum of Art, New York.

1984 Continuing programme of exhibitions—Denmark, France, Switzerland, Scotland, England, East Germany (4 centres). Created Commandeur de l'Ordre National de la Légion d'Honneur on occasion of President Mitterand's visit to Much Hadham.

1984–5 Exhibitions in USA and Greece.

Dedication
In memory of James Mitchell

First published in the United States 1986 by
Chronicle Books
One Hallidie Plaza
San Francisco, CA 94102

Published in the United Kingdom by Ebury Press.

Library of Congress Cataloging-in-Publication Data
Moore, Henry, 1898–
 Henry Moore: My Ideas, Inspiration, and Life as an Artist.
Bibliography: p.
Includes index
ISBN 0-87701-391-8

1. Moore, Henry, 1898– Interviews 2. Sculptors—
England—Biography.
I. Hedgecoe, John,
II. Title.
NB497.M6A2 1986 730'.92'4 (B) 85-30906

Filmset by Advanced Filmsetters (Glasgow) Ltd
Printed and bound in Italy by Arti Grafiche
Amilcare Pizzi S.p.A. Milan

Photographs by John Hedgecoe
Edited by Suzanne Webber

ACKNOWLEDGEMENTS

I would like to give my grateful thanks to Harry Green
for the design of the book and to Julia Hedgecoe, Anna
Selby and Rosemary Wilson for helping in transcribing
and editing my notes, tapes and conversations with
Henry Moore.
The publishers would also like to thank the Henry
Moore Foundation for their help in researching dates of
the sculptures.

Contents

Introduction

My first meeting with Henry Moore was in May 1952. I had arrived early in the vicinity having left Guildford at 6 am. I was a student at the Art School there and this meeting with the master sculptor had taken a long time to arrange. I had met many artists and Gallery owners who knew him well and who had promised they would take me on their next visit, or they would fix an appointment for me, but it was terribly difficult because he didn't like to be disturbed whilst he was working and he was always working, so nothing happened for over a year.

In the end it had been very easy. In the School refectory I met a girl, a new student, who happened to mention that she had visited Henry Moore's studio last weekend and had met the great man, how wonderful and charming he was and how easy it had been to talk to him. She lived close by in Bishop's Stortford and as I was rather captivated by the girl it hadn't been too difficult to persuade her to telephone Henry Moore and say that a fellow student was staying for the weekend and could they please visit. We were told to be at 'Hoglands' at 9.30 and 'don't be late' as Saturday was shopping day and they always had lunch at 1 o'clock at the Foxley Hotel.

My new girl friend was familiar with the area, so we drove through all the back roads and leafy lanes on a sunny morning, mist drifting across this rather hilly part of Hertfordshire. Henry Moore had moved to his house here in 1940, after his studio in London had been damaged by a bomb. It was called 'Hoglands' and had previously been a pig farm and was to provide for Henry his wonderful collection of animal bones; the ground was thick with them wherever you dug.

The seventeenth century farm house was at that time divided into two, lived in by two farm labourers, and an adjoining out-house was the village shop. One half of the house became vacant so Henry and Irina moved in. They immediately felt at home and loved the surrounding country-

side. Henry found it easy to work here. When the other half of the house became vacant later, luckily Henry had just sold the large elmwood reclining figure, now in the collection of the Detroit Institute of Arts, and they were able to purchase the house for just £900.

Arriving there, we were told that Henry was expecting us and was in the far room. This was the inner sanctum, the maquette studio, a secret place where he worked out his ideas for his sculptures and was not to be disturbed. He stood up as we went in and greeted us warmly, his deep blue eyes alert and twinkling with his soft smile and quiet voice. I felt that at a single glance we had been scrutinized and examined. His firm handshake was held several seconds and he told us he was pleased we were on time as he was taking Irina shopping and she didn't like being late.

Henry Moore, a well built, stocky figure, was wearing a blue striped shirt with a matching blue tie and tweed trousers over which he wore a blue and white striped butcher's apron. He sat back into his wicker chair. His workbench was cluttered with tins, stones, bones, plaster maquettes, an array of dentist's tools, some strips of wax and some gallery cards with notes written all over them. A small turntable was immediately in front of him and on this there was a small plaster maquette. As he talked to us he kept turning and inspecting the small sculpture from all angles. He asked about the Art School and told us of his time as a student and how important it had been for him. It was essential that we should work hard because it would be valuable in the future: it was the time to discover and be aware, to develop ideas and to be perceptive, to visit galleries and museums. Because of the first world war and his father's desire for him to be a school teacher he had started as an art student rather late, so he worked extra hard because he felt a need to catch up and this he quickly did because most of the other students weren't as single minded as he was.

In this tiny, cluttered room, full to bursting with small sculptures, maquettes, newspapers, bones, boxes of stones, old shoes, boxes of tools, postcards, with string tied round the handle of the old shop door, the only clear area was a few feet of working space. A small paraffin stove provided the heating with an additional, tiny, single bar electric fire directed at his feet. With three of us there it was a little crowded and obviously difficult for him to work. After an hour or so he suggested we had coffee and then he must take Irina shopping. As we left he asked if I would like to come the next day, Sunday, when he would have more time, and so started a friendship that has lasted over thirty years. From that time on I used to visit regularly, at weekends and

during the long vacations, spending several days at a time photographing both the sculptor and his sculptures. The first time Henry asked me to photograph some of his sculptures was on that first Sunday morning and I managed about twelve pieces. When I returned on the next Sunday with giant, 20 × 16 enlargements, Henry put them all round the room and proceeded to voice his approval and criticism of the pictures. The session lasted nearly two hours. There wasn't one photograph that escaped without some very critical remark, so feeling despondent I thought of giving up photographing sculpture, as it was just too hard to please. Henry then carefully explained that he often had exhibitions arranged by the British Council which usually consisted of about twelve sculptures, twelve drawings and a number of photographs. He wanted some of mine for his next exhibition and then chose all but two. It was his way of telling me that you could always improve and that when it came to sculpture, the sculptor could always see more than the photographer.

Obviously over the years I have come to understand more about what he is trying to do, and I have tried to express it in my photographs. Henry has said 'a sculpture should have its own life and the observer should be able to feel that'. Within a sculpture there is a pent-up energy, strong and vital, thrusting outwards. A sensitive person will respond to this and appreciate the power within, not accept only the outward appearance. When I asked him how this energy within could be created, he answered by saying that it wasn't something the sculptor was purposely seeking, but if a sculpture worked for him, then it contained it.

He has spoken of how he came to open up his sculptures, the hole joining the front to the back, how the void has a sculptural presence. It is worth recording that he felt another influence was that as a child his father was very fond of baked apples for pudding—he had to go down to their dank, dark cellar to fetch them and he was frightened of the dark, so he used to go down the steps sideways always with one eye on the lighted doorway. Later when he was carving deep into his sculpture he said he always felt he wanted to find a way out, remembering that cellar.

Henry, up to the age of 85, worked seven days a week and all his waking hours, on his sculptures. He has made no diversion into other areas of art, no compromises in the face of public derision nor for financial reasons either. His life style has hardly altered from the early days when he was distinctly hard-up, whereas now he is immensely wealthy. He has been able to realize his sculpture in a monumental size, in bronze or in marble without worrying whether someone is

going to buy it or not. He will talk all day, whilst working, about his own work or the work of a past master, but he will seldom discuss his contemporaries and is not greatly interested in seeing their work. Nothing he ever says is for effect or to impress and he always thinks about what he is going to say. He never runs anybody down, if he doesn't like them he doesn't talk about them or their work. He says that good art is a product of a good mind, so don't fill it up with rubbish.

In Spring of 1966 Irina, Henry's wife, slipped and broke her thigh bone. It took many weeks to mend and several months of convalescing. Throughout this time Henry was very worried and would often say that he could never imagine a life worth living without Irina. He couldn't concentrate on his work at this time and asked me whether we could do something together. From this suggestion stemmed the idea for a book that I had held vaguely in my mind. The aim of it was to give a greater understanding and appreciation of Henry and his work.

For eight months—two days a week— we concentrated on putting words to the many hundreds of pictures taken over the previous twelve years. These words were then edited and refined until Henry felt they expressed precisely what he had in mind. The book was launched with a great hullabaloo but both Henry and I felt a little deflated. Shortly afterards on one of my Sunday morning visits Henry said, 'What are we going to do now, we can't let it stop?'

But it has taken nearly another twenty years before I felt the need to do another book. This time it was Irina's suggestion. Henry in his 88th year is now unable to do any new sculptures and only occasional drawings with difficulty, due to his arthritis. As we spoke of his work and of his very full and happy life, there were accounts that filled in the gaps between what has previously been recorded and so we decided on a new, smaller book, concentrating on the ideas and inspiration, for his sculpture. In this book Henry talks of the help he has had in his life, of Miss Gostick at his secondary school and how she first opened his eyes to the wider world and appreciation of art; of the eminent critic Herbert Read who promoted him in his reviews and articles at a time when few others believed in him; but above all of Irina his wife and constant companion, adviser and critic: 'Irina is wonderful, she has always been the same, she is not impressed by status or wealth, dislikes pomp, knows her own mind and sticks to it.'

Although he has often said that no single influence can ever be attached to any of his sculptures, he describes in this book his main sources of inspiration and how he develops his ideas.

JOHN HEDGECOE

I lived in Castleford, apart from being in the army, until I suppose I was 22 years old. One of the first and strongest things I recall were the slag heaps, like pyramids, like mountains, artificial mountains. There were pit heaps all over—the great waste, the unburnable rubbish. We played about in them, and got very dirty.

We lived in Roundhill Road all the years I was a child and growing up. I remember the street and I can see the sun just managing to penetrate the fog, and

the coal heap at the end, it's all very familiar. There were seven of us children in that one little house, no bedroom to yourself. In fact, there were three or four in one bed!

I think people place much too much emphasis on my early life, on the coalmining background. My upbringing was very normal as with the majority of children in this country. Writers and critics love to link one's early life to the present almost as if one hasn't changed.

My father was a miner at the time of a very long coal strike. During that time, he did odd jobs, mended shoes, any job at all. He was good with his hands. He was politically active and used to hold meetings in our front room. It was, I suppose, about the setting up of a kind of trade union. It must have been 1906 or thereabouts.

or he would make me take up the violin again. I passed on the third attempt and gave up the violin forever.

I wasn't frightened of my father, but we were brought up to respect him; it was the Victorian idea of the family and he was the head of it. He was the boss and he expected absolute, complete control. Without my knowing it —I didn't know

We had a very thin time, but my father was unbelievably resilient and ambitious for his children. He had had to learn everything himself, from books and so on. He had had no help from his parents so he had a terrific struggle to do what he did. But he had tremendous hopes for his children and he believed in education and he made all of us go in for exams to get to the local secondary school, as it was called then; it became a grammar school later.

I failed the first time that I took them. And I said to my father, I've failed because you make me learn the violin —I hated the noise it made —I don't do my homework because I have to do all that practice. So he agreed. I stopped the violin. I failed the exams a second time, but my father said he would give me one last chance to pass

it —he was a marvellous man. He'd had to work down the mines when he was eight or nine —as children did in those days. Somehow, he'd got himself out of mining and he determined that his children would, too. The one way out for poor children was to get a scholarship to the local grammar school. From there you could get into a training college and two of my sisters and one brother all did this and became teachers. In fact, my brother became headmaster. It was the possible way through for a miner's son. My being the youngest, of course, my brother Raymond was already teaching long before I got to the grammar school. One of the greatest experiences was going away from home for the first time and staying in this village where he taught.

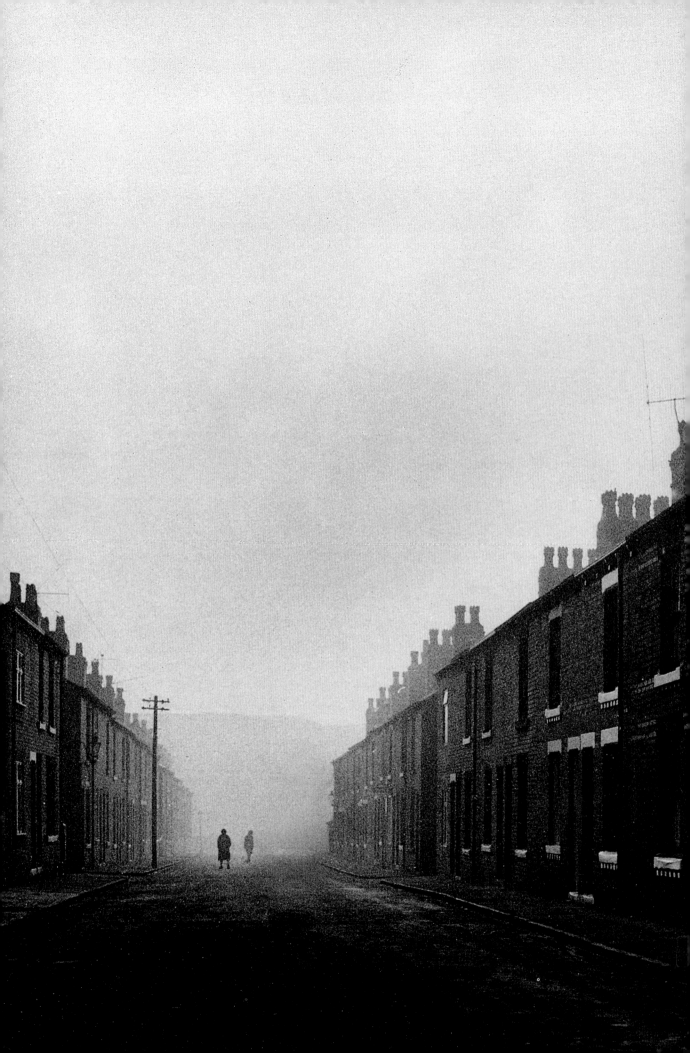

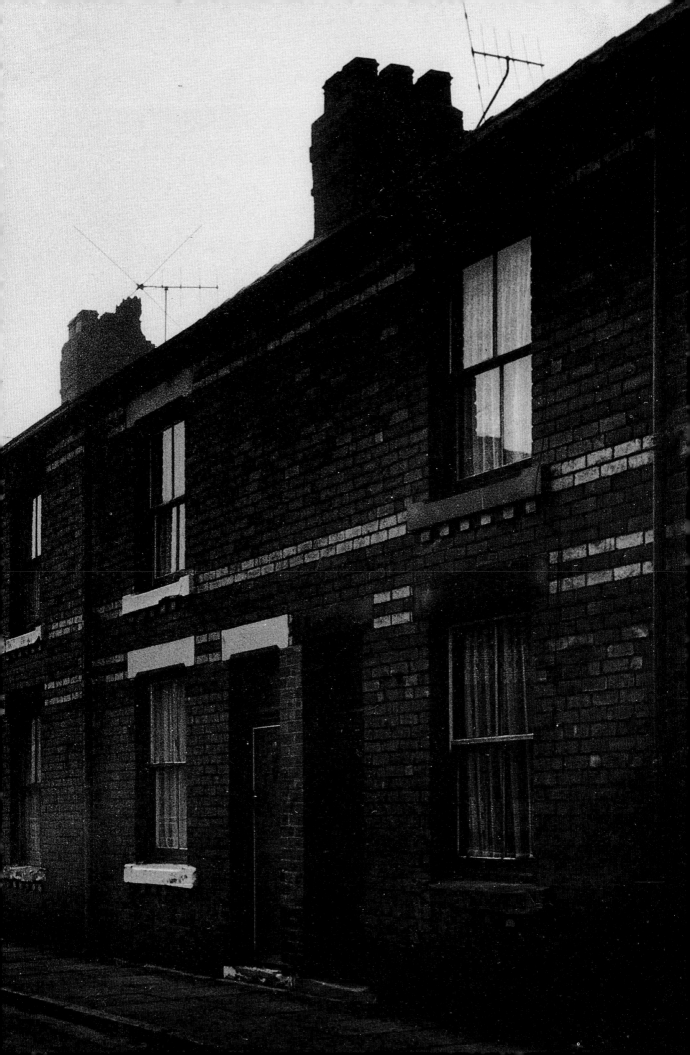

When I first went down a mine, as a war artist, I thought what wonderful, what unbelievable people coal miners are. It is the worst life one could ever be made to have. The second day it wasn't so bad. By the third day I could have gone on, and I did, for a week. It's just what you get used to. It teaches you to accept life and nothing after that seems bad.

At home, we lived a communal life, we were never much alone. We lived, mostly, in one downstairs room. It was a very homely, matey, crowded way of living. You saw a lot of people; there was a lot going on.

I was, next to my sister Elsie, the youngest member of my family. Elsie was very keen on athletics running. She always came first. In some ways I blame myself—I encouraged her to go faster and faster and train harder and harder and then she died of heart failure. It upset me for years. So, after that, the family poured their affection on to me. I was the youngest and they all looked after me and helped me. My eldest brother, Raymond, liked drawing and I used to get him to draw for me when I was a small child.

I had a grandmother whom I used to have to go and see every Saturday or Sunday down in the town. I hated it. I had to go up a long flight of steps and there was a dreadful smell. I had to go and kiss her and to me she was terribly revolting. But there we were, it was part of the pattern of life. That was Castleford.

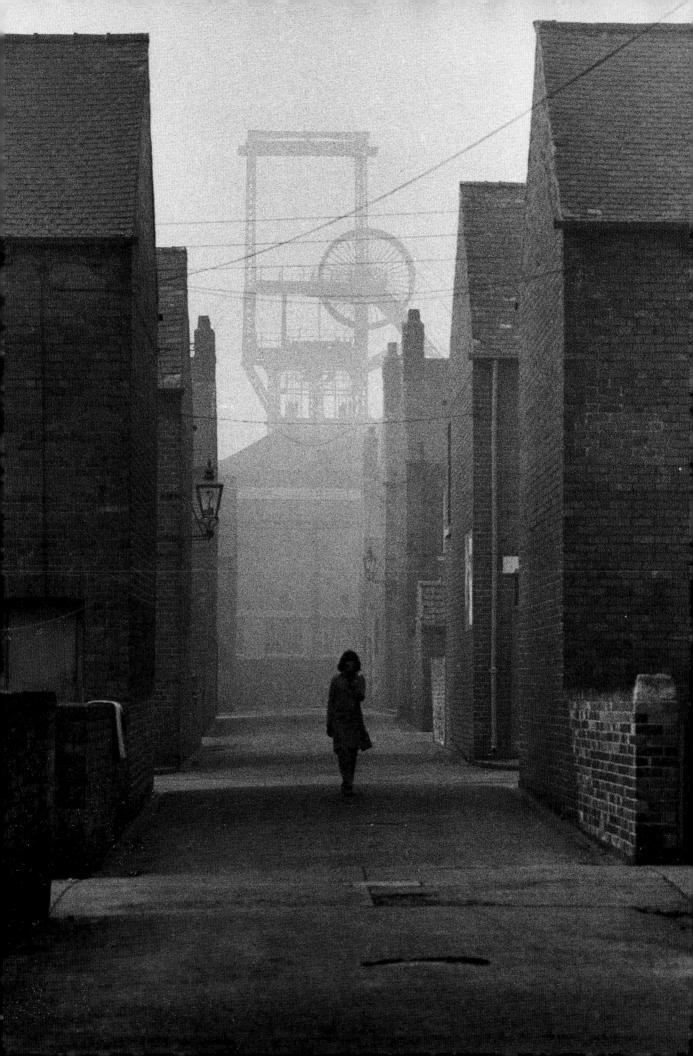

We used to play games in the back streets—hoops and marbles and so on. There were two or three different types of marbles that I enjoyed very much indeed. There was one game called Ringy in which you drew a circle with a stick in the coal dust that was thick and black on the street. The circle was about ten feet in diameter with a hole in the middle just big enough for a marble to go in. You played from outside of the circle and it took practice to get it into the hole. You had a permanent dark, blistered knuckle. It looked very bad but you got used to it. It was a game that taught you to control things with your hands—a sculptor would be no good if he couldn't use his hands.

When I got to the grammar school, it was wonderful. We had a football pitch on a hillside. If you won the toss and were playing against another school, you knew what to do and had an advantage. I used to play right wing and I was quite good. I wouldn't have become a physical training instructor in the army if I hadn't liked games. I think that helped with the sculpture, too. You can't be a sculptor if you can't use a hammer and chisel, if you can't use your arms. Your muscles need to be strengthened. That's why I was able to do carving and was good at the technique.

In the mining area where I was brought up, you had to look tough and manly, which meant you had to have a girlfriend. If you didn't, you were thought cissy. As a little boy there was the girl next door, Millie. I was only about eight or nine and we played together. If you got to about ten or eleven and didn't have a girlfriend, you were looked upon as if there was something wrong with you. When I got to about twelve I remember falling for a girl. I walked on air from Castleford to Pontefract and on to Ferrybridge because I'd kissed her.

The grammar school was mixed and you could stay there till you were seventeen or eighteen. For morning prayers we stood in rows, all of the girls in front of me. I could have told all the girls of that school from the legs downward.

As children we would go to the slaughter house every Wednesday. You could stand at the door and see them fell the cow, the sheep, or the bull ready for the butcher. It was done with an axe with a point on one end and blade on the other. Two or three men would get hold of the halter around the bull's neck, put the rope through a ring in the wall in the slaughter house. And those men would pull the animal gradually towards them with its head right up so that it couldn't move it. It was in this position that they started to butcher with the pointed end of the axe and felled the bull so it was unconscious and then they'd stab it and let the blood run out and so on. One used to go and watch that every week. It was a gruesome sight but we'd say, 'Let's go and watch the kill.' It was an excitement. People got reputations, the butchers, for being worthy. Sometimes they didn't hit the right part of the skull to go into the brain, they didn't kill it. But then they would stab it as it lay down. It was a well known thing, I wasn't the only one that watched.

I had a happy childhood, full of physical enjoyment and exercise. I enjoyed all the games and the fights as well. I fought one boy with my hand tied behind me—I said I could beat you one-handed. You had to stand up for yourself, it was daft if you didn't. Then you were just made a scapegoat. We were brought up to be very independent.

We had a shed and it was a good place to be alone in; I used to keep my fishing hook there and things I collected while walking. Just walking to school and home again I might find some leaves or conkers, snail shells, the same things that attract all children. Then there were the long walks, usually on a Sunday when we would walk miles into the countryside. We would sometimes pick bunches of flowers and grasses and things. We used to play a lot by the Calder canal. I think I was always very aware of the trees and branches and the way they responded to environmental forces. But I just imagined everyone else was the same.

It was a great excitement for me to discover and to be aware of form as a three-dimensional reality. It happened gradually as a young man and then as a student I became more and more aware of the way light revealed form. Then suddenly the most commonplace objects came to have for me such significance that they no longer existed as just objects, but as shape and form in space. It has been the same with nature and the human figure, both sources of unending interest for me.

My first serious bit of wood carving was
the school memorial for former students
wounded or killed in the First World
War. I must have been sixteen or
seventeen at the time and the war had
been on a year. Miss Gostick lent me
the tools—I had only used a penknife
before.

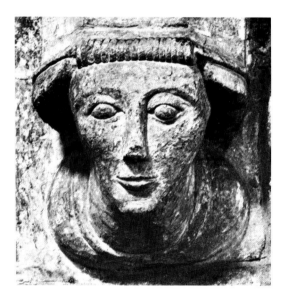

Methley Church, just outside Castleford,
contains the first real sculptures I
remember. I was very impressed by these
recumbent effigy figures, particularly by
the simplicity of the woman's head.
The female figure is always more simple
than the male, less muscles and
wrinkles. It was this and the almost
Egyptian stillness of the figure that
appealed to me, as well as the hands
coming away from the body.

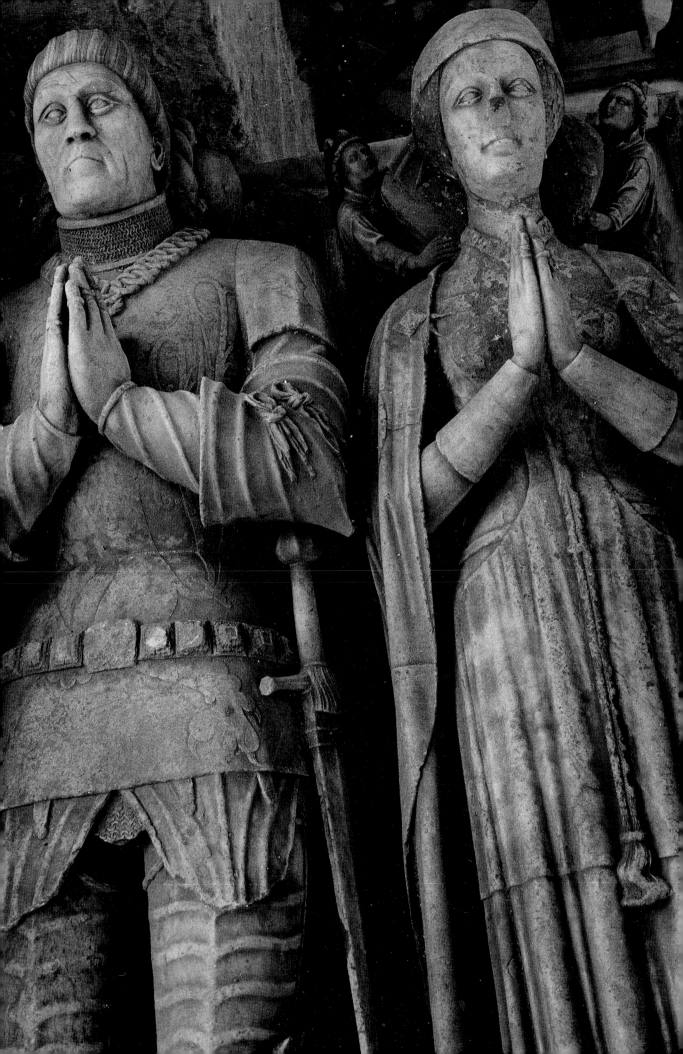

I loved school. When I got to the secondary school, Alice Gostick came to teach art. She was one of the biggest influences on the direction I took. She had travelled a lot and been to Florence and London. She encouraged me and the other two boys who were interested in painting and drawing—Albert Wainwright and Arthur Dalby. We would compete with each other for doing the poster for the school play. Miss Gostick encouraged all three of us—she lent us books and introduced us to pottery. She would ask us up to tea and all of this was very different from life at home.

But even before all this, even at elementary school, I wanted to draw. The drawing lesson was on Friday afternoon, the very last lesson of the week. The teacher was tired, the kids were all thinking of the weekend, but for me it was the lesson of the week. I drew everything and anywhere, animals, trees and then figures. The figure was always important, animals too, as they were living things, but I always came back to the human figure.

Writing was almost as great an ambition in my schooldays as was drawing. To make up a good essay or story was just as enjoyable and engrossing. I even wrote a play, *Narayona and Bhataryan*, which was a very romantic story about two Indians. What it was about I've forgotten completely now.

While I was still at the grammar school, I took student teacher training. I taught for two days a week and went to school for the rest. That was from sixteen to eighteen. I knew I wanted to be an artist

and that it would be an awful struggle, so I had to find a way of earning a living. I could do that by being an art teacher.

At eighteen, I got called up. I tried to get into the Artists' Rifles because I thought it would be full of artists. But they were full and had a waiting list so I joined the Civil Serves Rifles instead. I was in the army from 1916 to 1918 and I used to draw trees, flowers, huts, ruins. I drew the people picking lice off their clothes. It was very good experience.

I went to France and we won the battle of Cambray — only forty-two of us came back out of the four hundred who went out. I was not horrified by the war, I wanted to win a medal and be a hero. It was the lance-corporal, who was the head of my section who got the medal. I remember I went out in front of the rest,

firing at the enemy. It was my first real life experience. I vividly recall one of the fellows in this front-line trench lost his nerve and began to weep and so on. It was affecting the others so the officer told me to take him back to the casualty clearing station. Of course, we were in a big open field, so I took him by the hand and quietened him down and explained what was happening. Once he understood, he couldn't wait and started dragging me by the hand! I was very ashamed because I was sure everyone would think *he* was taking *me*.

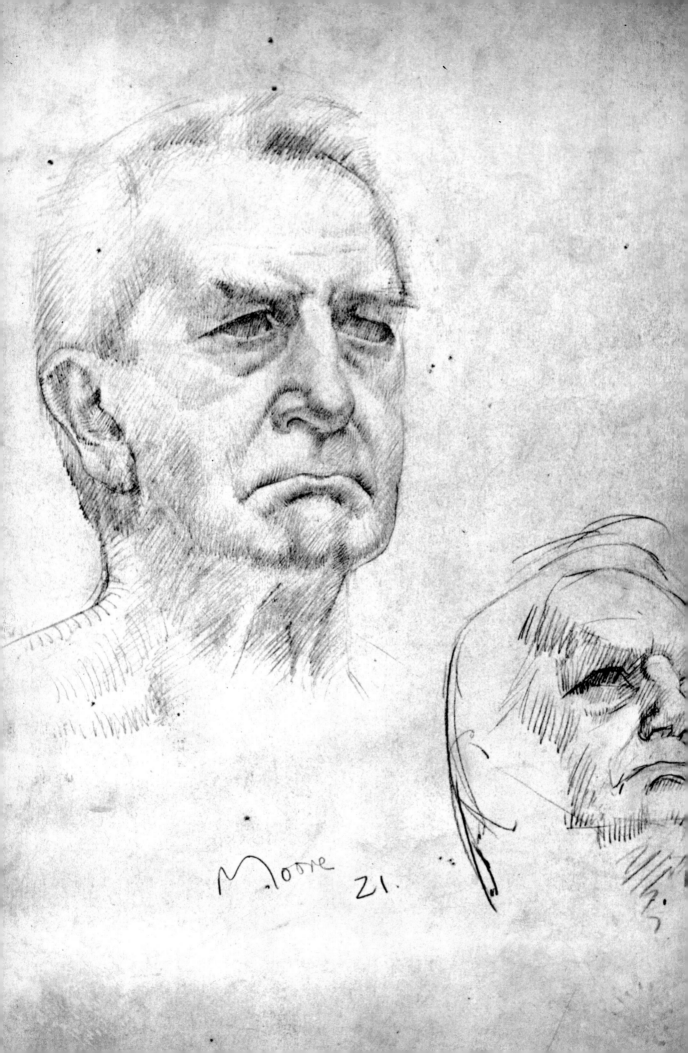

When I came out of the army, I went back to teaching and no longer found the discipline such a problem as I had as a boy of seventeen. Having been a physical training instructor in the army, I now knew how to exercise control. Then the educational authorities gave help to those people who had had their educations interrupted by the war. I applied for an army grant and was given one. This was what enabled me to go to Leeds School of Art.

When I went to Leeds Art School, I was twenty. There was no sculpture course, but they taught painting and drawing. Of course, it was sensible to do this first. But then they had to start a sculpture school just for me when I said I wanted to be a sculptor. They got someone called Cotterill who had just left the Royal College—I was his only student. He would never leave me alone, he was always there behind me, always watching. He wasn't a good sculptor himself.

While I was at Leeds, I lived at home in Castleford and I used to catch the 8.20 train every morning, running from home to the station.

I was a very conscientious student and it was terribly important to me to get high marks because I knew, without them, I would never get the scholarship to the Royal College of Art. One had to take exams—drawing and sculpture—and there were other subjects which I worked on for the scholarship, like anatomy and history of art.

After I'd been at Leeds for about a year, Barbara Hepworth came to the school. When she arrived, she was just going to do an art school course, like the foundation course of today, and she would have become a drawing teacher in a secondary school. I became a bit sweet on her and we went out together. Through my influence, she changed and wanted to be a sculptor.

We had to draw from men at college. We weren't allowed to have female models at first because of Victorian prudery. I can remember the first time we had a female model—what excitement there was! It was considered very daring in those days. To me a female figure is of more interest. The difference is not aesthetic, it's real. A woman has a different function, she is softer, she doesn't have the boniness. It isn't that men and women grow up differently, they are born different.

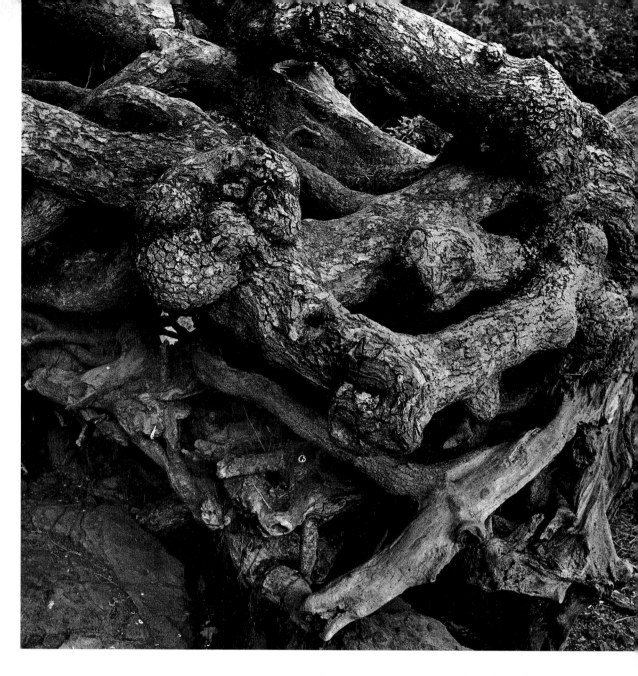

We never went away on holidays, but we went walking or bicycling—not far, say the two or three miles to Pontefract. We would go blackberrying or collecting chrysalises. And I loved fishing in streams and pools and in old clay quarries.

Half a mile outside Castleford, you would be in lovely countryside. There was a great contrast between the weekdays when you would play in the streets and the weekends when the countryside was what mattered. The back streets which were so grimy and muggy and dirty made one love the country. I knew I liked the countryside, but I was most conscious of the contrast.

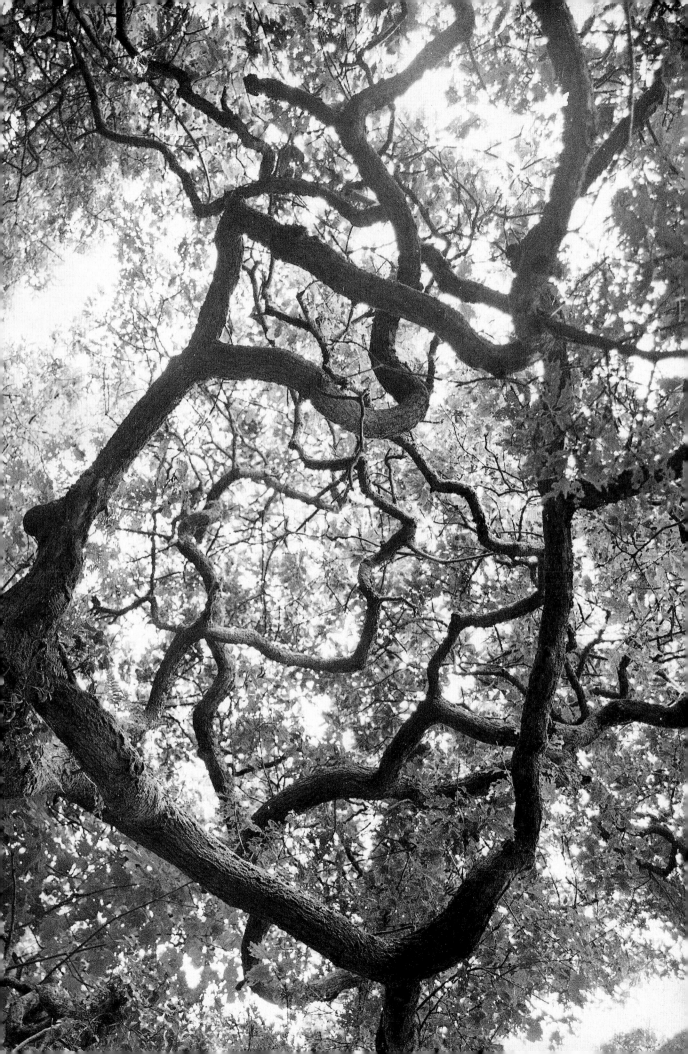

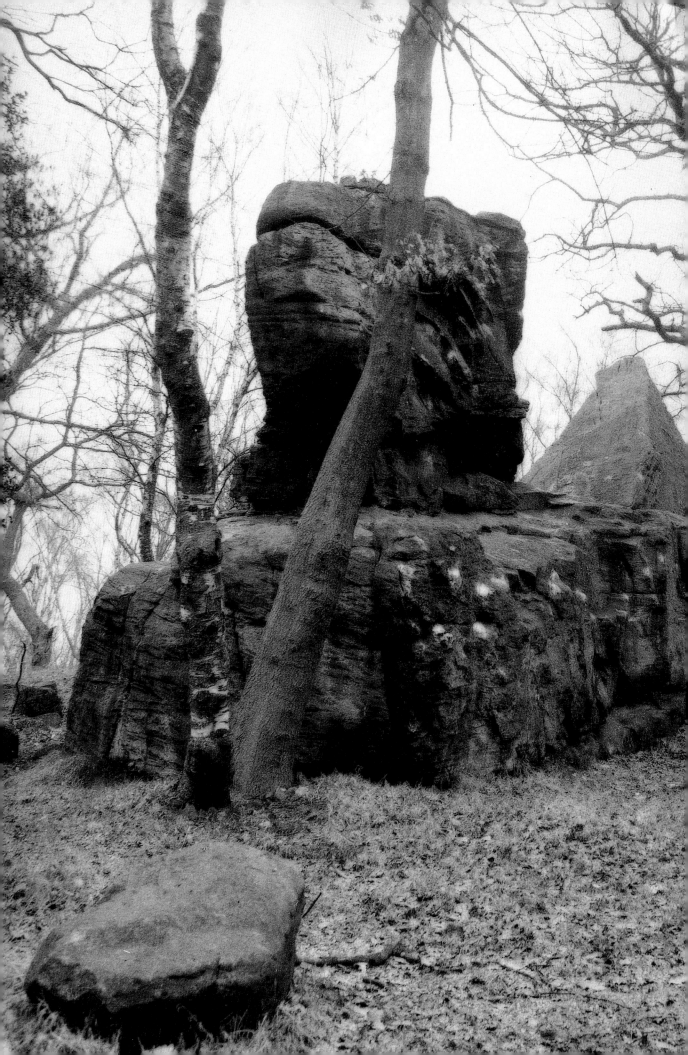

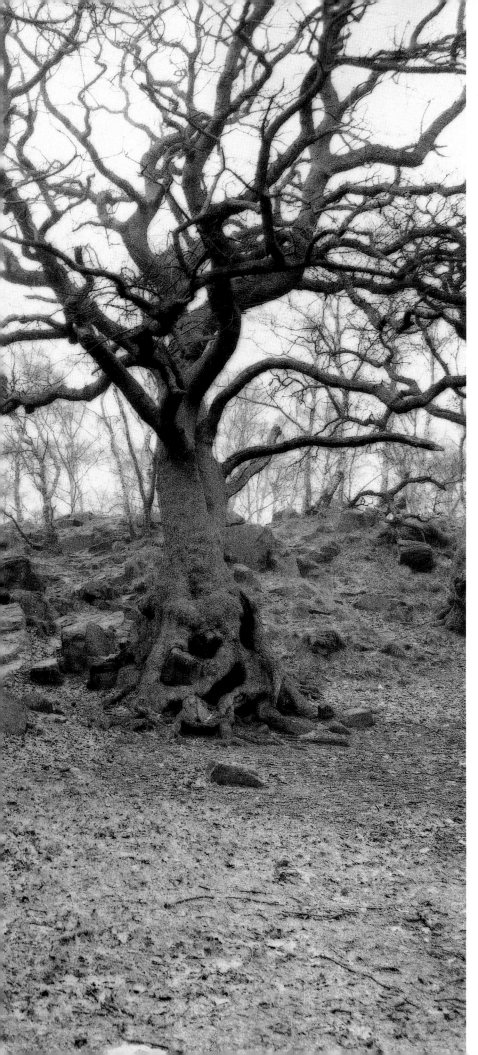

At one time I thought I wanted to write, I wrote little plays and essays. I thought then that poetry was the biggest and most marvellous of human activities. But, actually they're all the same. Poetry and sculpture are both about people trying to express their feelings about life, about nature, about their response to the world.

In Yorkshire in Adel Woods just outside Leeds, there was a big rock amongst many that I've called Adel Rock. That influenced me quite a bit. For me, it was the first big, bleak lump of stone set in the landscape and surrounded by marvellous gnarled prehistoric trees. It had no feature of recognition, no element of copying of naturalism, just a bleak, powerful form, very impressive. It was the local beauty spot, so to speak, and I knew it from a child. And much later, when I was a student, I would visit it with friends. We would picnic and draw and play around. It was an exciting place for me, Adel Woods.

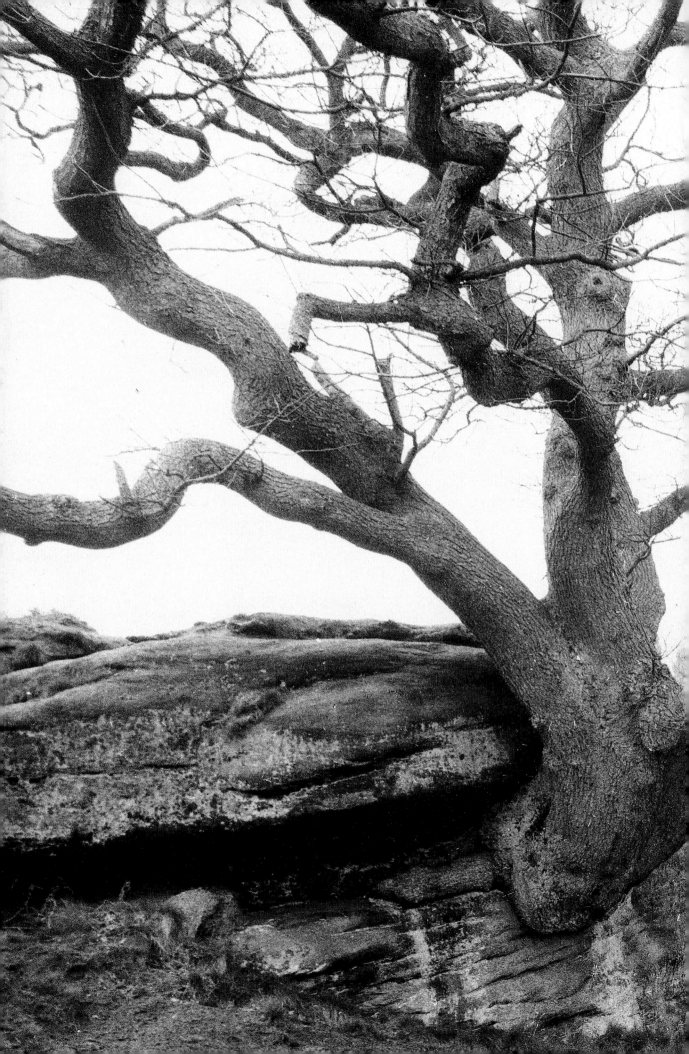

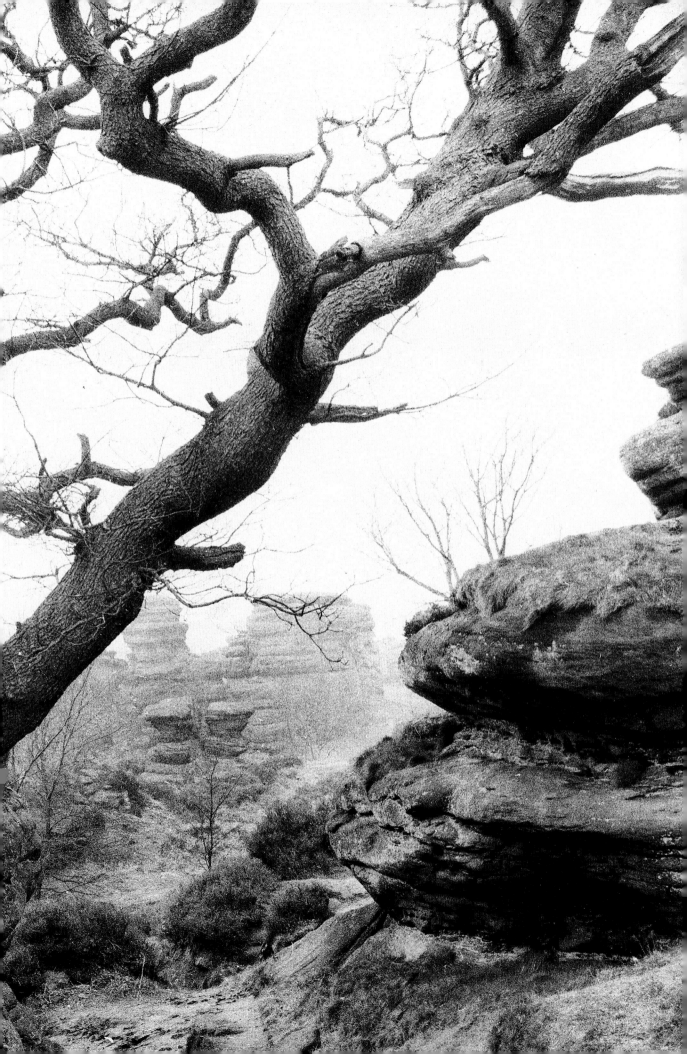

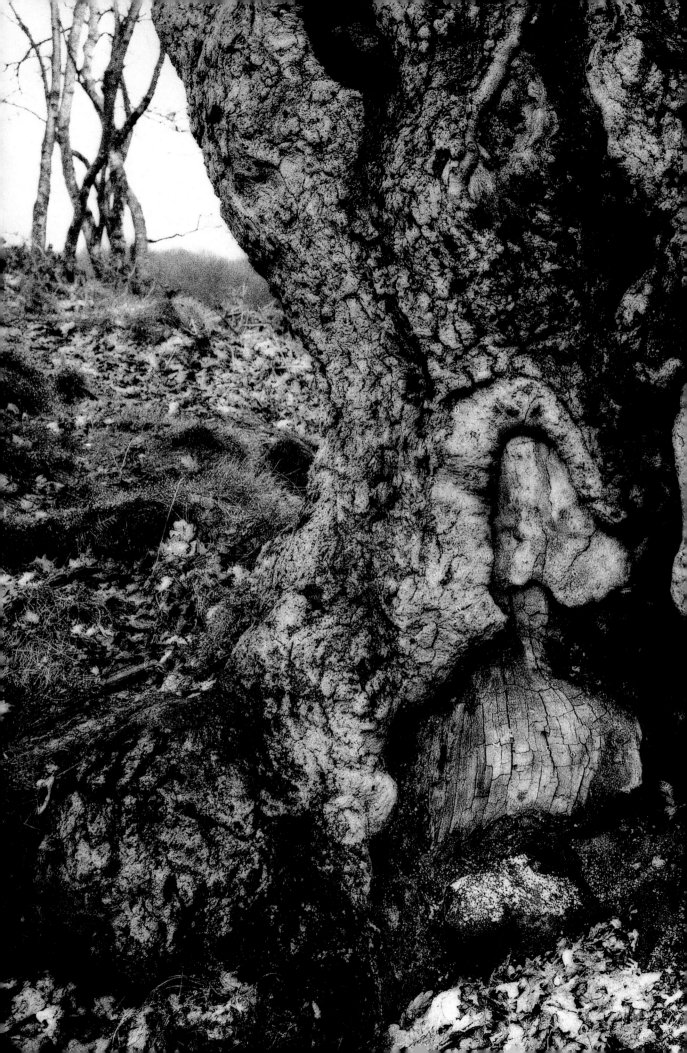

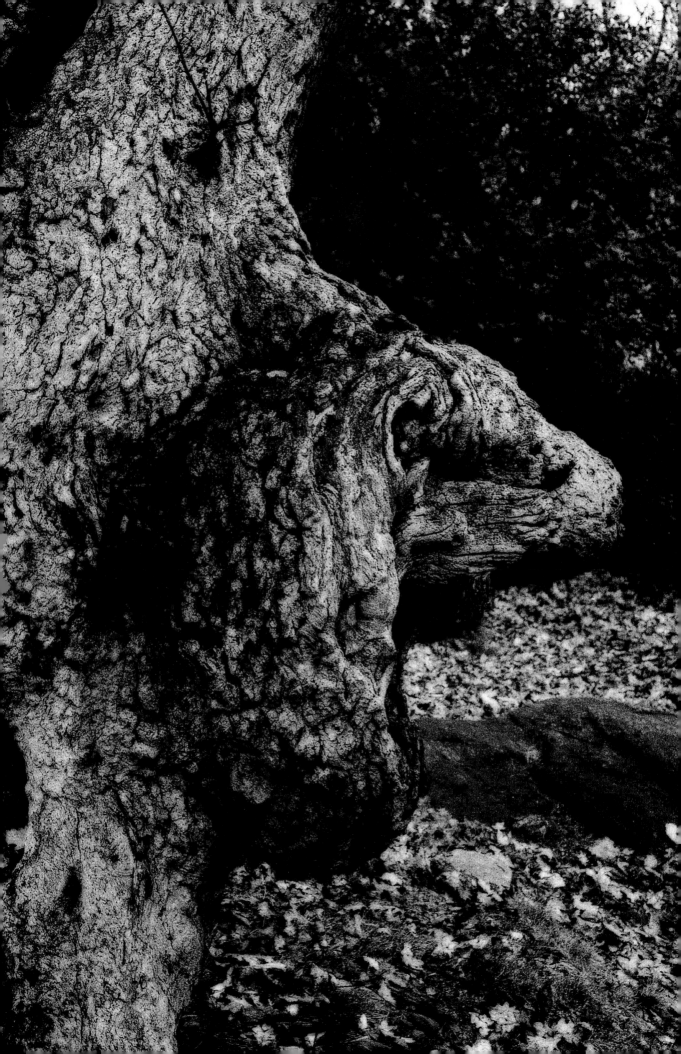

Sadly, my father died in 1922, just after I'd started at the Royal College of Art. My mother had no knowledge of art; she, like many parents, just thought that whatever I did was jolly good. I remember one day when I was carving a big piece of stone, she wondered aloud why, when I'd been to grammar school, I should have chosen such a hard physical job. She felt that if one could avoid sweating at manual work, one should! When I first moved down to London to the Royal College, I lived in a horrid little room in Sydney Street in Chelsea. It was about eight or nine feet square. You could just get in the door if you pushed yourself against the bed. The landlady served haddock every morning for breakfast. But it was the first time I had had a room of my own and I enjoyed it.

When I was a student, copying existing works of art was a major part of the curriculum. It was a very good thing, you can't do without it. It's learning to draw at the same time; you find out whether you've got an eye that can judge proportions and distances and so on, strengths of black and light, and tone values. Copying is a great help for all that. I was taught by Barry Hart who had been taught as a stonemason and was used to copying. He was a good craftsman but not a creative person and, unfortunately, the attitude at the College at that time was that we should produce identical copies, using a pointing machine. I persuaded Barry Hart to let me try to carve freely—but I had to pretend that I was still using the pointing machine!

I used to spend my time off at the weekends studying, looking in and drawing from the objects in the museums around the Royal College of Art—the V & A, the Natural History Museum, the Science Museum, the Geological Museum. I loved the British Museum, too. That was my main choice, rather than the Tate, which was all contemporary work. You can learn the history of art from the British Museum, from the very beginning, from Paleolithic Art to the Renaissance. Understanding this history is necessary to an artist—if you're going to be a good writer, then you've got to read. You learn the art that you practise not only by doing it but also by looking at what has been done in the past, what other people have done to point the way. If you had to do everything from ABC—if the writer had to invent his own alphabet—well, then you'd never get anywhere.

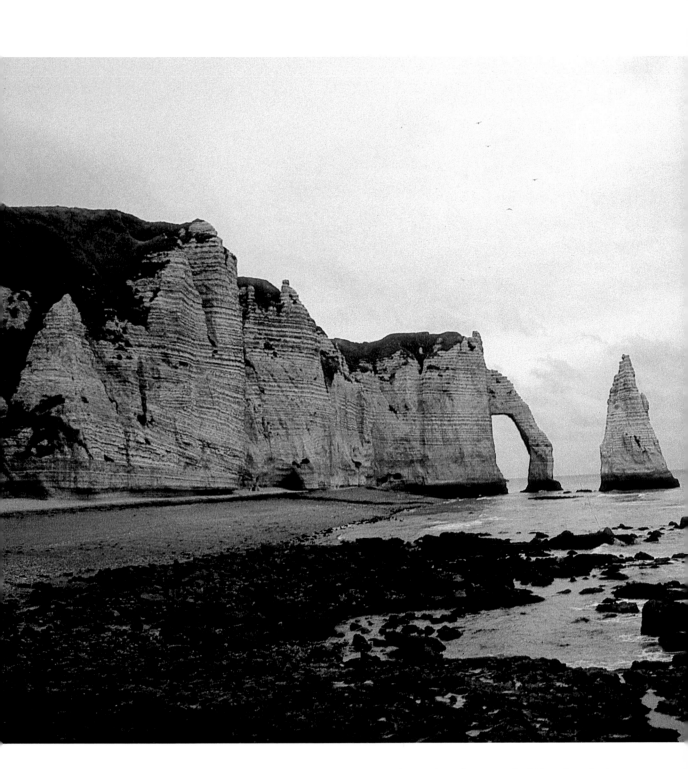

I have always been excited about natural strata and the actual forms of stone. Photographs of places such as the Grand Canyon, the rocky coast of Brittany and big, natural rocks in river beds have always excited me. I have often drawn rock strata and been influenced by its formation.

I have always thought Rievaulx Abbey (overleaf) a most impressive monument—more sculpture than architecture. When it is no longer usable, architecture inevitably becomes aesthetically like sculpture. This is perhaps why I like ruins, the Parthenon, for instance. Now that light passes through it, it is far more sculptural than if it were all filled in.

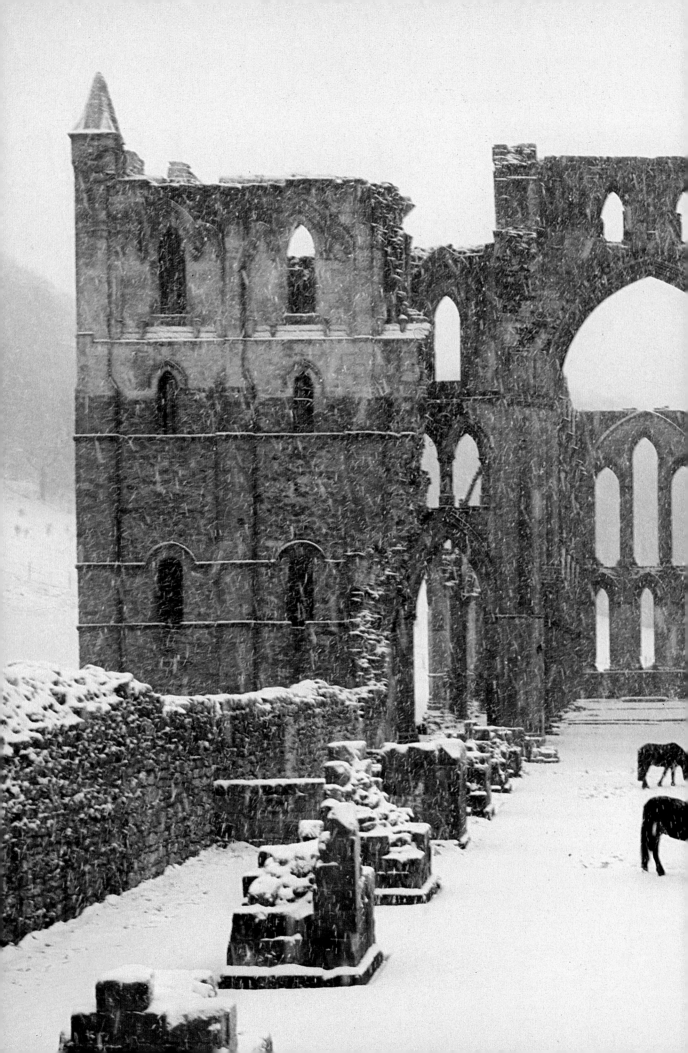

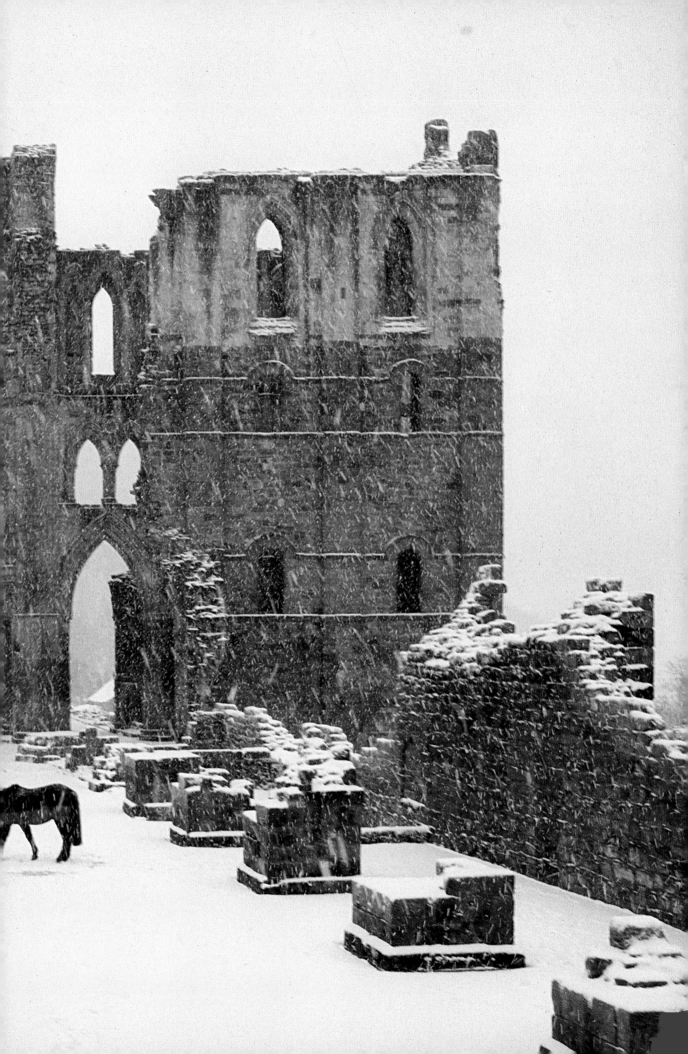

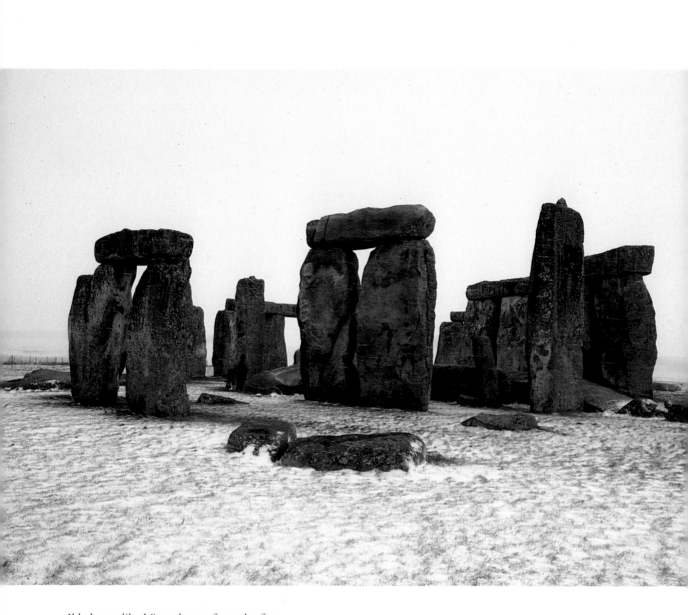

I'd always liked Stonehenge from the first
photographs that I'd seen and then I made a special
journey to go and see it. For me it was a bleak,
single, isolated monumentality with nothing to do
with human beings but to do with nature, to do
with landscape, it was almost as though those
stones were pieces of the landscape but moveable.

 I spent several years on the Stonehenge
drawings. I liked doing them. Photographs were
useful for reminding one, but then one would go
and look again.

Coming down from Yorkshire, knowing past art only from reproductions, it was terribly exciting to be confronted with real sculpture or painting. I have never tired of looking at art though I think I'd tire of being an examiner of painting or drawing or sculpture—that must be laborious work.

Another tutor at the college was Leon Underwood. He had a private school, too, in Hammersmith and I used to go there two or three nights a week. I couldn't have paid because I didn't have any money, only the £80 a year scholarship money. He was a good teacher, though a bit hard. He insisted that drawing was terribly important and you had to know the laws of light falling on a solid object and reflecting it back to the human eye; and that being translated into a two dimensional representation. You're not born with this understanding, you have to learn it, you have to be taught it.

There was one teacher who didn't like my work at all, I think because I was one of the students beginning to question what I was being taught. He didn't like this and he went for me. It did no harm, in fact, it was good experience for later criticisms. It was really all because in those days so-called 'modern art' was thought to be immoral and vulgar and God knows what—supposedly it was just about sex.

This was during William Rothenstein's time, who brought to the Royal College some sense of international reputation. He was from a rich, Jewish wool family from, I think, Yorkshire. He had wanted to be an artist and his parents let him spend two or three years in Paris, where he had met Rodin. He took to me, I suppose he saw some talent there. Through him, I met a lot of important people in the art and literary worlds. He became head of the College and that was jolly lucky for me. People thought that he was revolutionary though he wasn't at all, of course. The first two sculptures I ever sold were to his brother, Charles Rothenstein. They were wood carvings and they fetched £7 and £10, which was quite a lot in those days.

Epstein was very helpful and very good to me while I was still a student. He had the biggest reputation for sculpture in England and his approving of my work was the greatest possible help at the beginning. He bought two little sculptures of mine while I was at the Royal College. He was a great friend and knew what committed sculpture was. The others all thought that if a sculpture wasn't superficially realistic, it wasn't any good.

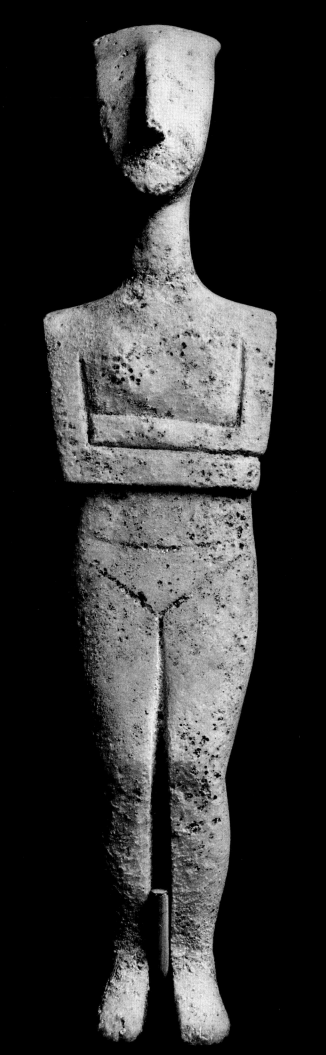

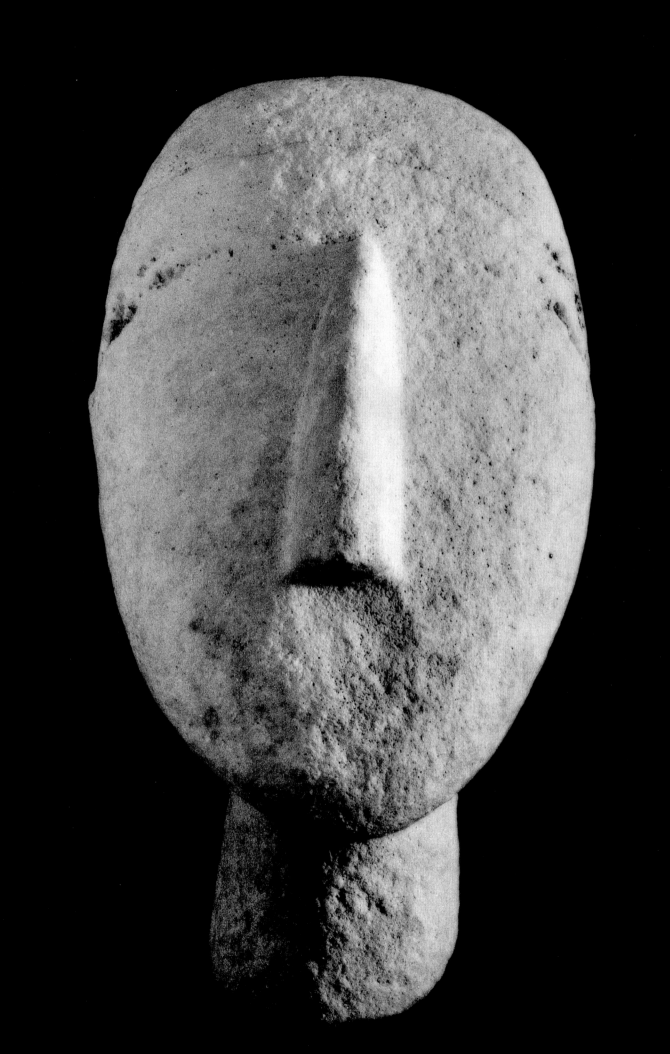

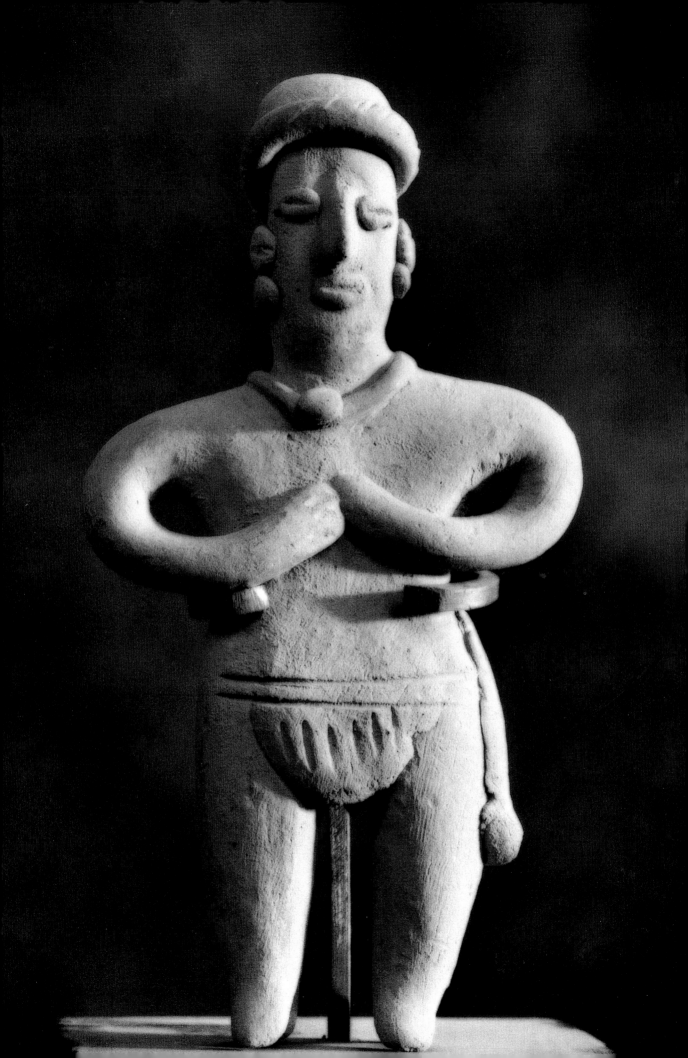

Epstein began to collect negro sculpture
and he encouraged me to study the
primitive and Mexican sculpture at the
British Museum, all of which influenced
and excited me. It was stone sculpture. I
liked this active, physical side of sculpture
and so began to know and enjoy stone
sculpture as a very great excitement.

It was a different world then. Primitive
art, anything other than Greek or
imitation Greek, Roman or Italian
Renaissance was all thought to be childish,
untutored, amateur or immature. Even in
the late Fifties, people were still making
jokes about my sculpture, cartoonists
likening it to a piece of Gruyère cheese
and so on. It was actually terribly good for
me —it helped my reputation enormously.
If it had been praise, you'd have thought
there was something wrong. To be
disliked by the average, the mediocre, was
necessary.

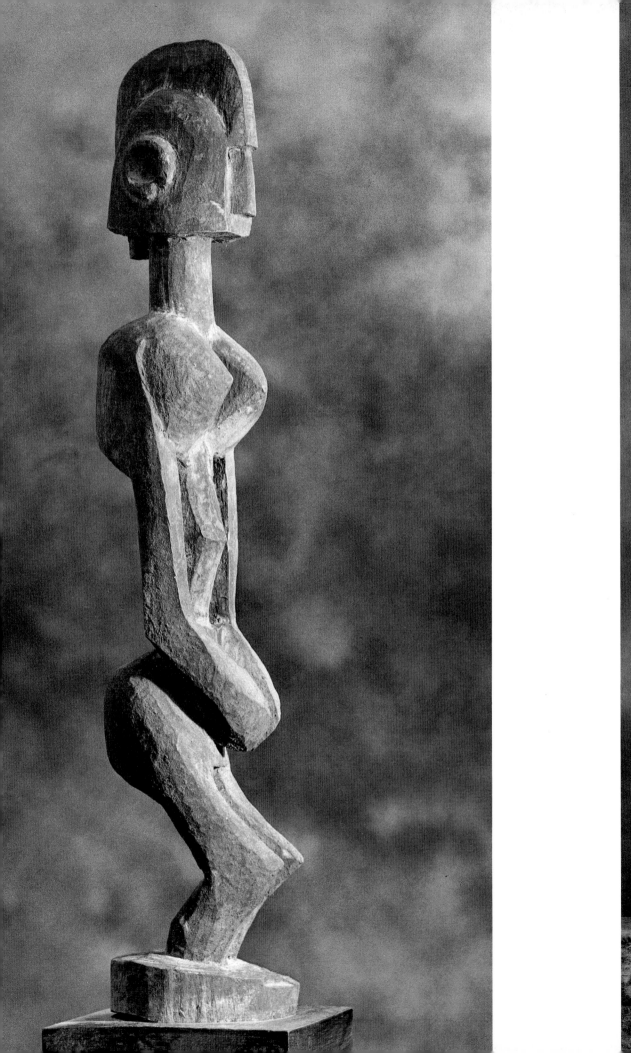

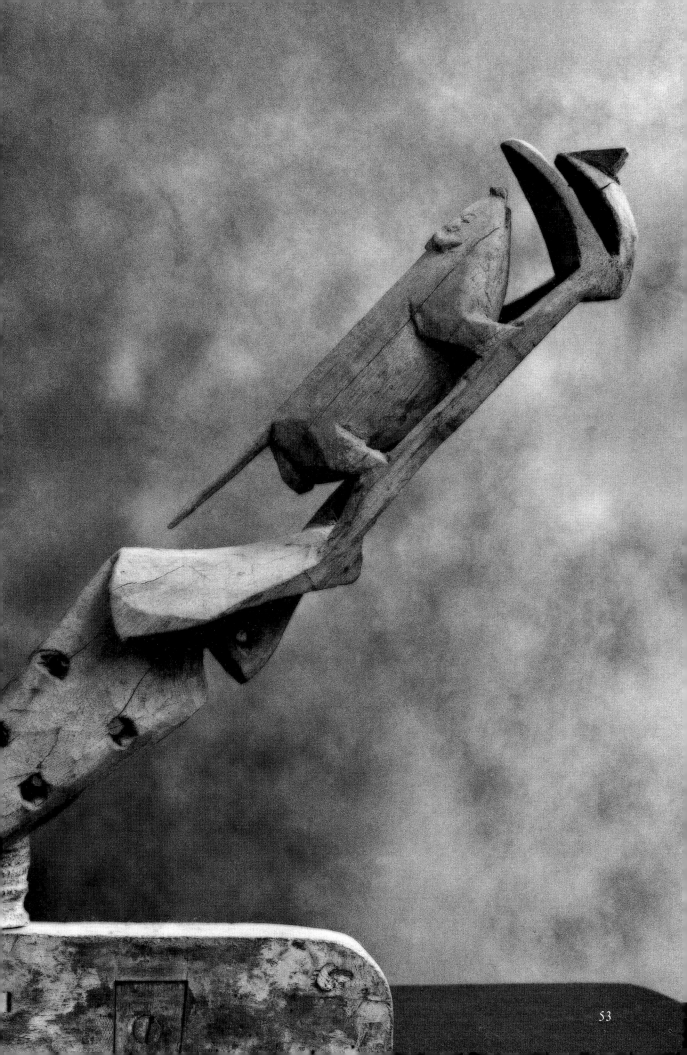

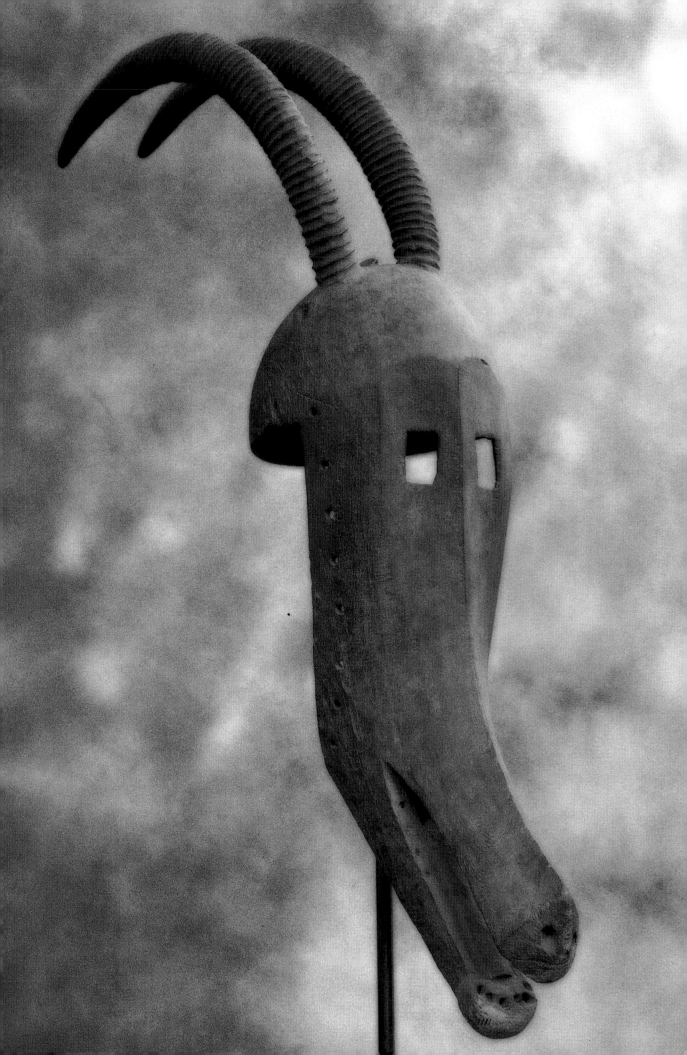

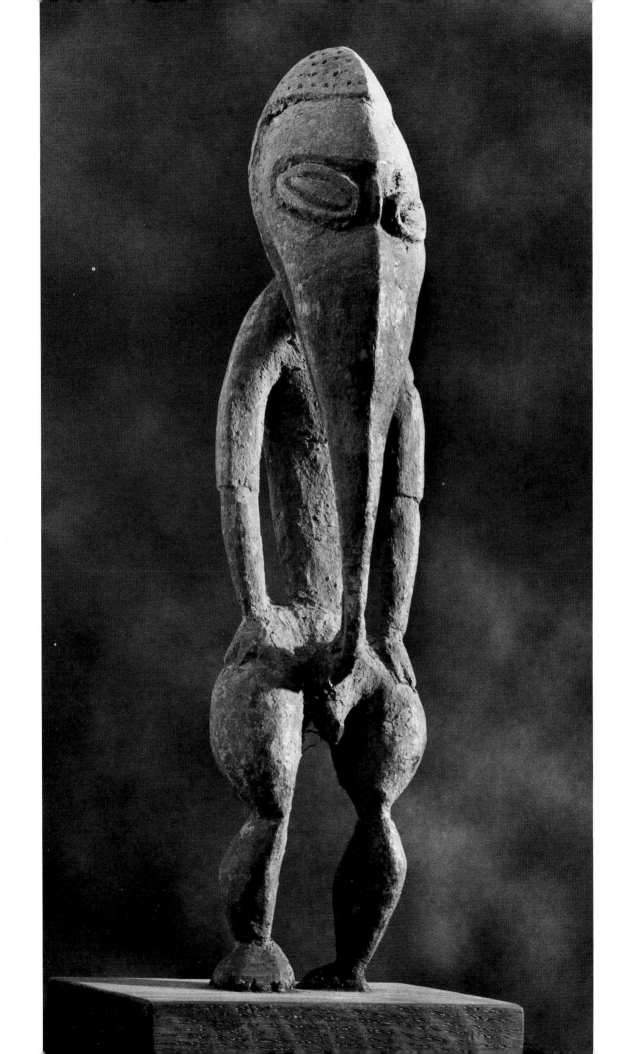

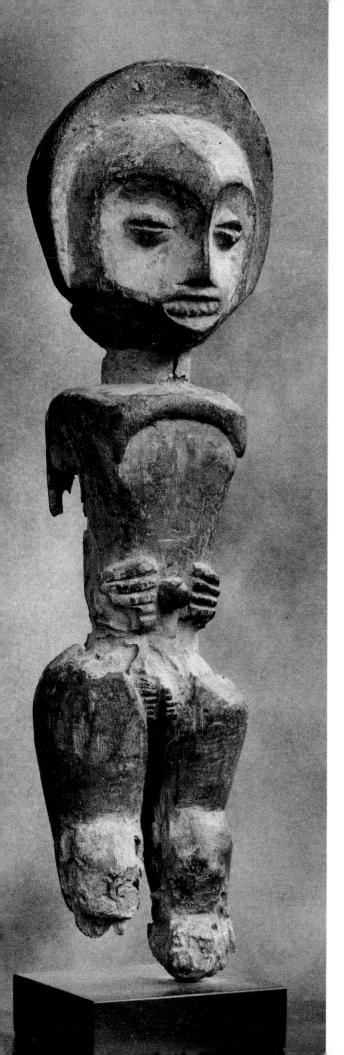

In the academic world, the teaching world, they didn't look at works earlier than the Renaissance because they looked upon them as being too primitive, childish, uneducated or I don't know what. There was no encouragement, people just wondered why I was interested and why I wanted to look at primitive sculptures.

I went to the British Museum where there was, and still is, a department of primitive sculpture, and I took to it straight away. By that time Victorian art was all frills and fancies, whereas in primitive sculpture they did it for some real purpose of expression, perhaps a religious purpose. It isn't decoration, it's something very important. Nor is it academic, in the sense of absorbing an influence or tradition. Primitive art doesn't look outside itself, it is more fundamental.

Cycladic art was a great influence. It had that purity of all early art which stems from the people who made it feeling something so very strongly, rather than later art which is often more to do with copying other influences. I felt there was more to be learned from the dawn of art and I wanted to know about the Paleolithic period. Fortunately, at this time I received a travelling scholarship from the Royal College of Art and so I went to Spain to see the cave painting.

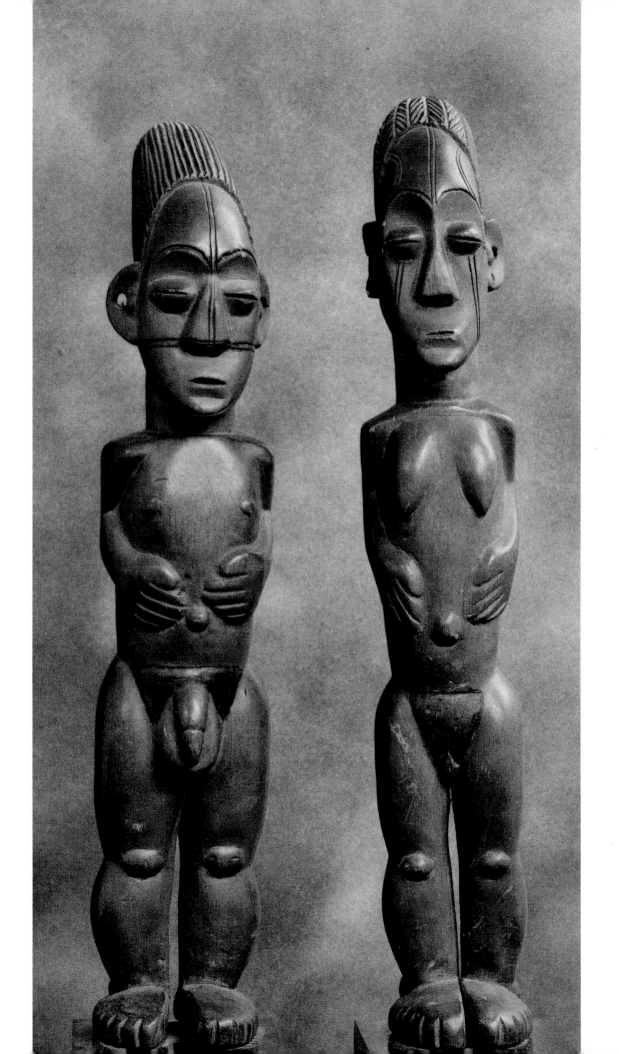

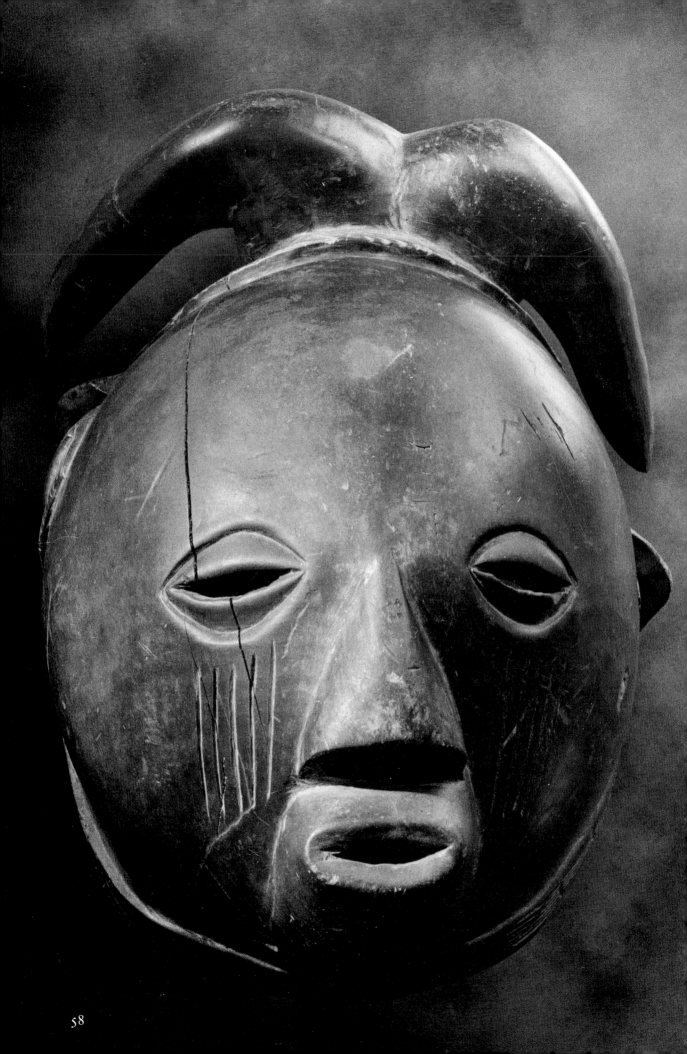

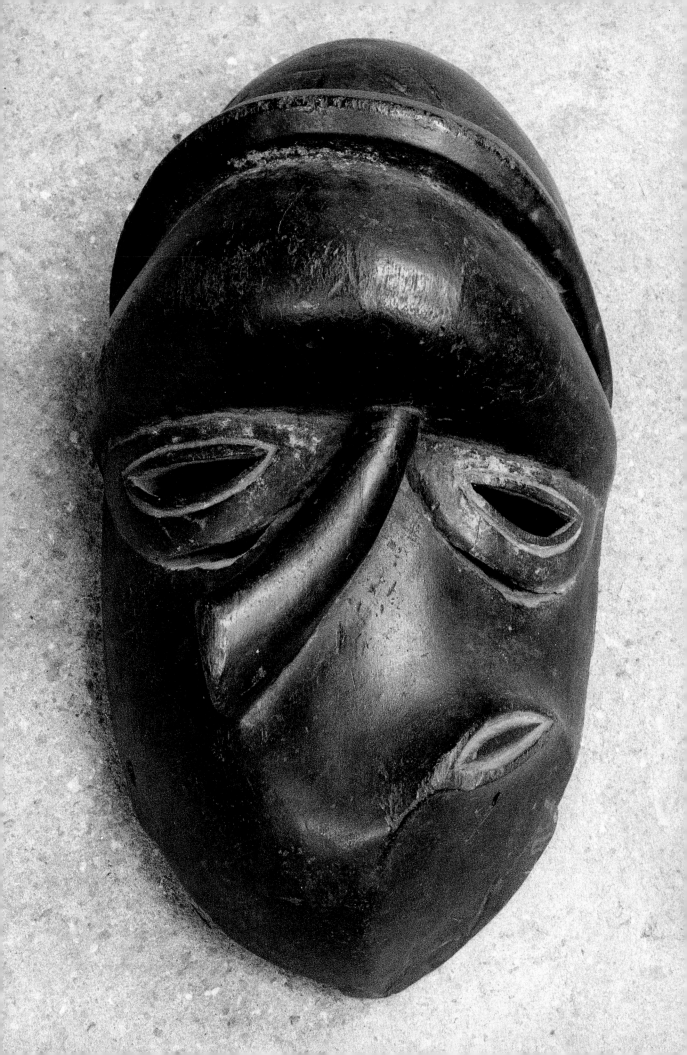

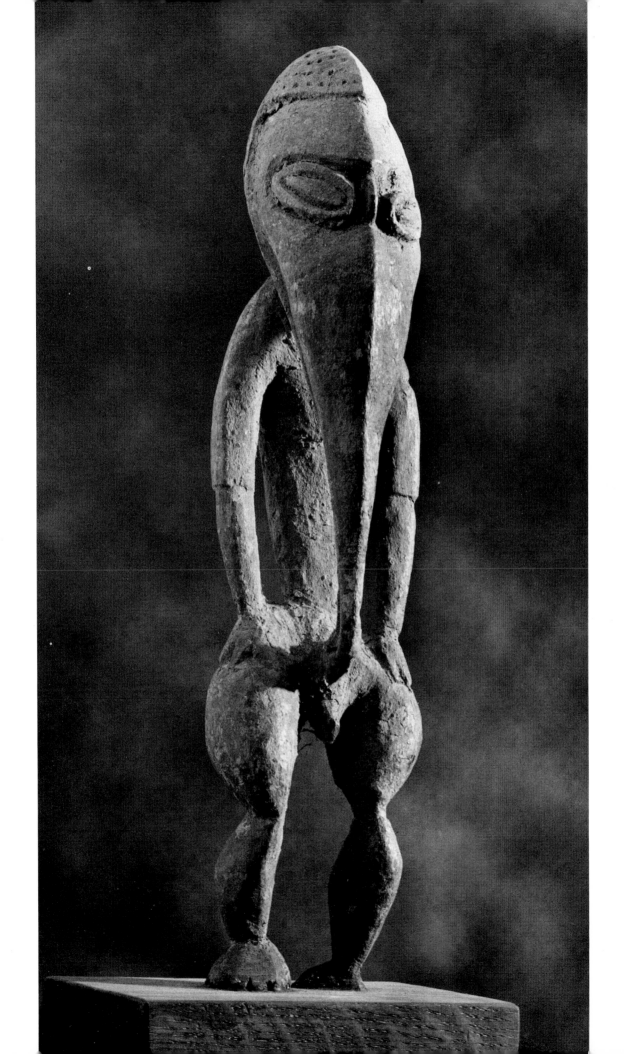

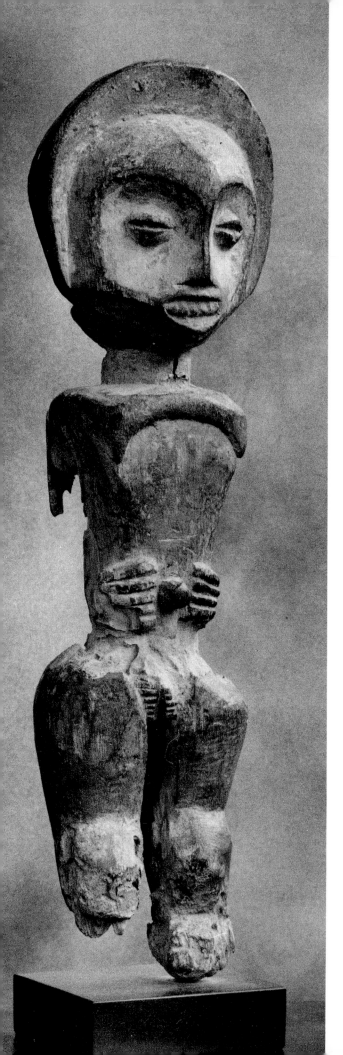

In the academic world, the teaching world, they didn't look at works earlier than the Renaissance because they looked upon them as being too primitive, childish, uneducated or I don't know what. There was no encouragement, people just wondered why I was interested and why I wanted to look at primitive sculptures.

I went to the British Museum where there was, and still is, a department of primitive sculpture, and I took to it straight away. By that time Victorian art was all frills and fancies, whereas in primitive sculpture they did it for some real purpose of expression, perhaps a religious purpose. It isn't decoration, it's something very important. Nor is it academic, in the sense of absorbing an influence or tradition. Primitive art doesn't look outside itself, it is more fundamental.

Cycladic art was a great influence. It had that purity of all early art which stems from the people who made it feeling something so very strongly, rather than later art which is often more to do with copying other influences. I felt there was more to be learned from the dawn of art and I wanted to know about the Paleolithic period. Fortunately, at this time I received a travelling scholarship from the Royal College of Art and so I went to Spain to see the cave painting.

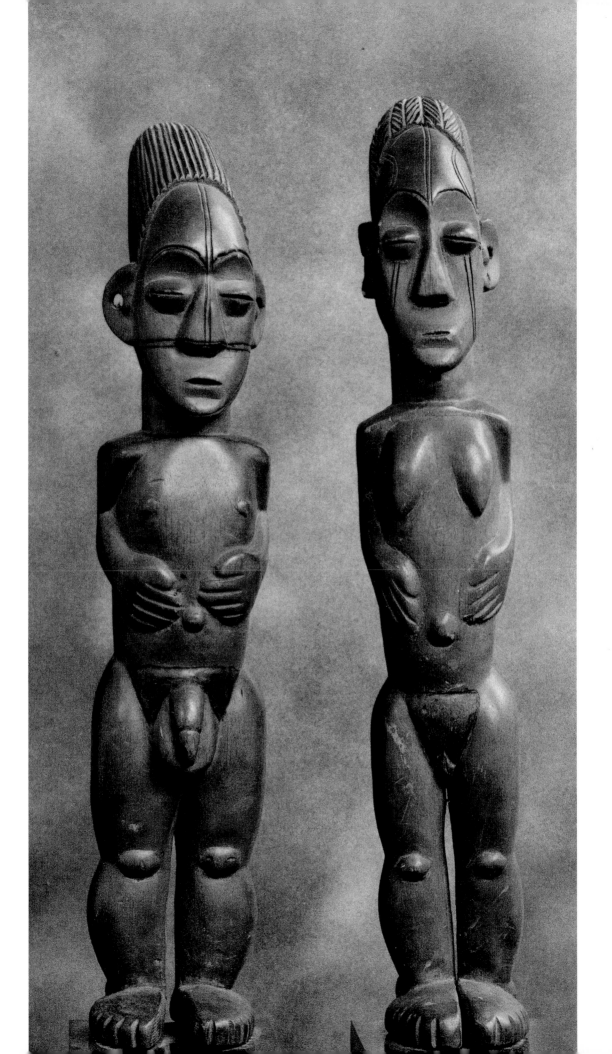

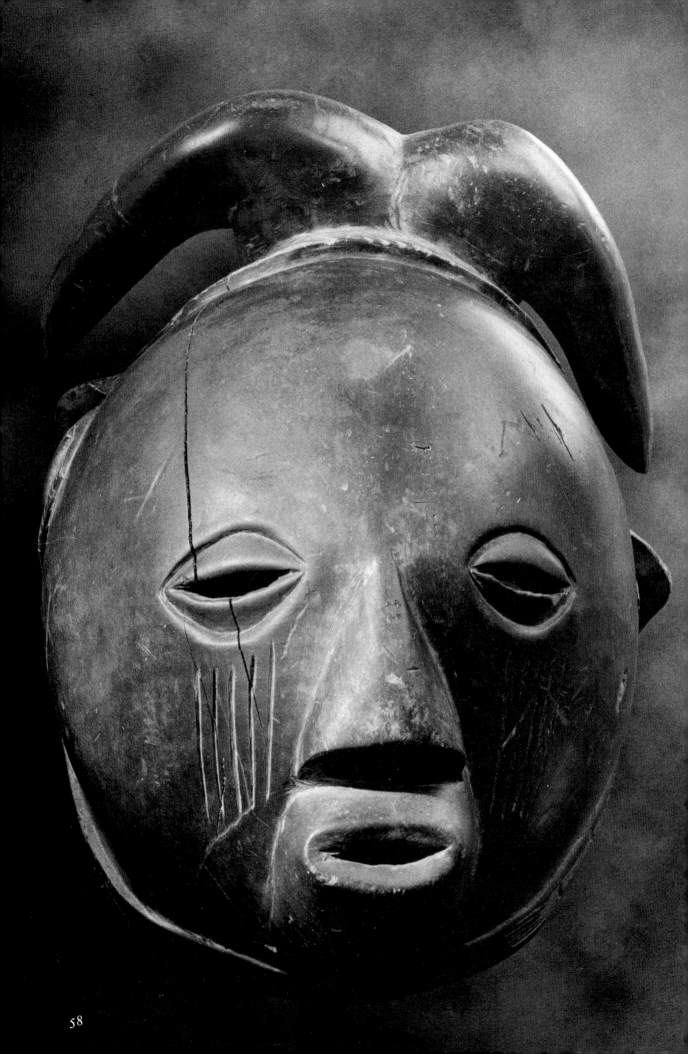

58

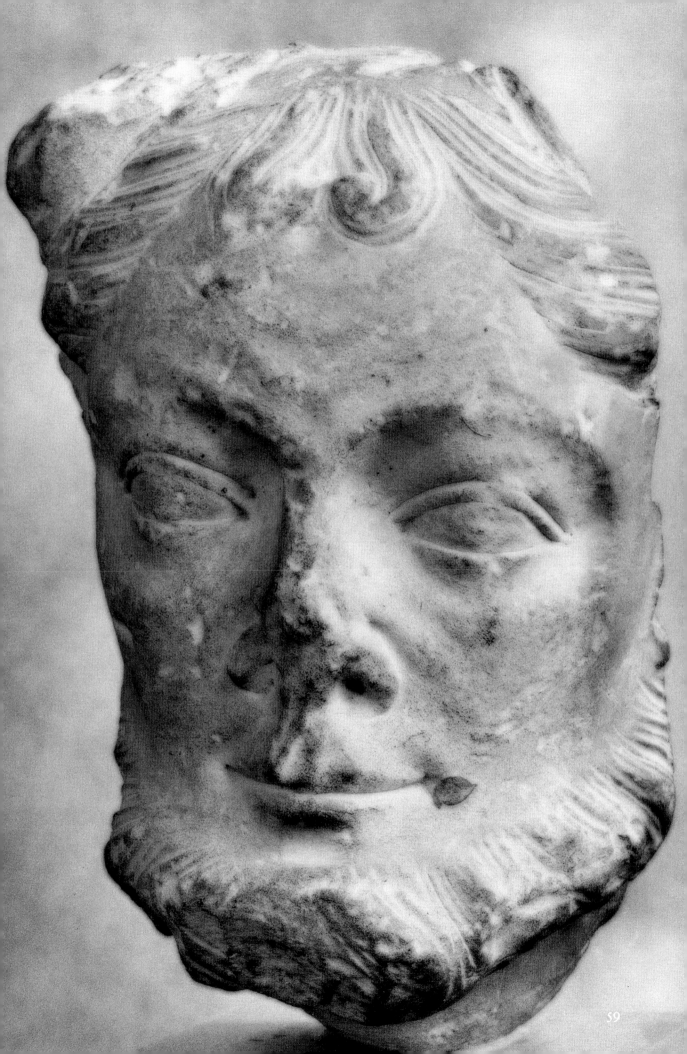

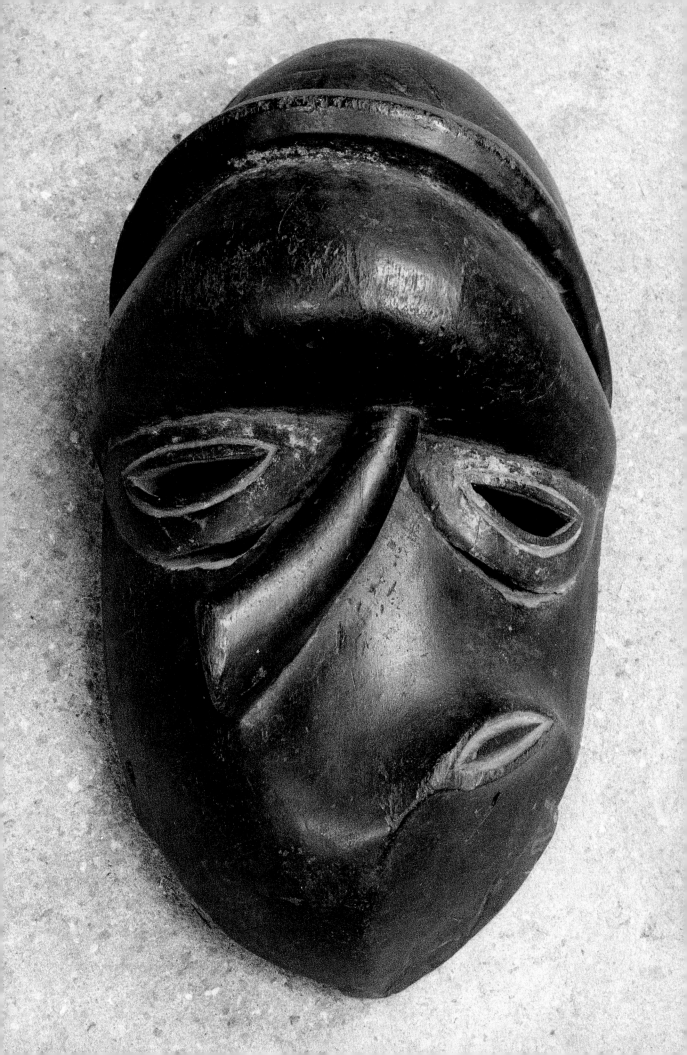

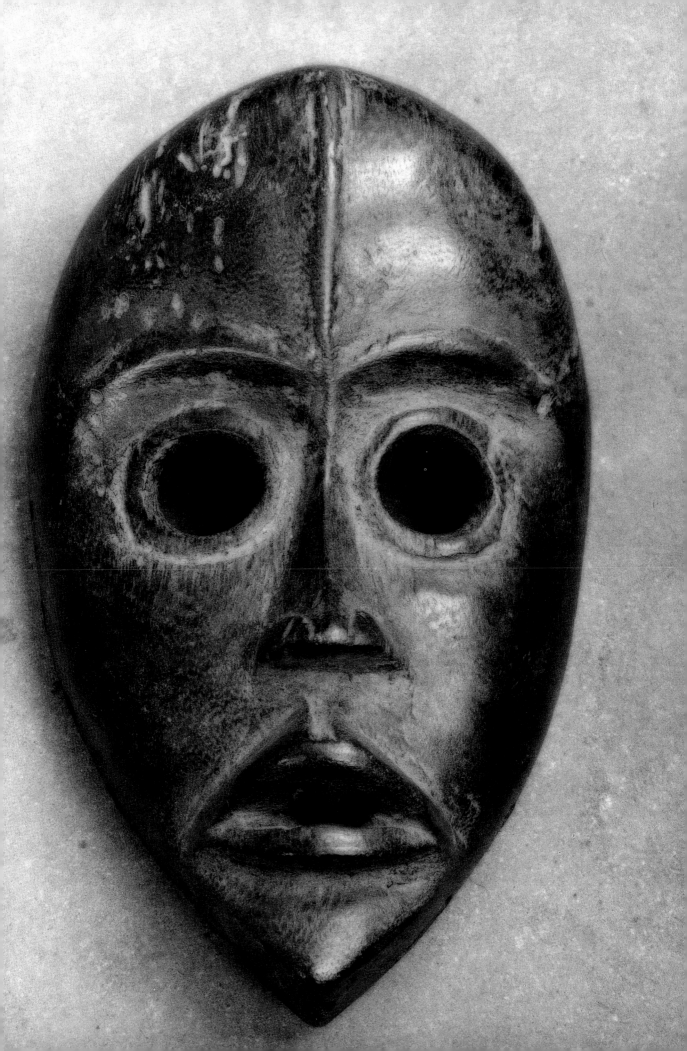

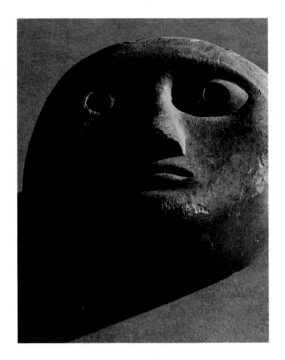

Masks isolate the facial expression, enabling you to concentrate on the face alone. They have, of course, been used throughout history, particularly as theatrical devices. Although the back of the head can be as beautiful and as interesting to a sculptor, it can't be as expressive, in the ordinary sense of the word, as the face.

Perhaps I have done six or seven masks in all. The first one in 1924 was definitely of Mexican influence, after seeing and admiring the Mexican masks in the British Museum.

In this mask I wanted to give the eyes tremendous penetration and to make them stare, because it is the eyes which most easily express human emotion. In other masks, I used the asymmetrical principle in which one eye is quite different from the other, and the mouth is at an angle bringing back the balance. I had noticed this in some of the Mexican masks, and I began to find it in reality in all faces.

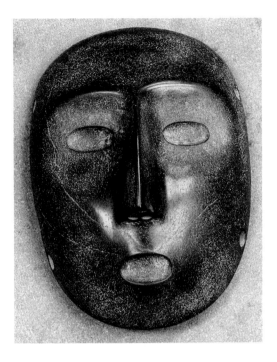

And as I began to find out that, in Nature, living things, because of the effect of their environment, are never perfectly symmetrical, this principle became fundamental to my work. You will find in everybody's face that one eye is different from the other, or the mouth is not quite horizontal, or one nostril is a little higher than the other, or the forehead comes out a little further on one side than the other.

And it is when you come to look at a person's face with acute observation that you will find these many small variations that make all the difference between a really sensitive portrait and a dull one.

The great advantage of sculpture is its three-dimensionality and that it can be seen from innumerable different angles. I prefer asymmetrical sculpture to the perfectly symmetrical because, in a symmetrical work, since one side is identical to the other, it can have only half the different viewpoints of an asymmetrical work.

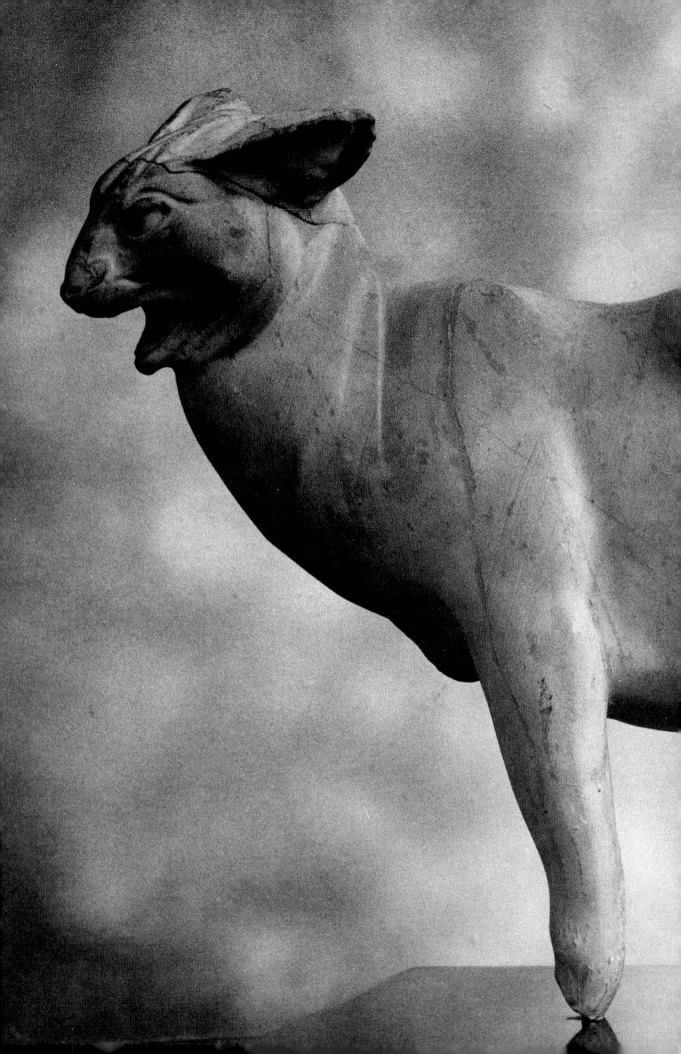

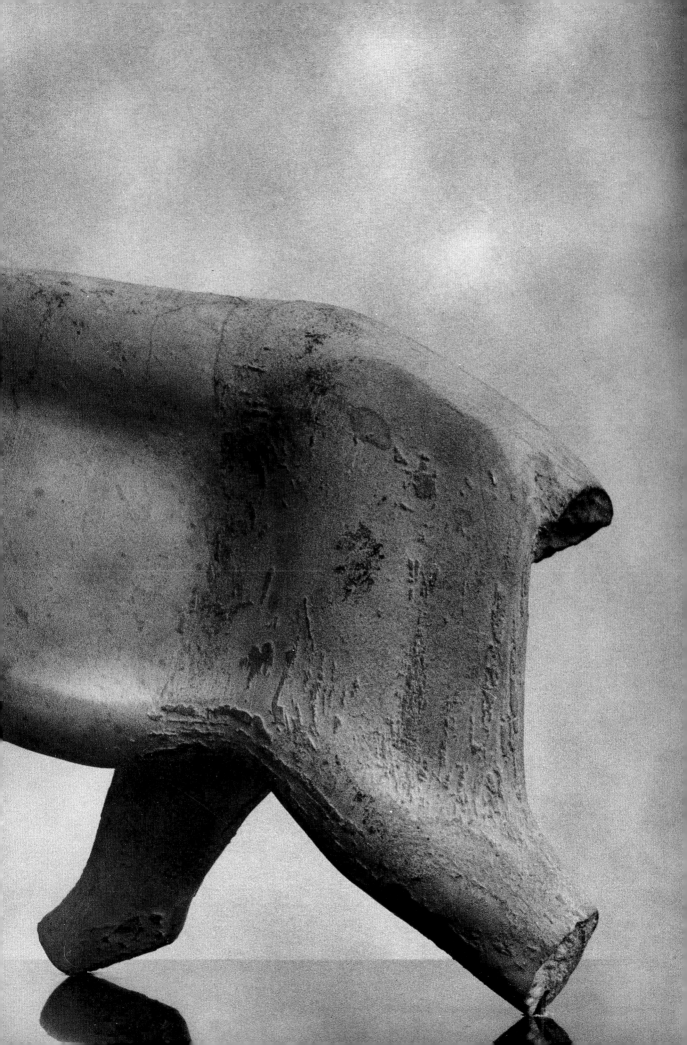

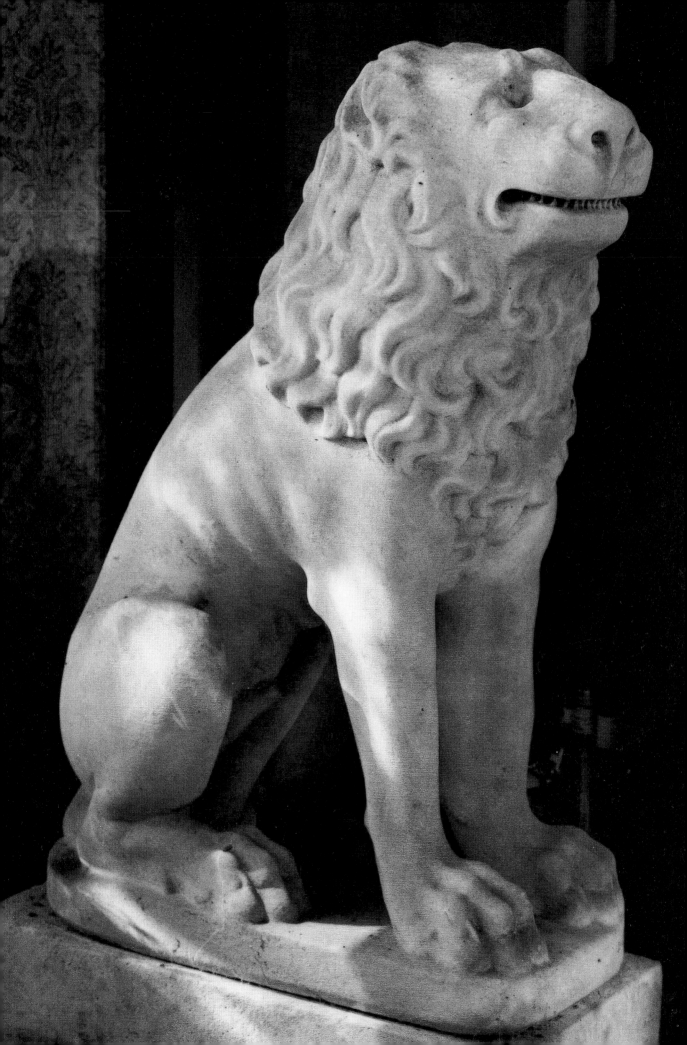

This is a Nonsuch Lion and what I have always loved about it is the life and energy in the sculpture. The carving of the marble is remarkable—the softness of the mane contrasts strongly with the strength of the backbone and the folds over the ribcage.

I think this is a very good Cibber. He's used the material well. It has a strength and monumentality about it. It's one of the figures of the *Raving & Melancholy Madness* for the gate of the Old Bedlam Hospital.

During the Victorian period, sculpture had become a process whereby the artist would model a figure which was then passed on to workmen to copy in marble. The workmen couldn't draw but they had tricks of the trade to do little bits of a figure—a trick for the ankle, a trick for the knee—and the end result was a lifeless sculpture. Eric Gill introduced a cult to popularize the idea of direct carving, of doing the whole thing yourself which helped the movement along. He was quite successful at one time, but the work wasn't very original and few people have heard of him today.

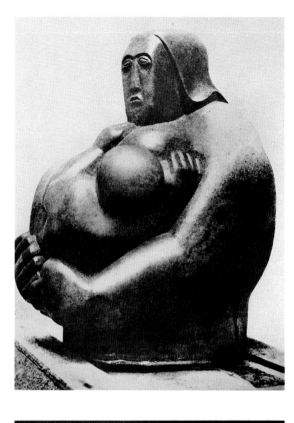

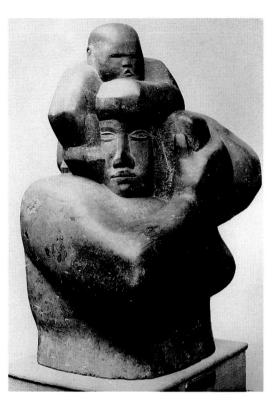

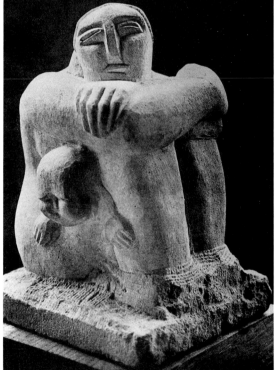

We all began to believe that carved sculpture was better than modelling, because there had been more human effort to make it, to shape it, you'd had to struggle, you'd had to work to do it. Now I realise that it doesn't matter how it is made but it mattered terribly then — the method you used, the tools, beginning with the point to split, to burst open the stone. It doesn't cut it, it bursts it. The claw tool, like teeth, like a series of pointings, but all tight together — one was very conscious of the method. Carving is a slower process and you have to visualize what you are trying to do, you have to know exactly what you are aiming for, whereas in modelling, you can alter it hundreds of times, you can add and take away. In carving you can only take away. It isn't that it's more difficult but it's more exacting.

When you are young you cotton on to an idea that helps you. I'm glad I did all of that carving — but I know now that there has been modelled sculpture which is just as good.

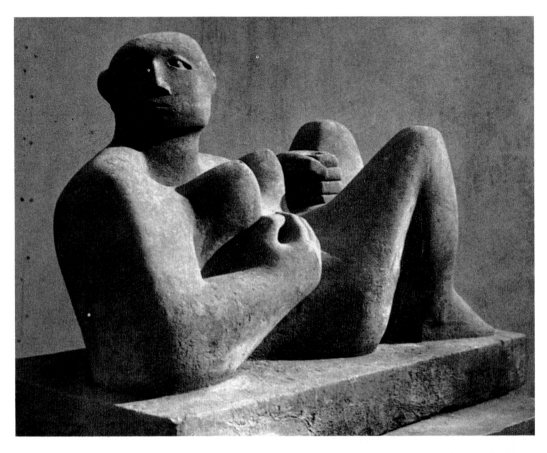

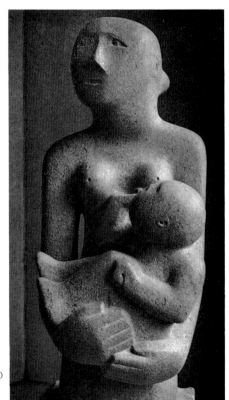

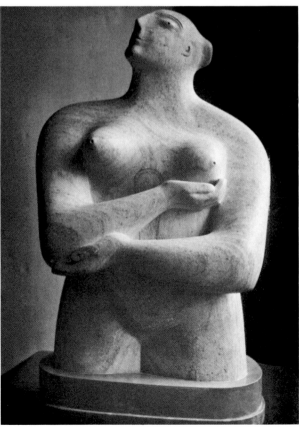

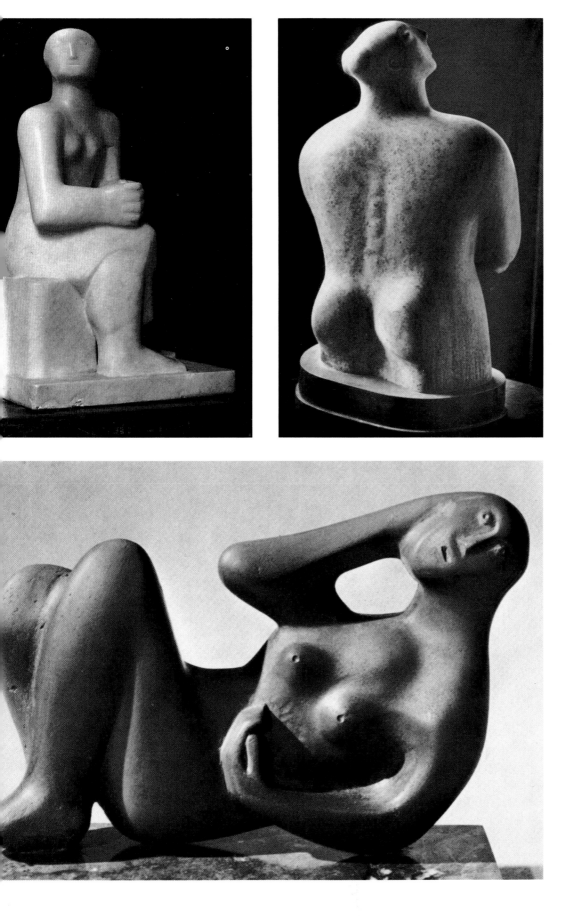

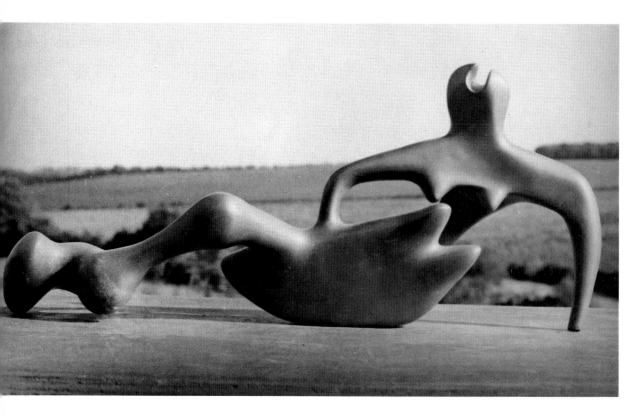

I've had a very, very lucky and fortunate life. I met a lot of people whom now I realize were the right people at the right time: Herbert Read was a critic, somewhat older than me but in my formative period he became friendly and sympathetic, a great help; Kenneth Clark, a rich man and head of the National Gallery, bought my work which helped greatly in giving others the confidence to buy it too or say that they liked it. I've been helped enormously but then I think everybody is. Nobody fights a lone battle in life. Parents help their children—you wouldn't grow up if you didn't get help. It's stupid to think we can do anything on our own, to pretend that we can exist without the help of others.

In those days, modern art had very little following, so it meant that one or two people who wanted to explain things which seemed to the ordinary person to be outré and nasty, had to band together to face the opposition. We grouped together as Unit 1. We had some exhibitions in London and the group was led by Herbert Read.

I remember going to a Surrealist meeting at which Salvador Dali was the speaker. We all sat there for about 25 minutes or so and nothing happened, just an empty stage. Everyone was getting fed up and starting to leave when suddenly there was an enormous bang and a great puff of smoke and, as it cleared, there was Dali standing in a diver's suit with a diving helmet, giving his lecture. Anything for publicity. We had already met him before he was well known, before he started being odd. He had come to our studio in Hampstead.

In my opinion there is both a 'surrealist' and an 'abstract' element in all good art. There is the mixture of emotional or imaginative non-logical inspiration, which is the surrealist point of view, combined with the artist's experience and idealism about the art he practises. I would not myself want to be called either a purely surrealist or a purely abstract artist.

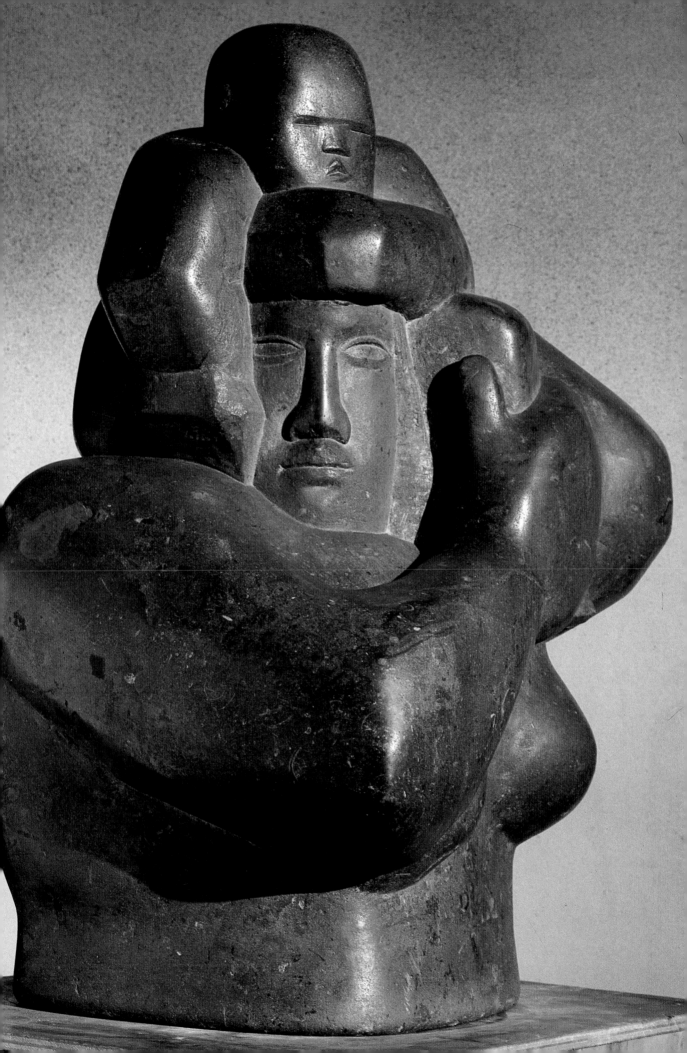

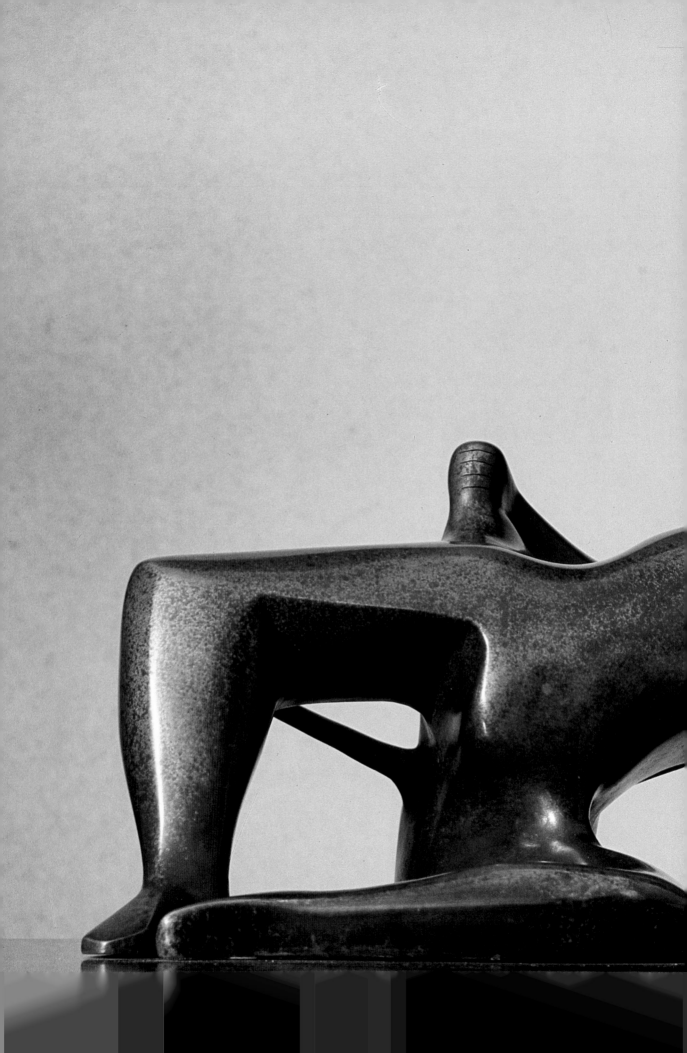

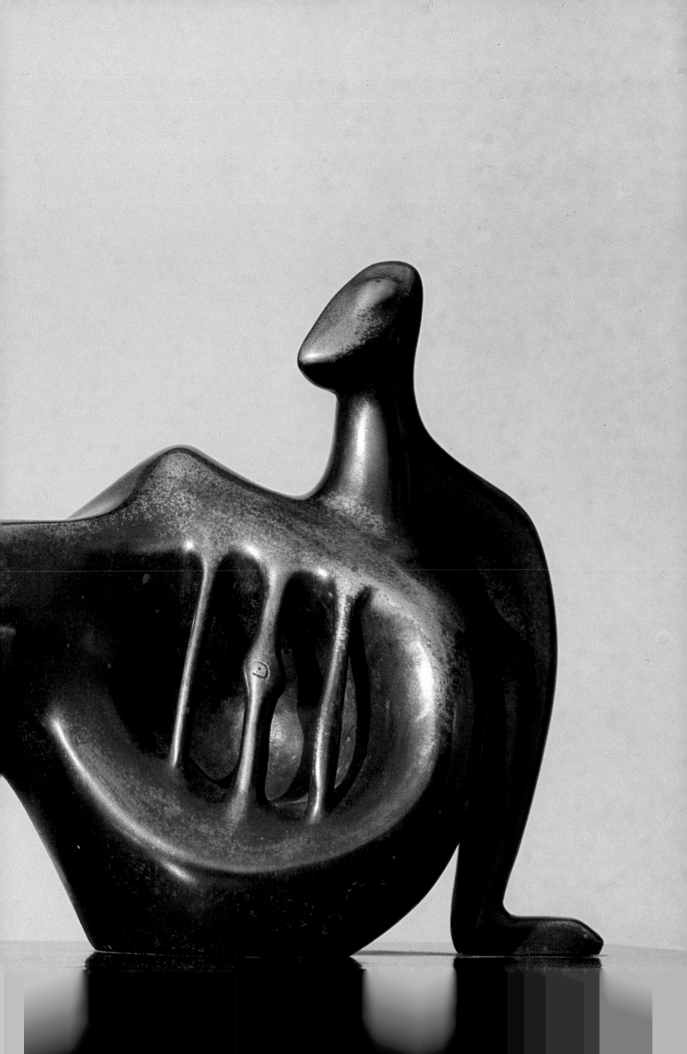

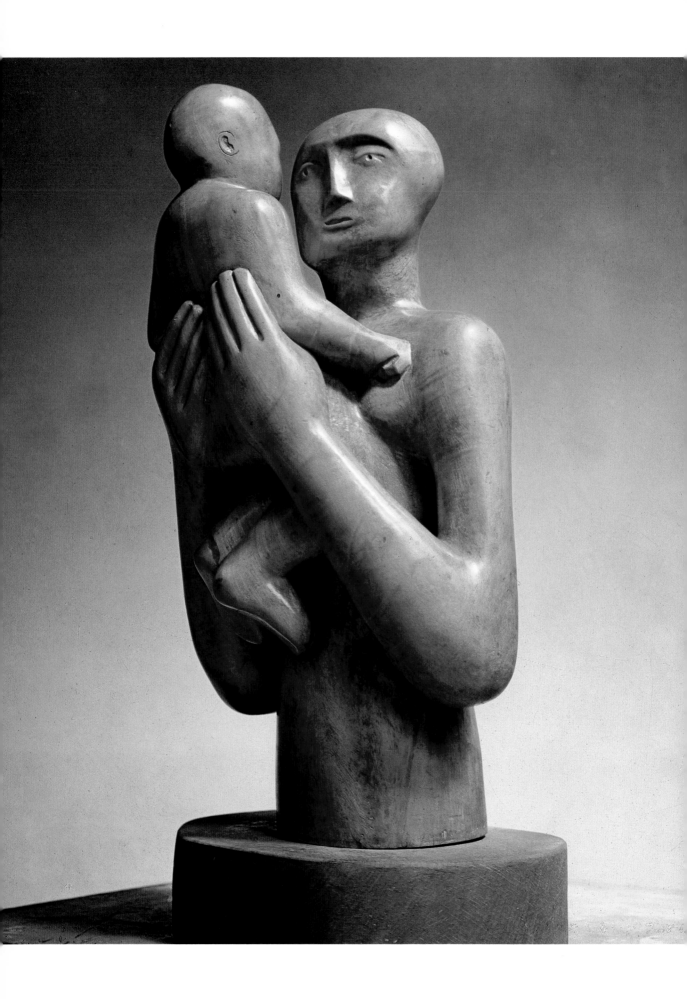

I had a tiny place in Hampstead when my mother came down to live with me. My sisters had got married and, as I was single, I felt I should take my share of the family responsibilities. I had begun to teach then and I hated having to leave her alone in the evenings. But she didn't mind, she knew how to rough it. She even did the cooking.

Early on, before there were any commissions, I was teaching at the Royal College of Art to keep us going. I had only eight students in the sculpture school, of which I was the head. I got rid of all the old plaster casts with poor surfaces, taken from moulds used over and over again. Then there was an article in the paper saying that I was corrupting the young with my ideas and I lost the job. So that wasn't much fun—we didn't have any money coming in a all.

Rothenstein was very good at backing me up. I had a lot of press against me, silly art critics who went for me and Rothenstein said, 'I believe in Moore. I appointed him for a seven-year period, as this period has not yet come to an end, he stays.'

When I lost the job, I started selling enough, just enough, and then I got a job at Chelsea College of Art. The real income was the two days' teaching.

I was against commissions because they restricted you. But I would agree to one if they would let me do what I wanted to do. Someone who wanted a Royal Academy figure wouldn't have come to me. Mainly my work wasn't commissioned, I did it and hoped to sell.

The British Council was a help to me in a practical way, financially, in assisting me to earn my living by doing sculpture and drawing and so making it possible to give up teaching. They sent my work to the Venice Biennale and various other exhibitions where occasionally it sold. Curt Valentin, he was my biggest help and friend. He promoted me in America and put on exhibitions of mine. Luckily he liked sculpture. And in those days nobody liked sculpture. He helped Graham Sutherland and Francis Bacon, too. For some reason or other he was rather keen on English artists.

Harry Fischer liked my work. Lloyd was purely a money man, but very quick on the uptake. Harry Fischer was more sincere, less smart. We used to go with him to Germany to see different towns, different paintings. It was very difficult to get exhibitions early on. There weren't the galleries and people weren't interested in contemporary art. I was fortunate to have my first show at the Warren Gallery.

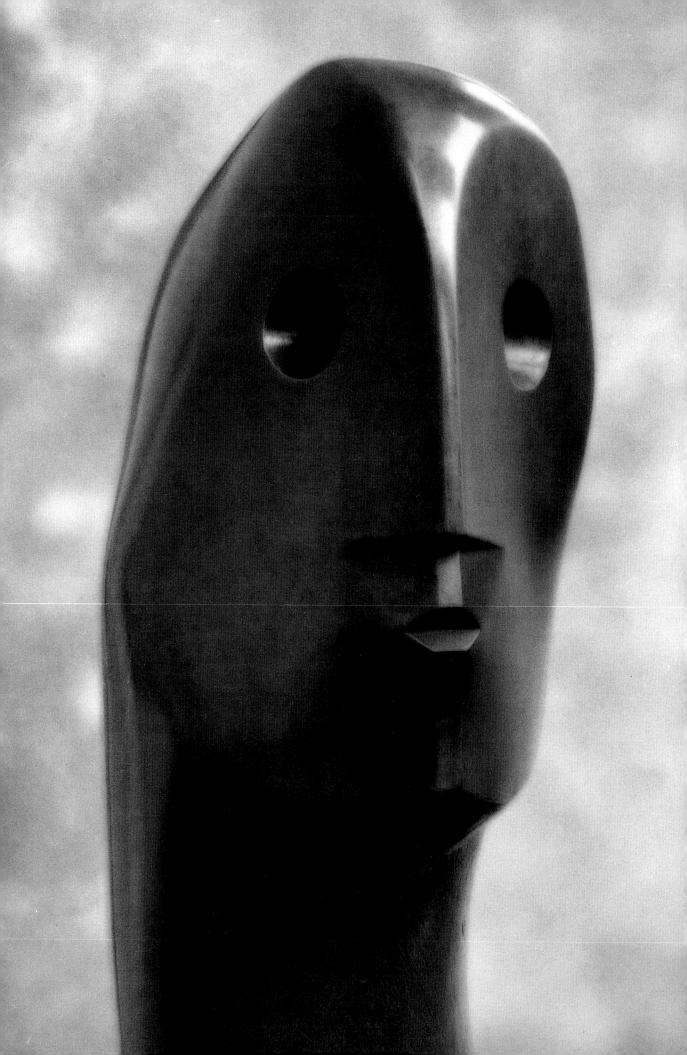

When looking at one of my sculptures, I think it's like going on a journey, each time you return you see something different, something new. Sculpture doesn't have just a front view and a back view—there are countless in-between views which are just as important and just as expressive. There was a stage when I wanted to draw models not in movement, but between movements, going from one stage to another. A good photographer could take a hundred photographs of a figure turning from the front round to the back and to the front again without once repeating a view.

My analogy with a journey is that there's something different to see at every turn that you make. All sculptors must be interested in this three-dimensional aspect otherwise they'd be something else—designers or pattern-makers. It's the difference between being a painter and a sculptor. Being a sculptor means that you are living in this three-dimensional world and that's what makes it exciting. You must be discovering the whole time. A sculptor wants to know what a thing is like from on top and from beneath—a bird's eye view and a worm's eye view. It's infinite.

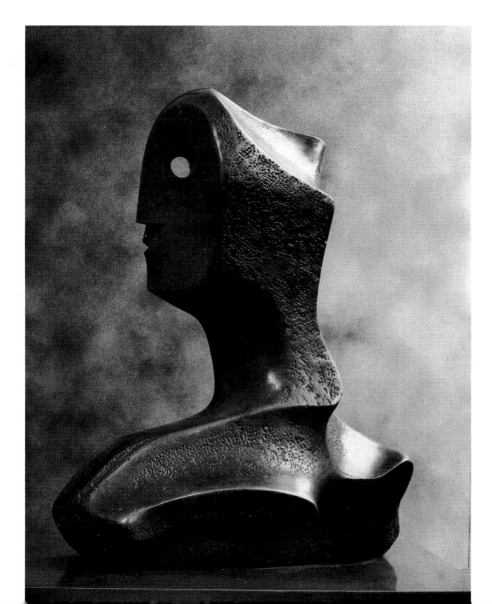

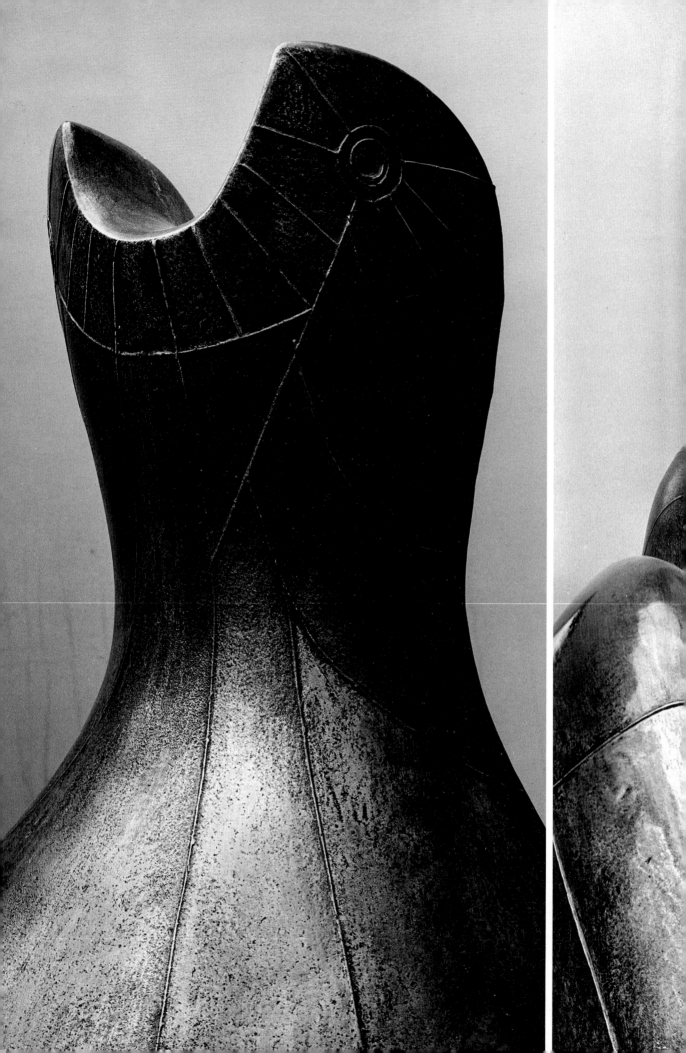

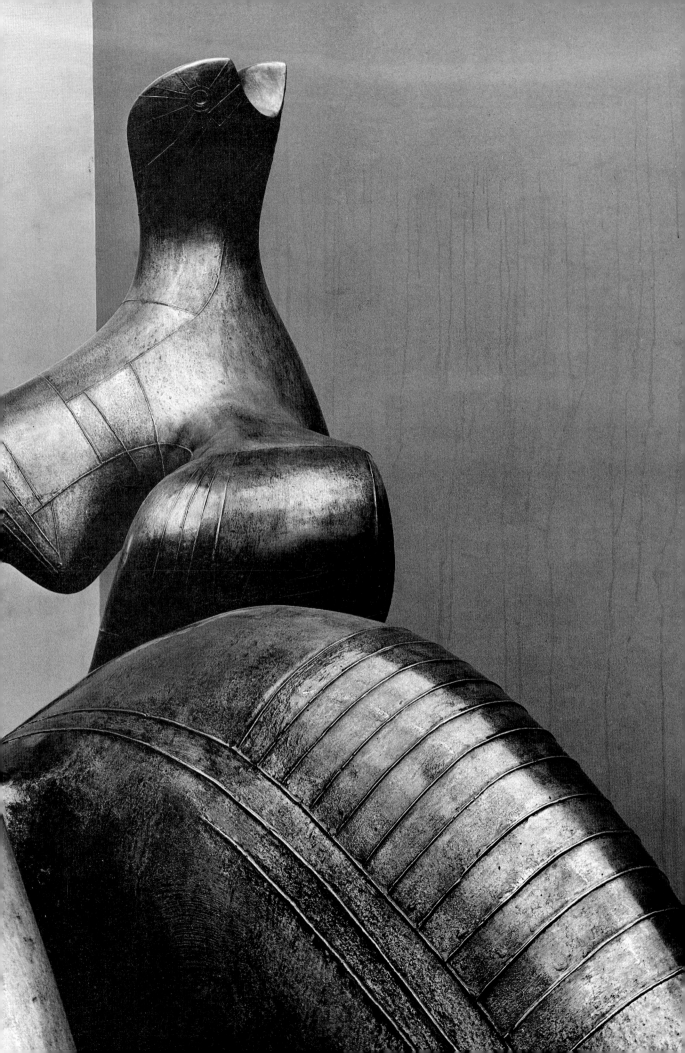

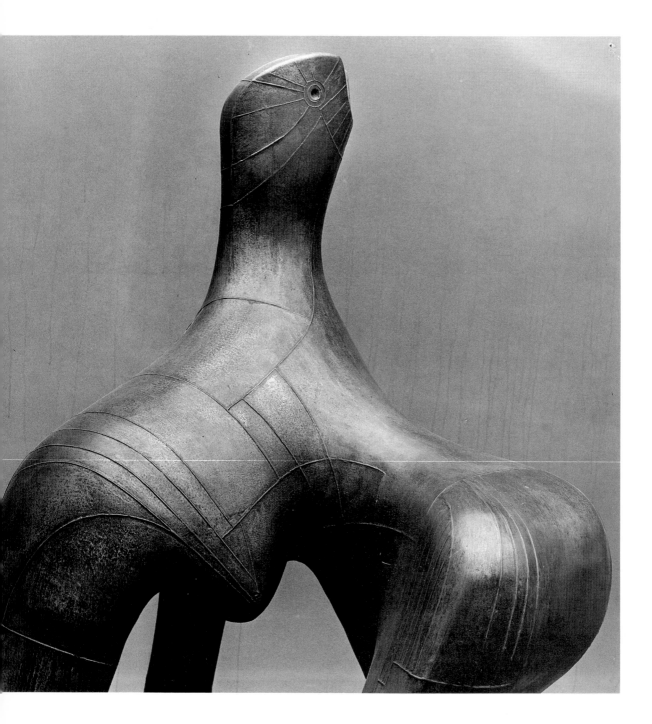

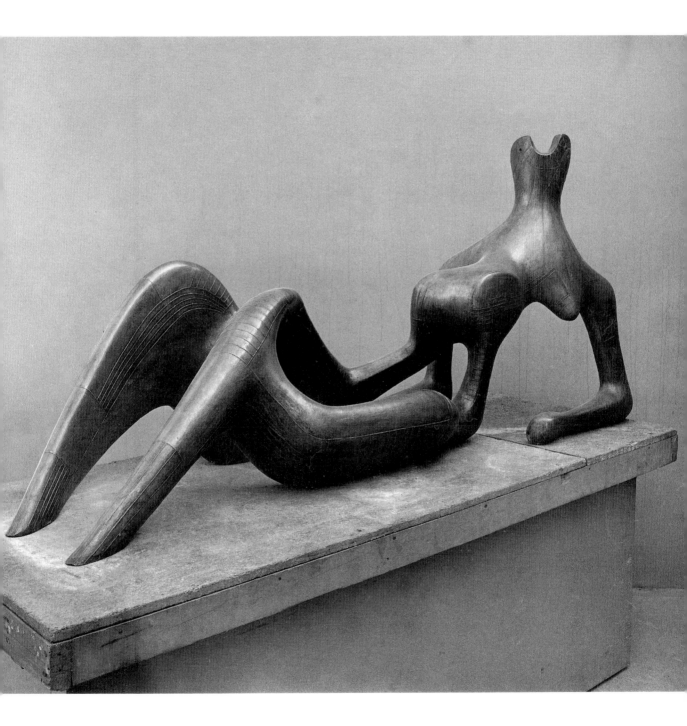

Sculpture is a very practical art. It's not like poetry which asks somebody to imagine what you wish to project. With sculpture you have to produce it. It's a real thing like building a house. So you have to relate it to the people who will live in it.

Brancusi's dictum of truth to material, that is letting the material you are working in help to shape the sculpture, had a big influence on me. You didn't try to make in stone something that would have been infinitely easier to make in wire or metal. For instance, in stone you couldn't make a figure that was very heavy at the top and had thin ankles because it would simply break while you were carving it. Nor did you want to do what the later Greeks did—put a tree trunk up the back of one leg so that the other could be more realistic. Instead you wanted the material to have its say. So a thing in stone should look different from a thing in bronze; or that a thing in wood

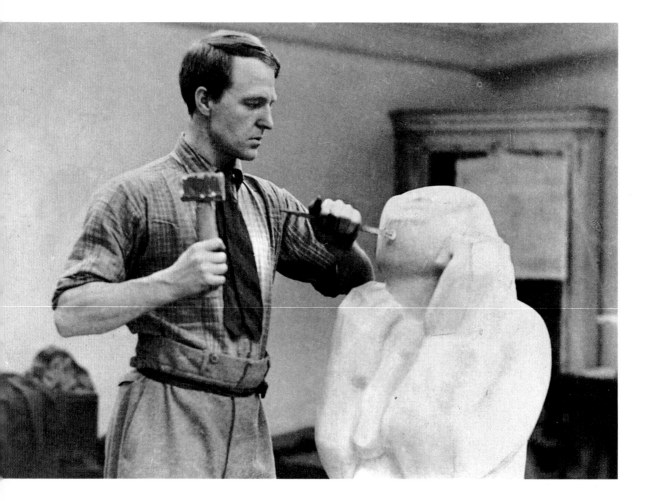

had qualities of its own, as thin as the branch of a tree, which stone can't be. This truth to material became a tenet.

Later, though, this became a restriction. After all, something can be so true to stone that it doesn't have any significant shape at all. It can be just a surface scratch or mark. So after a time, for me, this approach to sculpture became invalid

because it is, of course, the vision behind a work that matters most, not the material.

I have done some sculptures in marble which have also been cast in bronze and I can see no reason why they shouldn't. When the family group at Harlow got broken and I repaired it, I offered to cast it in bronze for them. Bronze is a copying material, nobody works in it directly. You work in something else and that then is taken as a cast. You fill the mould with metal and there you have a bronze. It can be a reproduction of a carving or of a model. Sometimes I think the bronzes are better than the originals—you can work a bit on the bronze to tighten it up. You can't alter it dramatically, but you can finish it in a way that makes it harder.

I think now that if the idea is good, it can actually be reproduced in many materials. The vital factor is the sensitivity of the artist working in whichever material he chooses. Some artists are more sympathetic to carving than they are to modelling. I was at one time but that is no longer true.

People say 'Are you trying to be abstract?' thinking then that they know what you are doing though, of course, they don't understand what the devil it is all about. They think that abstraction means getting away from reality and it often means precisely the opposite—that you are getting closer to it, away from a visual interpretation but nearer to an emotional understanding. When I say that I am being abstract, I mean that I am trying to consider but not simply copy nature, and that I am taking account of both the properties of the material I am using and the idea that I wish to release from that material.

If everybody tried to do a piece of sculpture in stone then they would look at sculpture completely differently. I've been doing sculpture now for over seventy years. I find new things every day that relate to my work and that I try to understand. There is always something new that interests me and if it takes me that long to understand it, it's hardly surprising that a casual observer with only a few moments of contemplation will have difficulty in understanding some of my work.

All human beings have to develop. When you think of people like Leonardo and Michelangelo as young men developing their understanding of drawing or painting with existing art and then comparing it with what they were later to add to it—it's such a very big contribution they have given the world. Painting, sculpture, novels, poetry—all of these are about one human being giving his point of view about life to another. It may be commonplace or, on the other hand, it could mean the opening of other people's eyes. That's what art is about, enriching life. An artist does what he wants in terms of his art. It's not done from a sense of duty. If you look after a child out of duty, you have nothing to give him, but if you do it out of love, then there's a wealth of difference.

Life as a sculptor is a slow process. When you finish a sculpture you don't feel elated, it's not like being rewarded. You don't do it for praise or for recognition. If you are disappointed or even dislike what you've done entirely, then that's awful. But if there's something about it that's added a bit to your own experience or appreciation, then that's good. If that wasn't the case, then you wouldn't go on. I don't get depressed if something isn't going well, but when I come to the end of one sculpture, I'm generally glad it's finished and pleased to start on something else.

Of course, there are other artists whom I feel are far greater, the Old Masters, Giotto and Michelangelo, for instance. To approach some of those would have been a prize but you don't expect to achieve it. It's like running a mile in three minutes—you don't expect to succeed but you still attempt to do it.

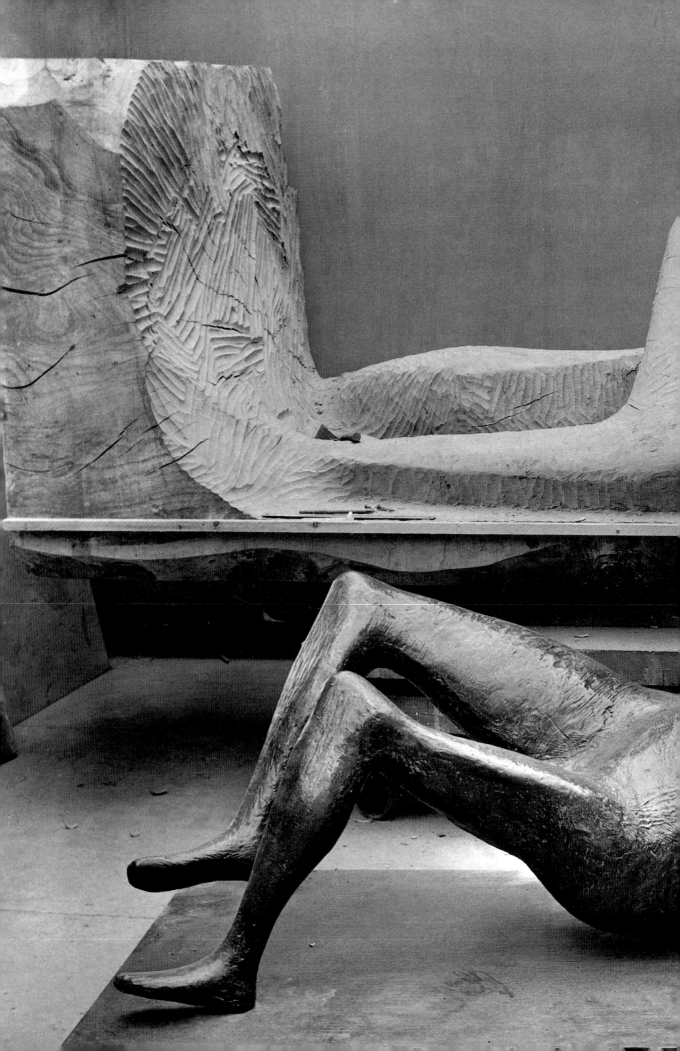

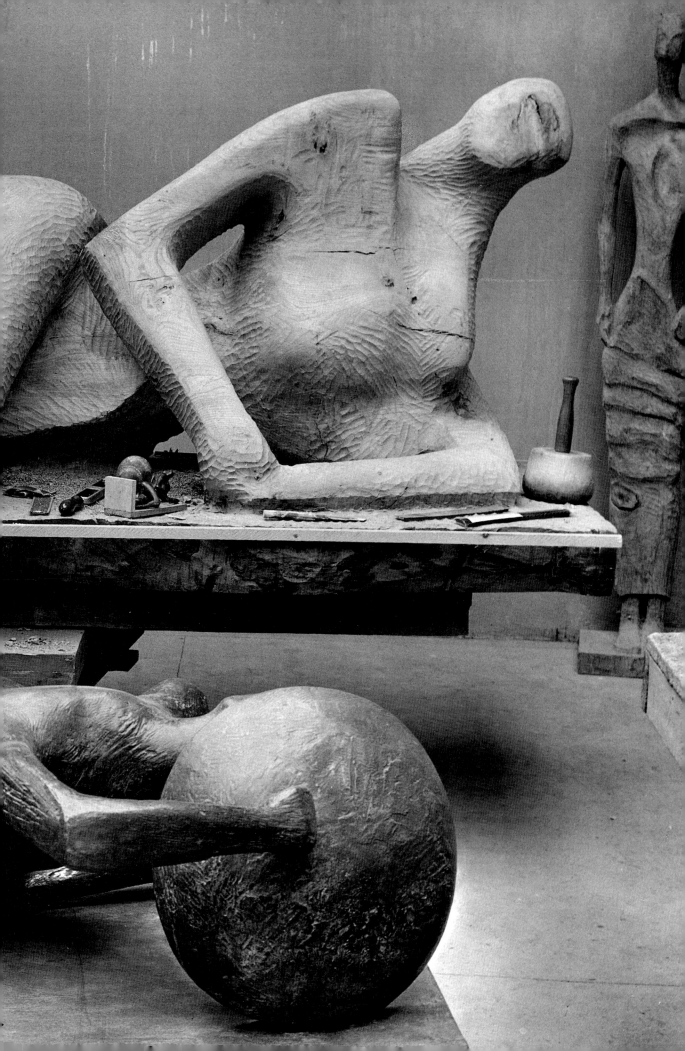

If you do a sculpture and call it a bird, you want people to relate to it as a bird. If somebody thinks it's an animal and yet it wasn't, then they would be trying to find something that was never meant to be there. I am sure if I called one of my reclining figures a horse, people would start looking at it to see if it resembled a horse—it directs their minds and eyes.

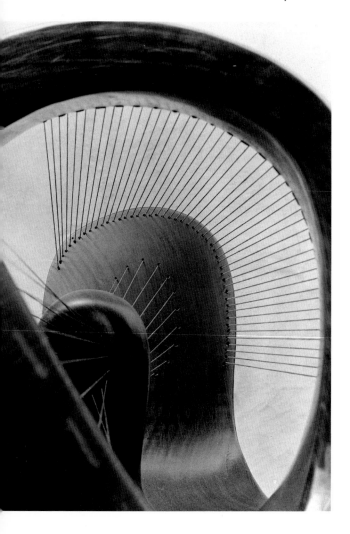

Thinking people should be given a clue to what the artist is trying to do. If they're not thinking people, then they hang their own preconceived ideas on whatever you do.

I decide the title of a sculpture after I have finished it. I didn't set out to do a sculpture called *The Bird Basket* or *The Bride* or even *The King and Queen*. Take *The Bird Basket*. It has got an organic form although the strings are abstract straight lines. The carving is in lignum vitae wood and at one end is the head and the other end is the tail. When I was working on it, I used to pick it up like a basket by the loop over the top. So the two words 'Bird' and 'Basket' are significant because they were arrived at in a practical way.

Words can never explain, though. They can point out a direction for how you should look at a sculpture but no more than that. This is as it should be, as all art should contain an element of mystery. Nothing reveals itself completely in life or art. There is always more behind it than you think. This is true of the things we are most familiar with—nature, the human body. As a sculptor, I am trying to expand people's vision, to see the outer dimensions, the mystery behind familiar objects. When I create a sculpture, I try to do it from the inside outwards, to imbue life.

Wood has to come from a living tree, to be alive in order to carve it. You use different tools and the way wood splits is different from stone, as well. It is still the same idea of cutting down from a big thing to a smaller thing. Wood doesn't break like stone, which can be awful to carve. Wood has a fibrous construction which makes it very strong, though thin.

I enjoy carving most wood. The ones I could get hold of most easily were elm, oak and the fruit woods. The closer the grain, the finer, the thinner the carving can be. Cherries, plums and apples are good for this, they have the right texture. My wood sculptures have given me great satisfaction. The forms that have come from the tree trunks have expressed both my ideas and the material.

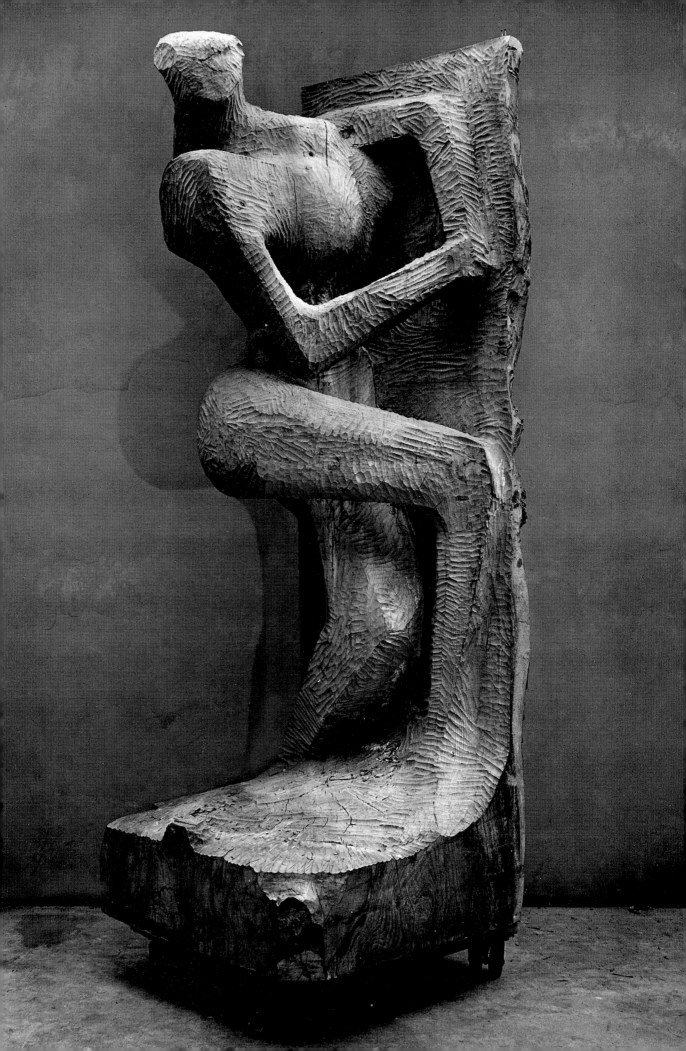

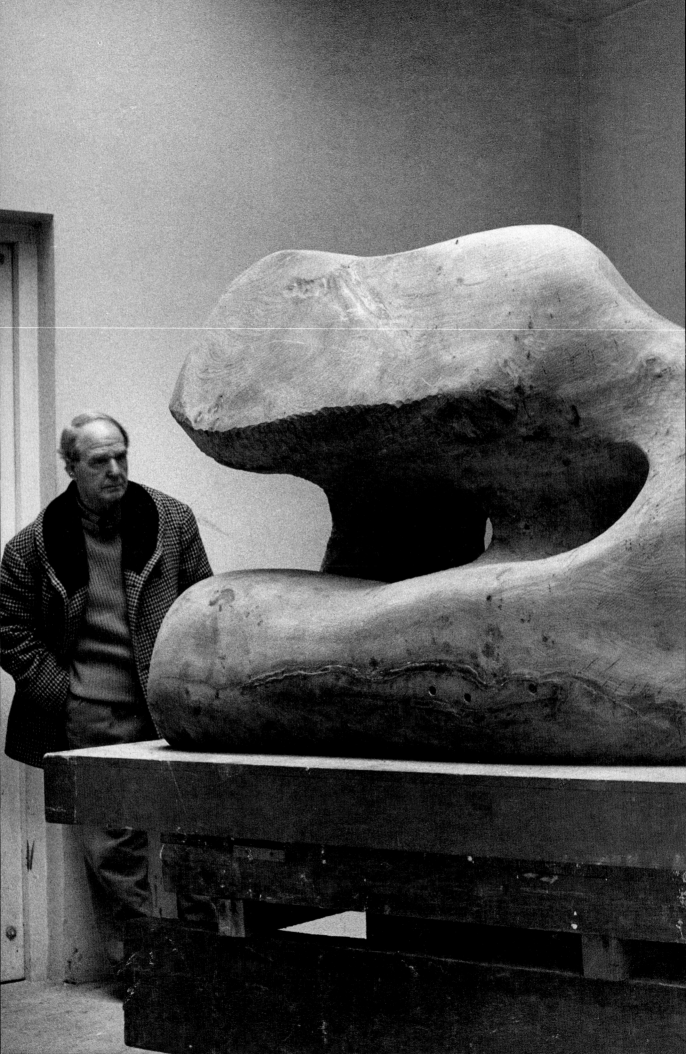

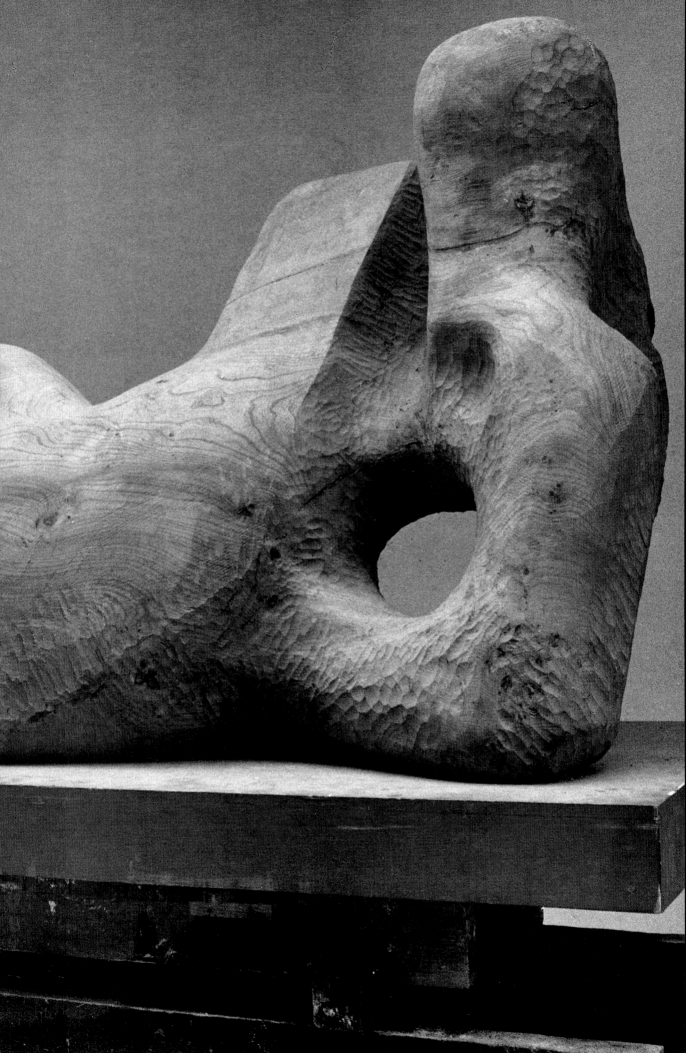

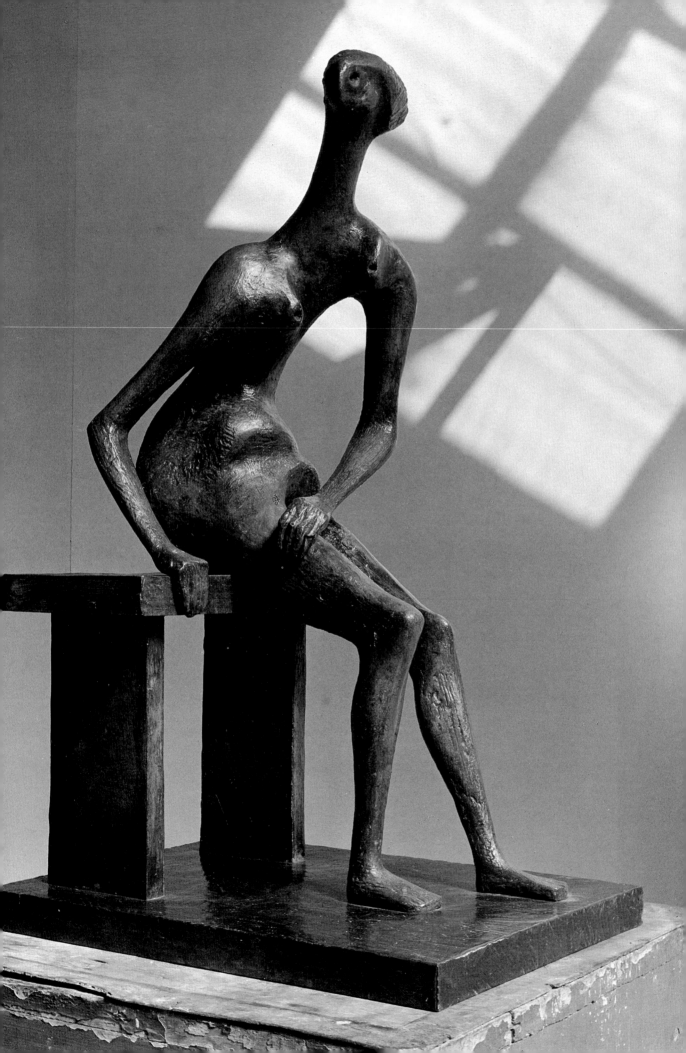

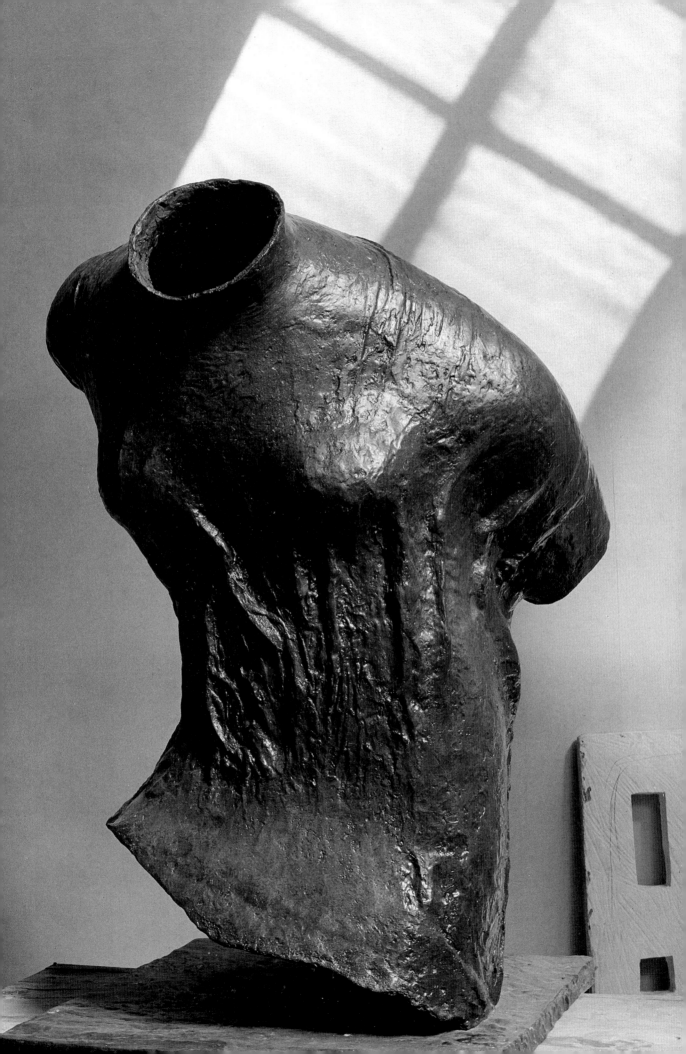

When you first begin teaching, you are teaching yourself. I learned a lot that way. You are trying to put into words and explain something that you haven't perhaps thought about before, or hadn't consciously realized. A certain amount of teaching is a good thing—it's only bad when it becomes repetition.

With teaching drawing, you can't expect a student to draw something moving about all the time. They must learn with something quite easy—a peg, a bottle—if they can't do that, how the hell can they draw a human figure? In the early stages, you would direct the model for them, let them do the three or four main positions: standing pose, reclining figure, seated figure, then you'd progress to a walking or a running figure.

Drawing is everything. If somebody comes to me and says There is a young sculptor and he's going to be very good—would you like to see his work? I say, What's his drawing like? Oh, he doesn't draw. Well then, I know he's no good. All the sculptors who have been any good have been great draughtsmen. Drawing is enough if you do it well. Lots of great artists do nothing else but draw. I started drawing—unlike sculpting—when I was five or six. Nowadays, I do nothing but draw. What I'm not content about is that they are not always good drawings. It is always a struggle.

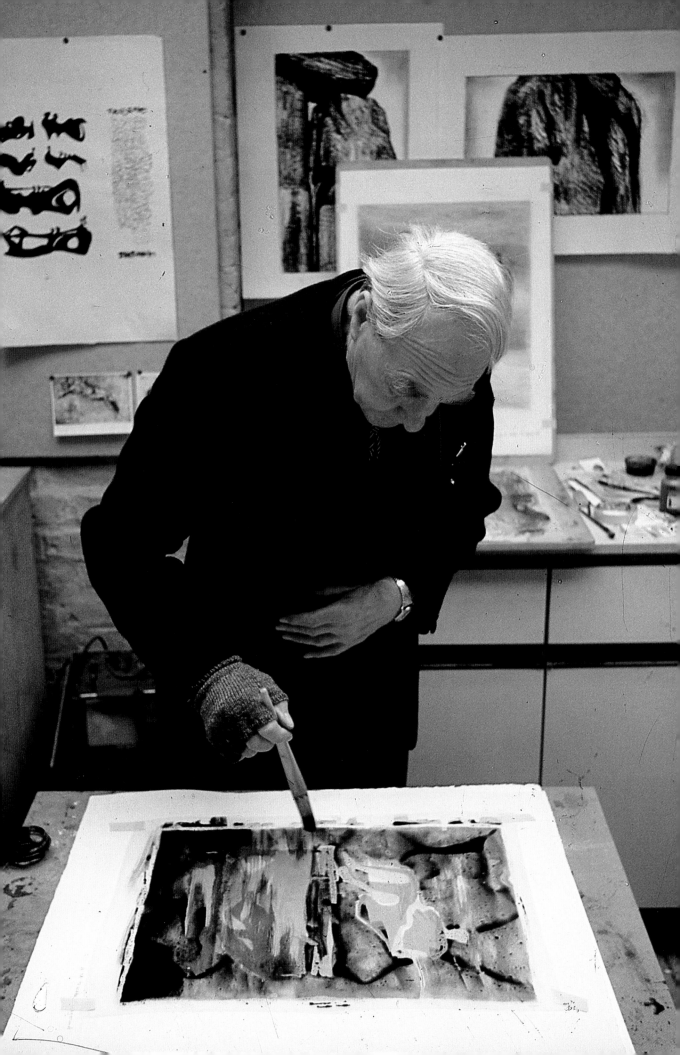

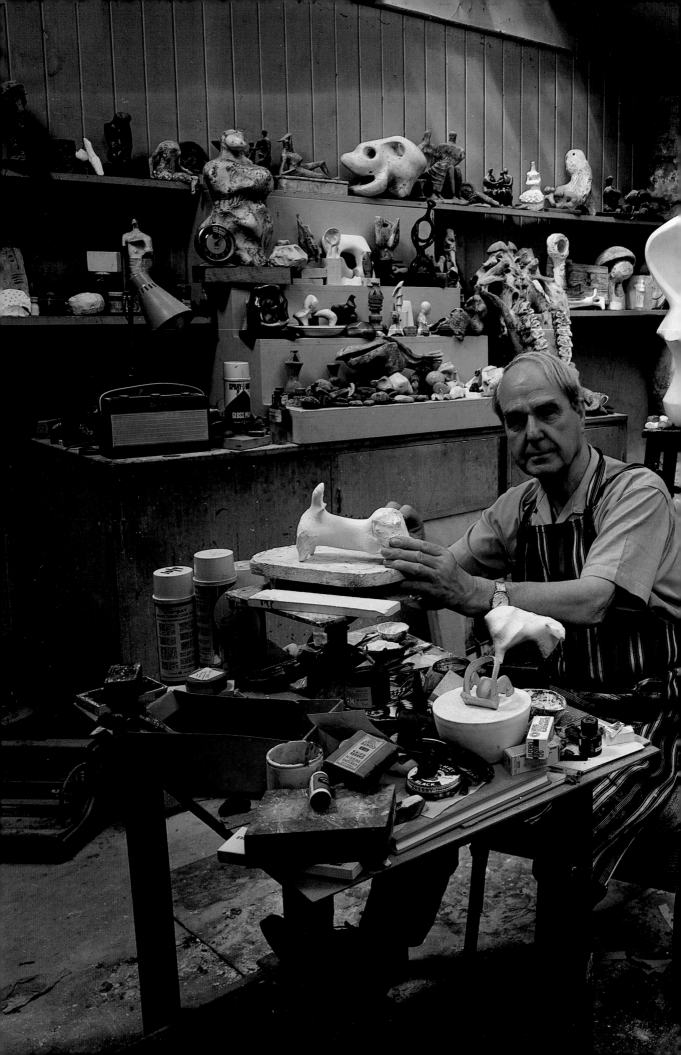

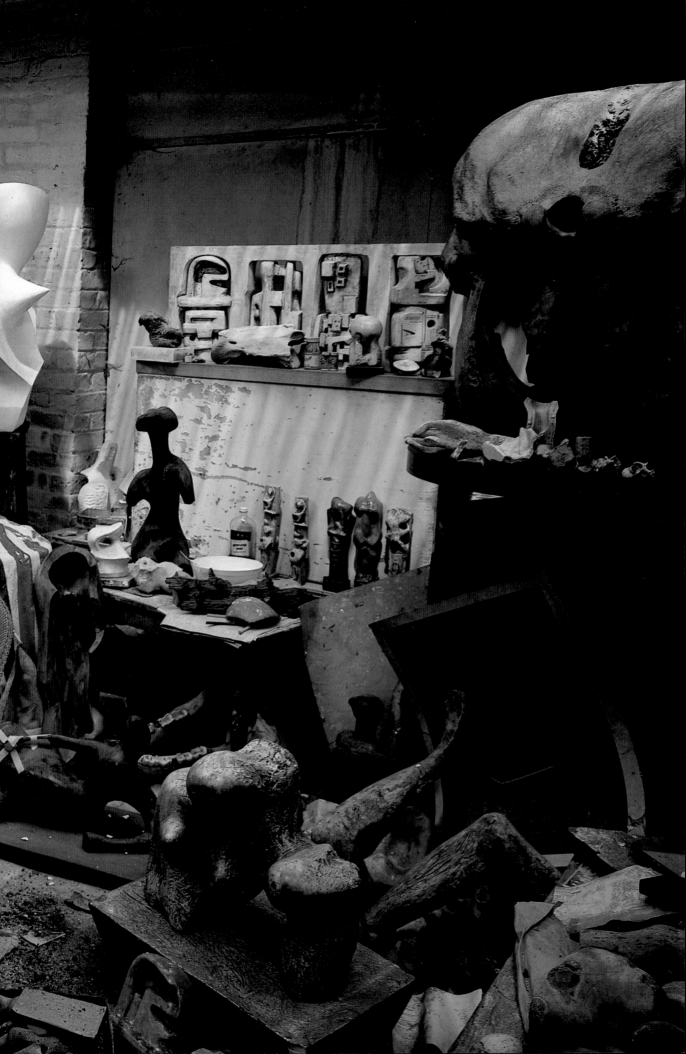

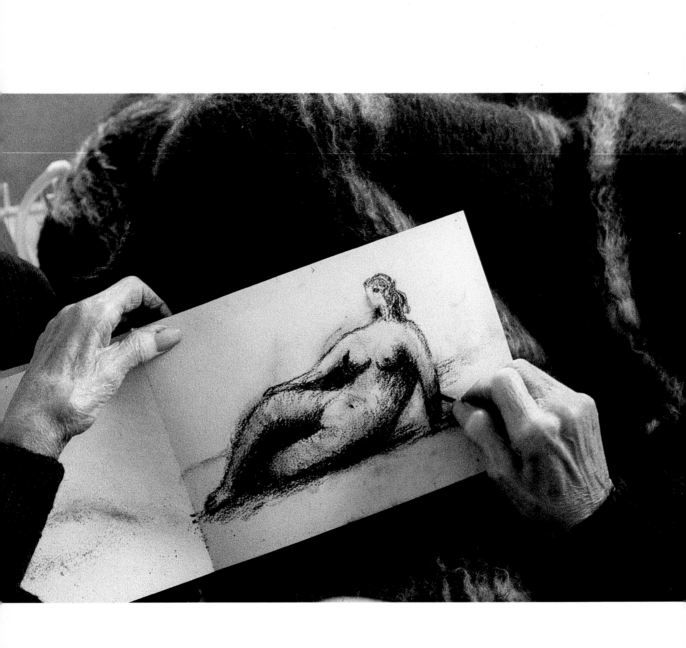

To develop talent and to sustain and enlarge early promise is a difficult thing—often this promise is the limit of the potential of an artist because he does not have the vision to enlarge on those particular faculties of his own; it has to be born within him and then nourished and further developed. I myself have always been suspicious of talents that are too early and too easily recognized, because this usually means that the artist is doing the easy, vulgarized work that is commonly acceptable to the art world of agents and dealers and publicists. For instance, to begin with you often have a student who has a gift for doing quick sketches and people think he's going to be a good artist, but in truth it may be the most vulgar, insensitive outlook in the world. Just because he's got a bit of direct expression, people think he's good. If it's vulgar and cheap and obvious with nothing original or personal in it then it's no good, however clever it might appear to be on the surface. Some people are good at getting an instant likeness, for instance, and you see them at the seaside in the summer doing portraits for £5.

My own success did not come quickly or so suddenly that one thought about it or considered a change had occurred in life. We never really worried about money. I had teaching to fall back on when necessary, though I tried to do no more than two days a week, during the three twelve-week terms. So, of course, there was masses of time for me to work on my own. And there were always the evenings, too.

Sculpture is a full-time job, a mental obsession. I used to work twenty hours a day sometimes. Irina, too, was always very good at keeping me working. You can't just do it 9 to 12 each morning. It has shaped my attitude to life, it's a three-dimensional world I live in. It isn't that I say, Now I'll do some work and I begin to look at things sculpturally. It is being able to make your mind free to perceive reality. That's all that sculptors can ever do.

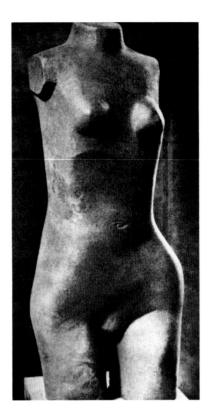

The human form has always been my main concern. It's what we know most about—the softness and slackness of flesh, the hardness of bone, all the energy that is pent up in our own bodies. The early Greeks understood that and it came from their deep understanding and close observation of the human figure, so when they carved their sculpture it was with vision, understanding and sensitivity. That is why the best Greek sculpture is so good. They knew what was beneath the surface, so were able to release the life force which gave an added strength and vitality to their work. There is a deeper truth to be found in the knowledge of sculpture than in just the appearance of a sculpture.

For me a work must first have a vitality of its own. I do not mean a reflection of the vitality of life—movement, physical action of a dancer or spontaneous action.

A work of sculpture can have in it a pent-up energy, an alert tension between its parts, an intense life of its own, independent of the object it may represent. When a work has this powerful vitality, we do not connect the word beauty with it. In my work I do not aim at beauty in the later Greek or Renaissance sense.

Between beauty of expression and power of expression there is a difference of function. The first aims at pleasing the senses; the second has a spiritual vitality which for me is more moving; it goes deeper than the sense.

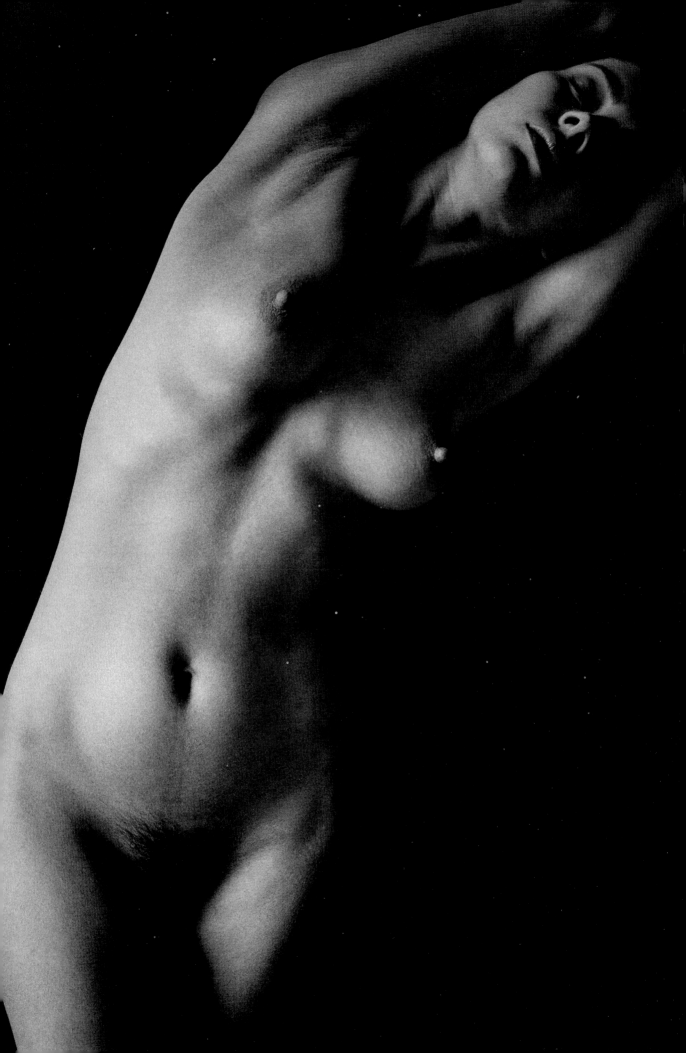

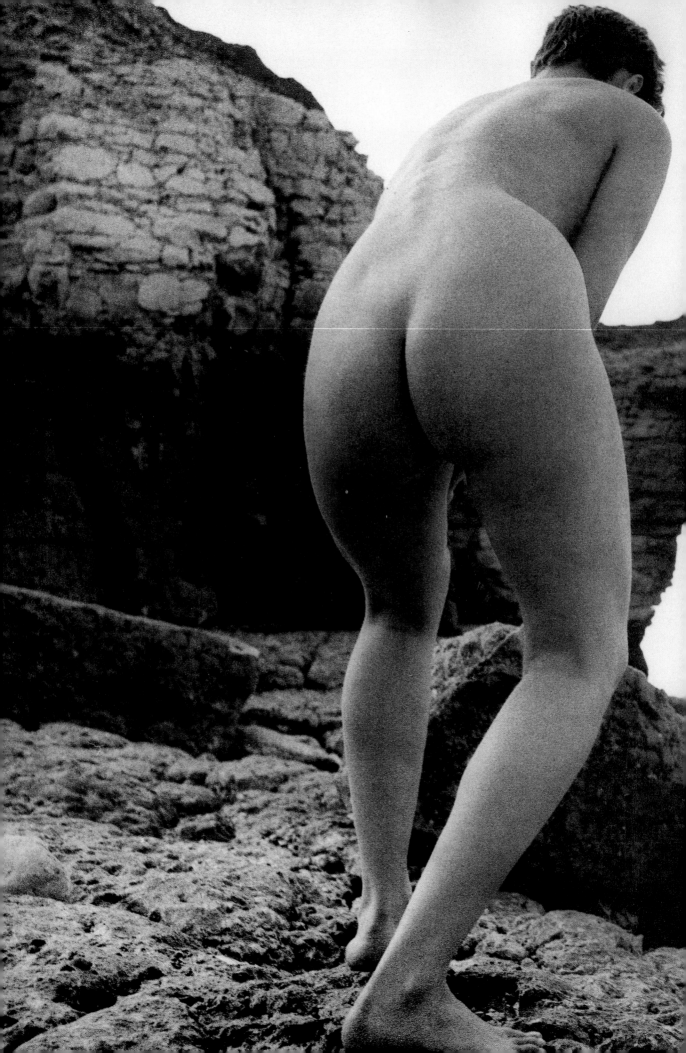

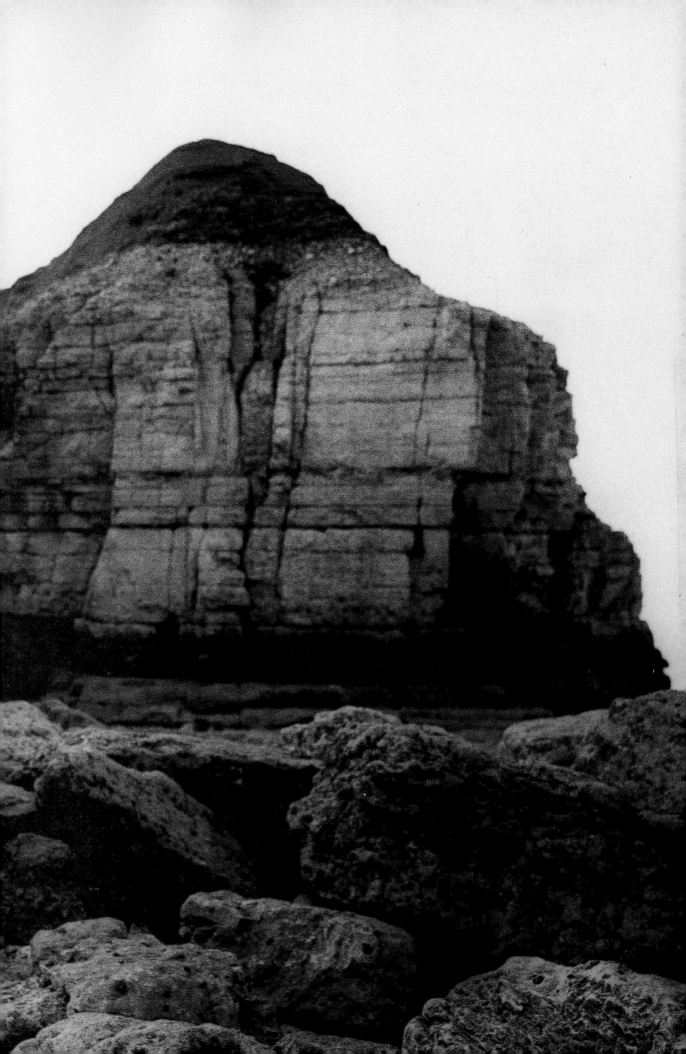

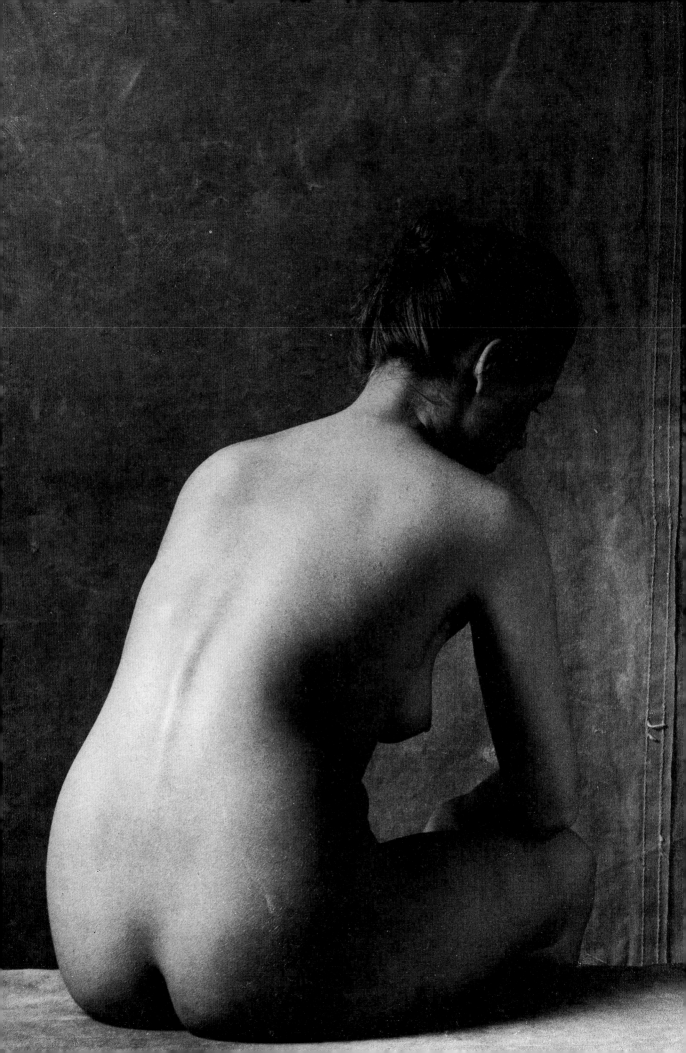

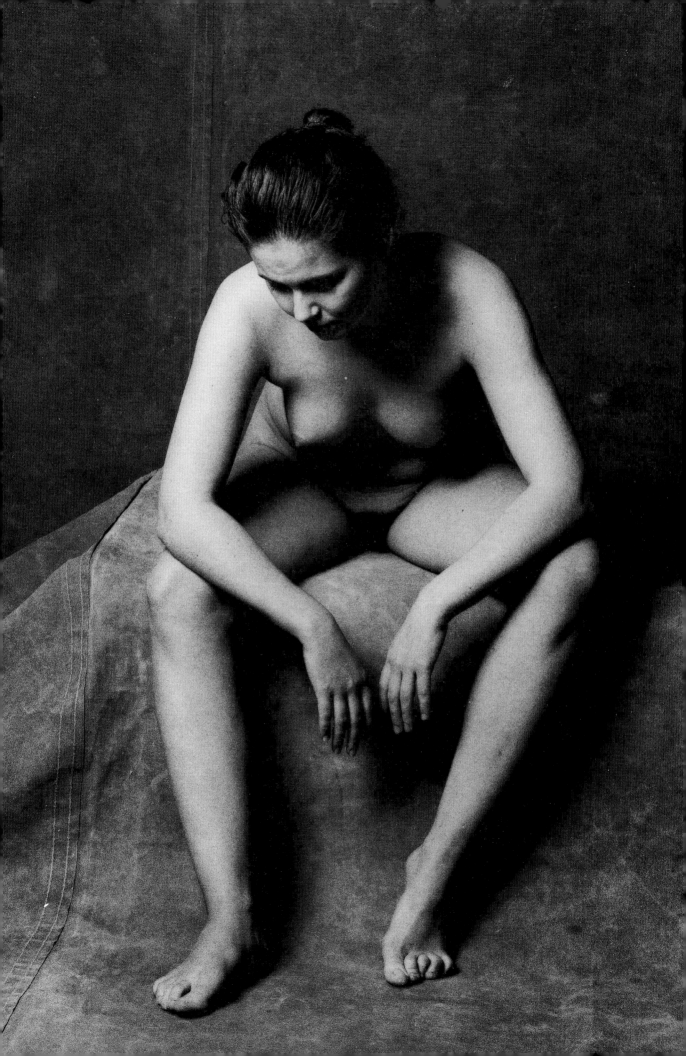

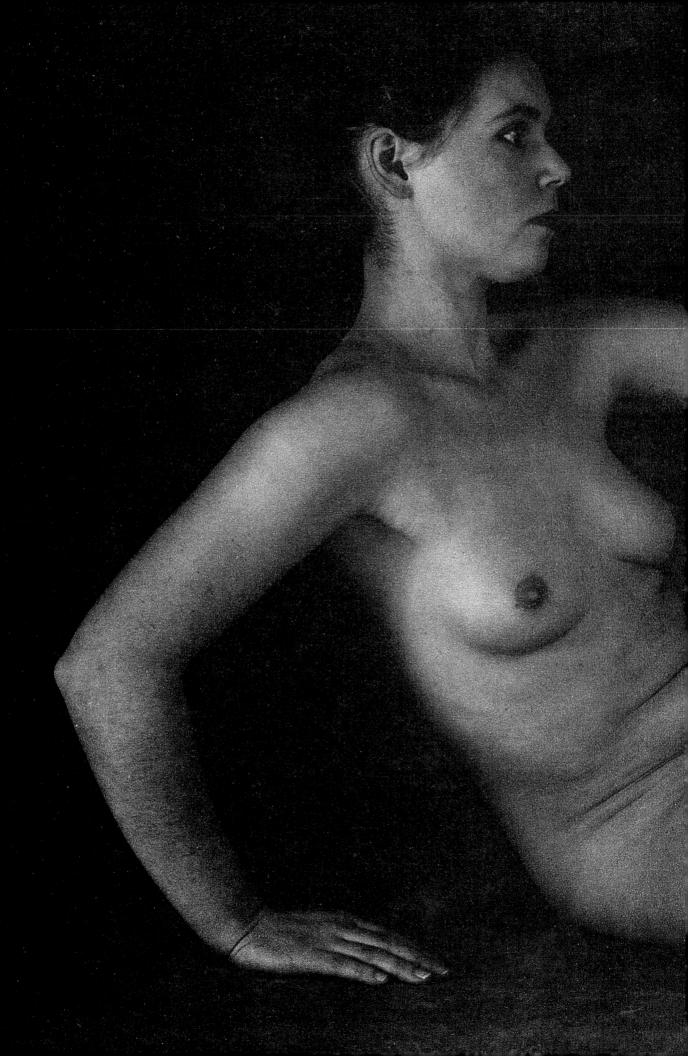

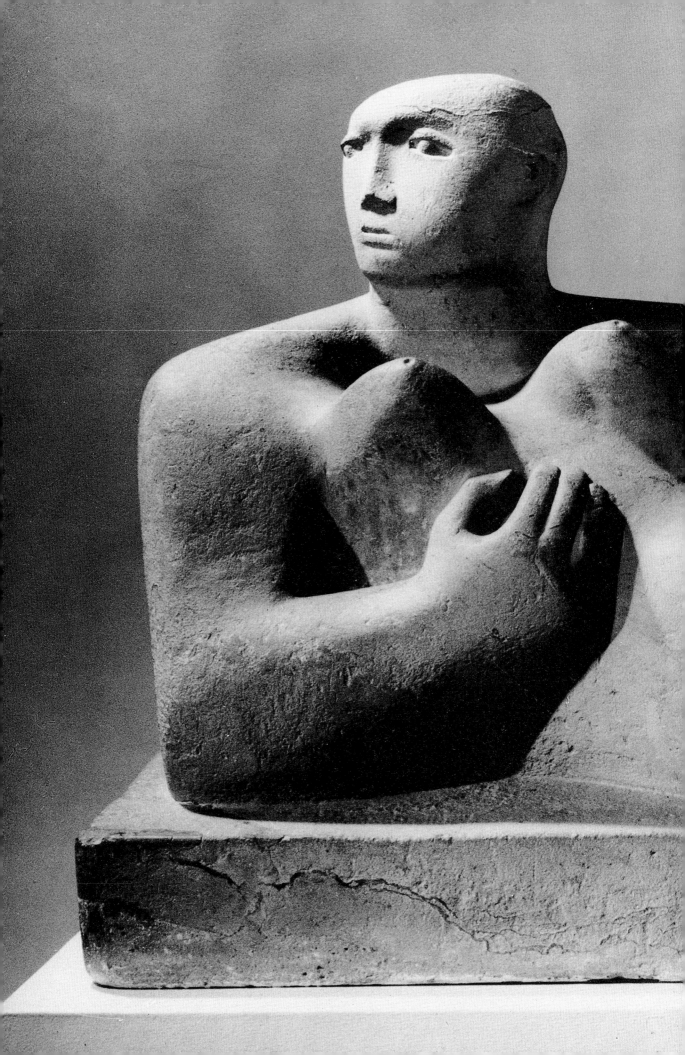

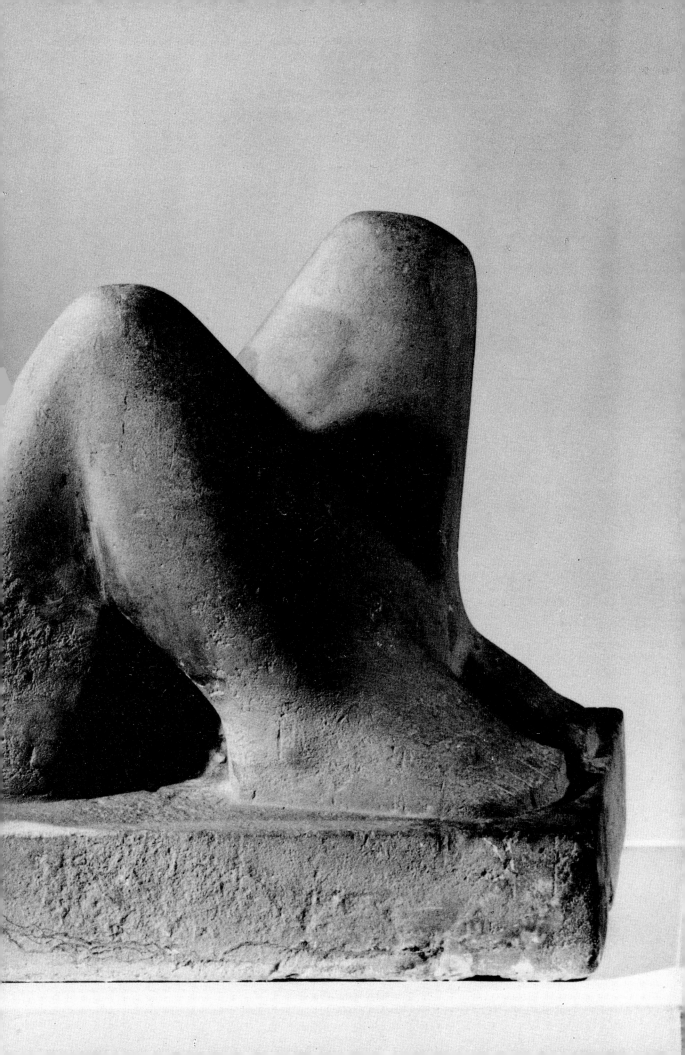

The two and three-piece sculptures were experiments and you must experiment. You do things in which you eliminate something which is, perhaps, essential—but to learn how essential it is, you leave it out. The space then becomes very significant, the distance between the pieces, it becomes an important part of the whole sculpture.

Making a sculpture in two pieces means in which you have, say, only the knee, a foot and the head. In the reconstruction the foot would have to be the right distance from the knee, and the knee the right distance from the head, to leave room for the missing parts—otherwise you would get it wrongly proportioned.

If you are doing a reclining figure, you just do the head and the legs. You leave space for the body, imagining that other

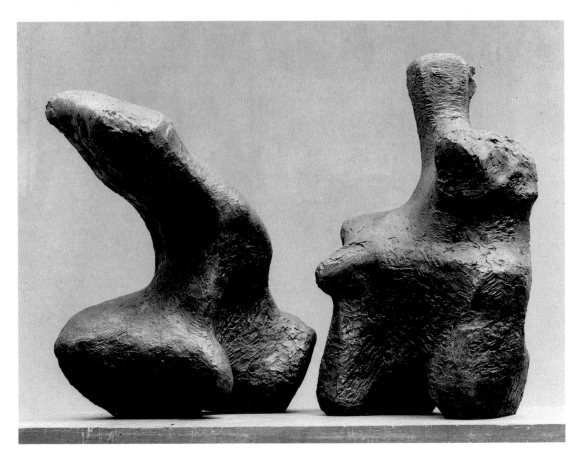

that, as you walk round it, one form gets in front of the other in ways you cannot foresee, and you get a more surprising number of different views than when looking at a monolithic piece. It's as though one was putting together the fragments of a broken antique sculpture part even though it isn't there. The space then becomes very expressive and you have to get it just right. I would judge it by changing the elements until I was satisfied. Sometimes it would take days, weeks or even months, but I would return to work on them. You have the sense of

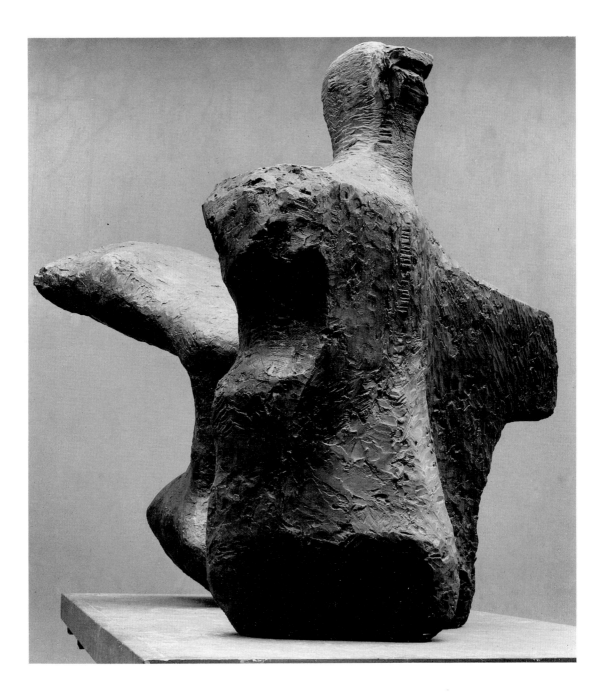

what it is you are trying to express in your mind and you know when it is satisfactory. It is really just common sense—a sense of form, a sense of reality, a sense of function. It is what you have learned from nature.

While I was making it, my *Two Piece* *Reclining Figure* (1959/60) recalled for me Adel Rock and the *Rock at Etratat* by Seurat. This particular sculpture is a mixture of the human figure and landscape, a metaphor of the relationship of humanity with the earth, just as a poem can be.

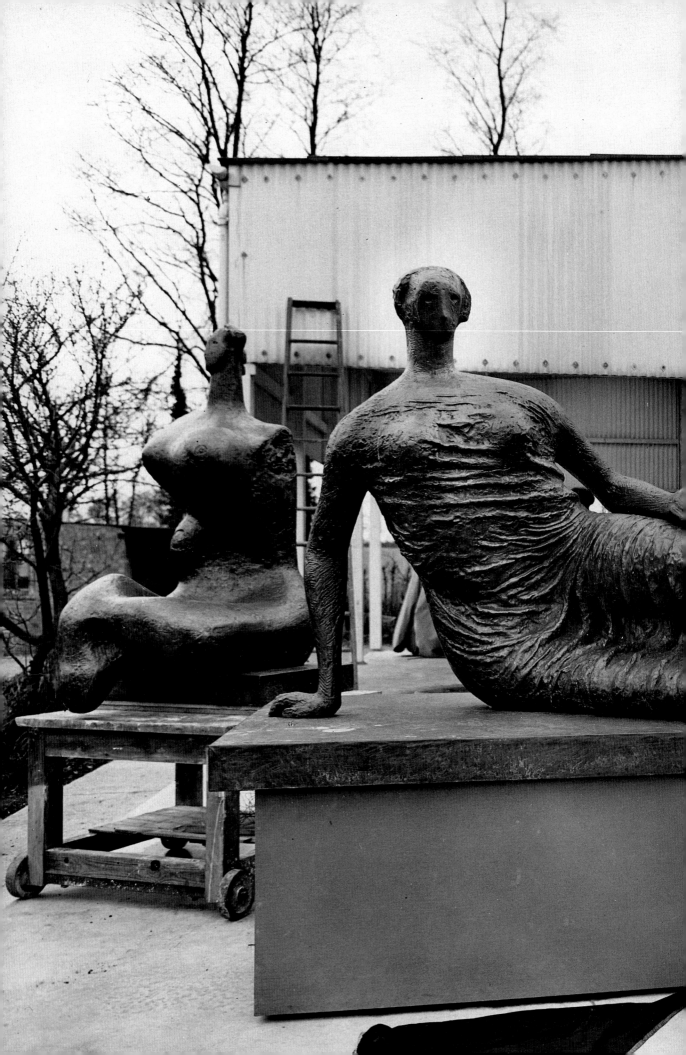

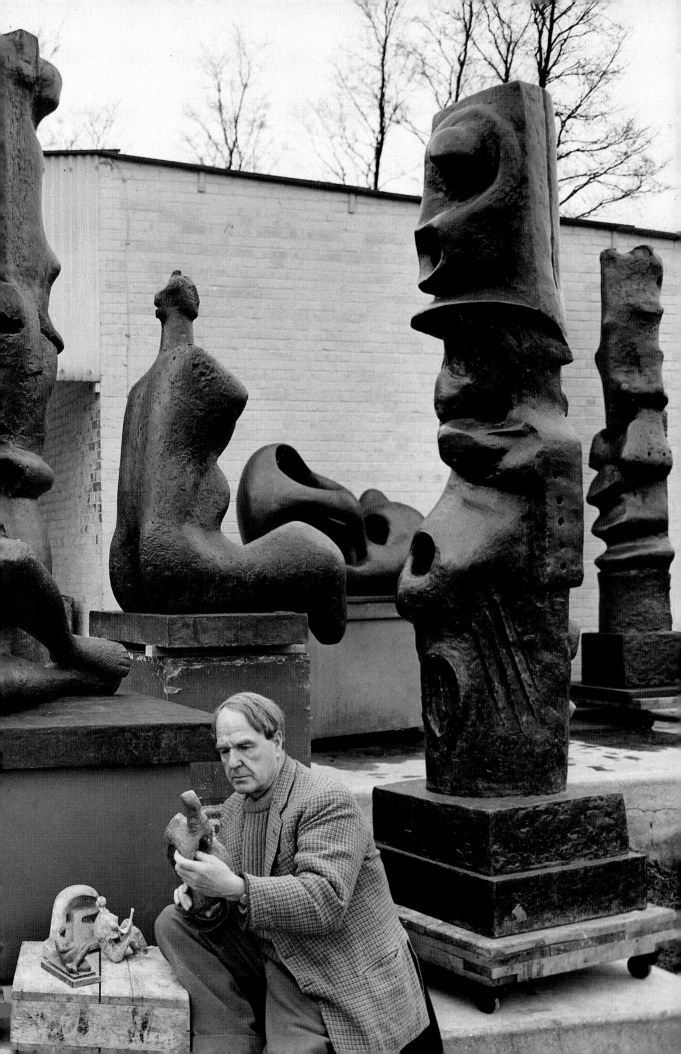

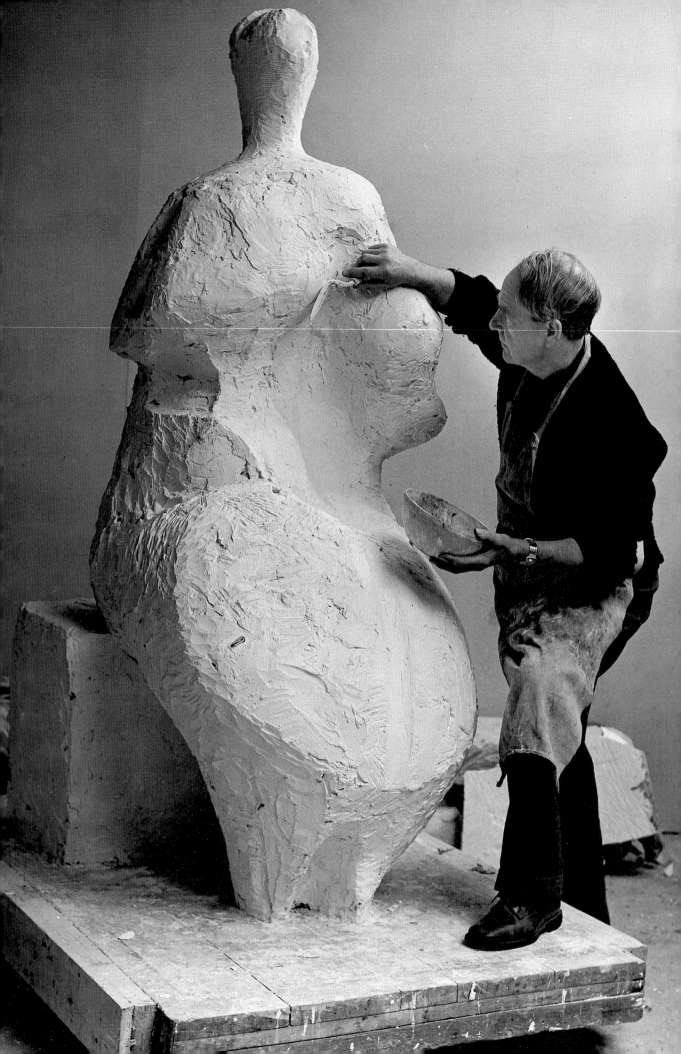

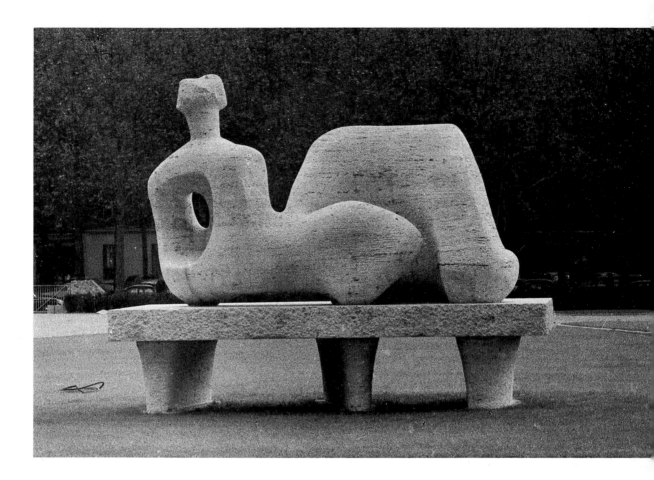

I've never been impervious to a pretty girl, but I've never wanted to draw the glamorous type, the beauty contest woman. But I think the life that most women have, with babies and husbands and household work, is tougher than men's. They have to be capable and physically strong. Perhaps that is why my sculptures of women look monumental, like big men.

I liked carving stone sculpture because it was restrained, restricted and had to synthesize form and shape. But, after a time, I began to realize that it was preventing me from including the full three-dimensional world with air around it, so I began to make holes in sculpture to make the back have a connection with the front. A hole can have as much meaning as a solid mass—there is a mystery in a hole in a cliff or hillside, in its depth and shape. My idea was that I was trying to make the sculpture as fully realized as nature, not just two reliefs.

For me, this was a revelation, a great mental effort. It was having the idea to do it that was very difficult, not the physical effort. A very skilled carver can carve a chain. I once saw a sailor's gravestone which had an anchor with a chain. The links were free, carved out of marble. It was very cleverly done but it had not required a sculptor to do it.

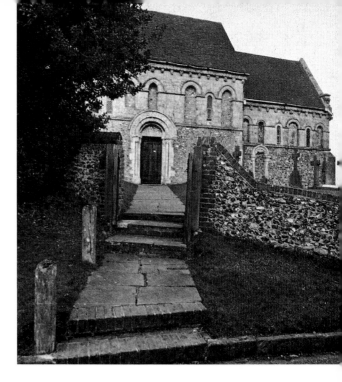

I've always enjoyed the countryside and we've always had somewhere to go to in the country or by the sea before we moved out of London, either a cottage of our own or on holidays.

At one time, we used to go to Broadstairs for our holidays and I used to collect pebbles and flints from the beach—the back of the car used to sag with the weight of them all. Sea pebbles and flints were a big influence on me—I regarded them as nature's sculpture. Nobody is sure how flintstones came about. I think some were formed by a natural casting process, since their strange shapes could not possibly be caused by wind erosion or constant wearing and fretting by the sea. At Shakespeare Cliff in Kent I used to carve the chalk. It's easier and softer, it has a compactness.

But the first time I carved chalk was as a schoolboy. The usual place to go was Bridlington. Flamborough Head was one of the sights—there's a beach and then it goes into an outcrop of chalk with great wonderful chalk caves—very exciting.

Shakespeare Cliff was near our first country cottage, Jasmine Cottage at Barfreston, and right next door we had a beautiful example of Romanesque architecture. I would save up ideas for the holidays at Barfreston and later at Kingston, near Canterbury where we moved in 1934. It was around this time that Bernard Meadows began to help me. He was twenty-one. We would get up at six o'clock, throw a bucket of water over each other, have breakfast, and then work until eleven. Irina would make sandwiches and we'd all go to Shakespeare Cliff to

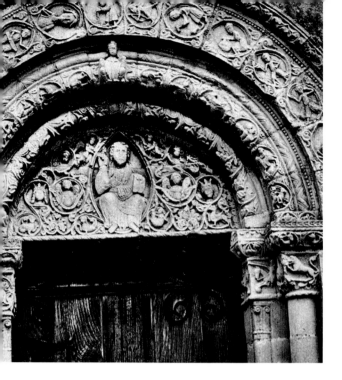

bathe and picnic. We'd get back by one and work till it was dark. After supper, I would draw until eleven or twelve. This was a regular routine and it was marvellous—I am amazed when I look back at how much work was done then.

Ivon Hitchens stayed with us in Suffolk. We weren't far from the sea there and we used to walk back from the beach to our house through a lavender field. It was lovely, so unspoiled. To me, it never mattered where I was so long as it was sunny and a bit different from home. But Ivon would take at least one and a half hours every morning deciding whether to go to the beach or somewhere else. Eventually, we'd end up where we started! I would just take a piece of stone and carve it on the beach—any beach would have suited me.

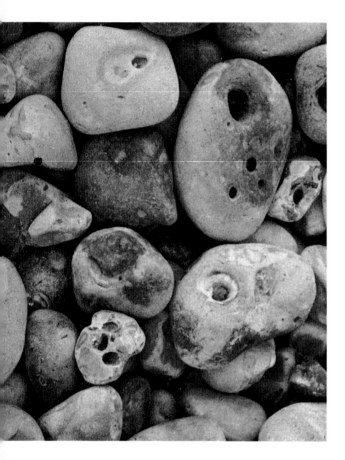

In my collection of found objects in my studio—stones, pebbles, bones, pieces of wood—for me they are all interesting shapes though some may find them exaggerated or distorted. But you must have some interest. You don't want a perfect ball or a perfect square because then there's no surprise. Anyway, I'm not sure what perfection is. A perfect circle drawn with a pair of compasses isn't really perfect when looked at closely—the pencil wears out after it gets half way round and the line would get thicker.

What I have tried to do is to evaluate and appreciate form for its own sake, for its own character. You can pick up an object, a pebble say, and give it a 'meaning'—of course, a pebble itself doesn't have any meaning.

One doesn't quite know how ideas have been generated or where they come from. Sometimes one is influenced by a particular pebble or other natural form, but it's equally possible to sit down with a blank sheet of paper and a pencil and a scribble will turn into something which is worth developing. It depends on how much background you have to draw on. The older you are, the more observant you are of the world, of nature, and forms; and the more easily can you invent. But it has to come from somewhere in the beginning, from reality, nature. Space, distance, landscape, plants, pebbles, rocks, bones, all excite me and give me ideas.

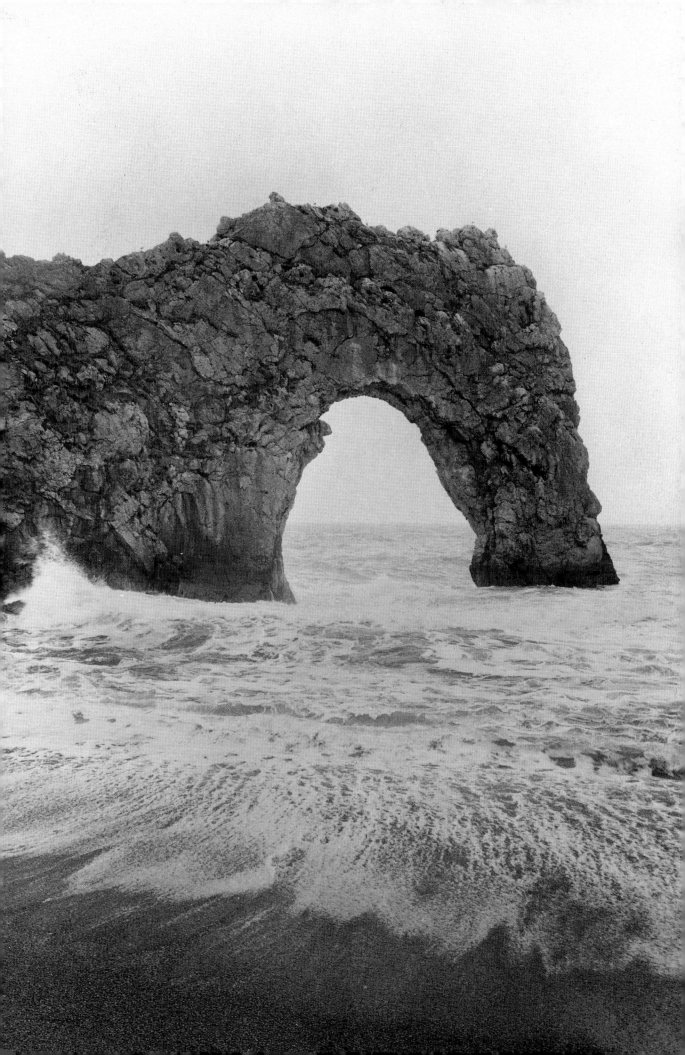

Nature produces the most amazing varieties of shapes, patterns and rhythms. What we see with our eyes has been added to by the use of the camera, the telescope and the microscope. This observation enlarges the sculptor's vision. But merely to copy nature is no better than copying anything else. It is what use the artist makes of his observations by giving expression to his personal vision and from his study of the laws of balance, rhythm, construction, growth, the attraction and repulsion of gravity —it is how he applies all of this to his work that is important.

Sometimes nature, in overcoming environmental factors, produces growth of an unusual kind. This asymmetrical response of trees and plants where there is insufficient space or sunlight has always interested me. If a tree needs more light, the branches will change direction; if a branch is cut off, it will be sealed and contained. I am trying to add to people's understanding of life and nature, to help them to open their eyes and to be sensitive. Nature is inexhaustible. Not to look at and use Nature in one's work is unnatural to me. It's been enough inspiration for two million years —how could it ever be exhausted?

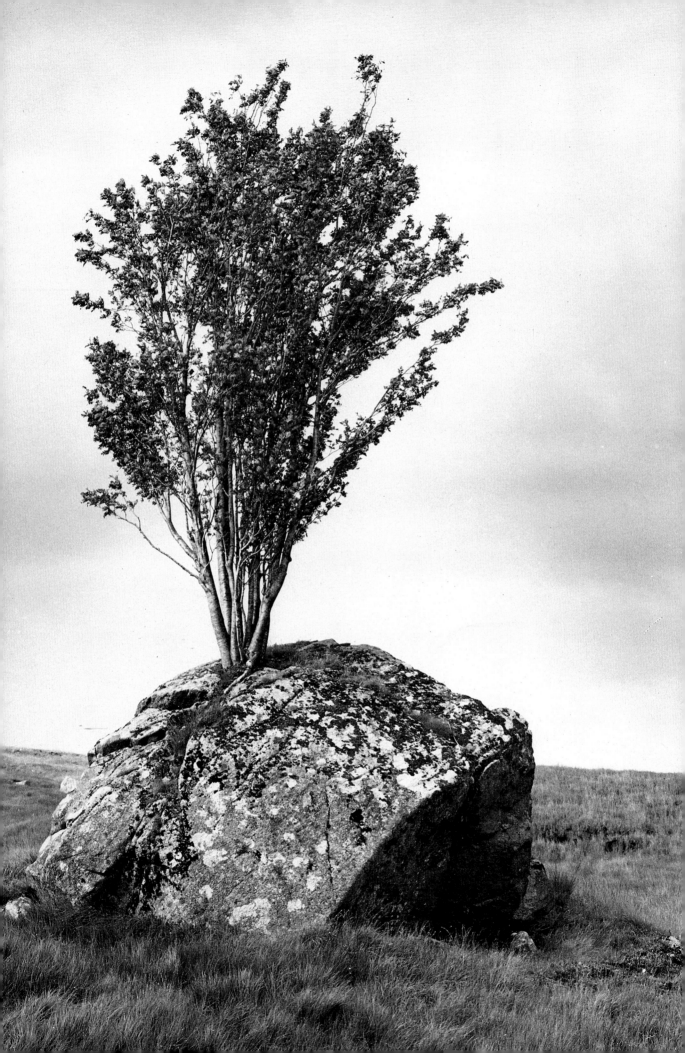

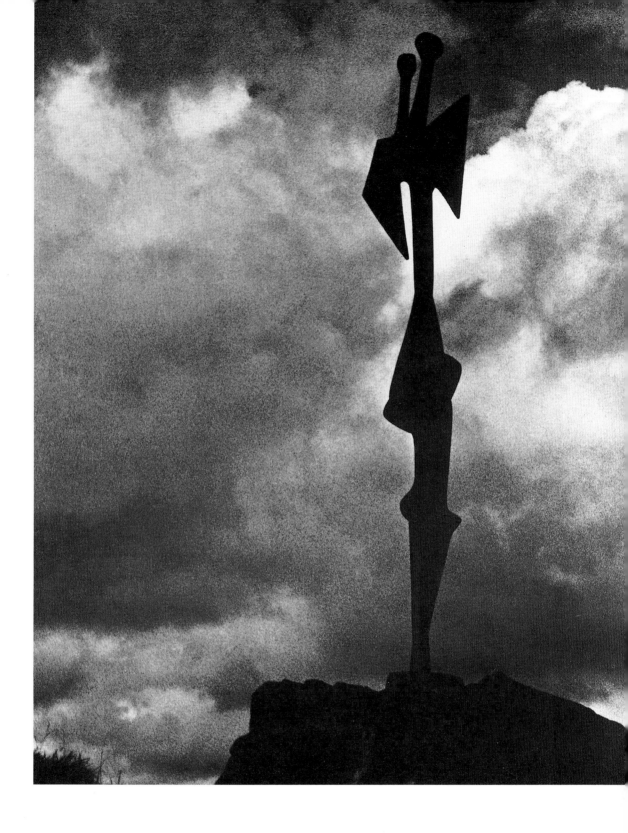

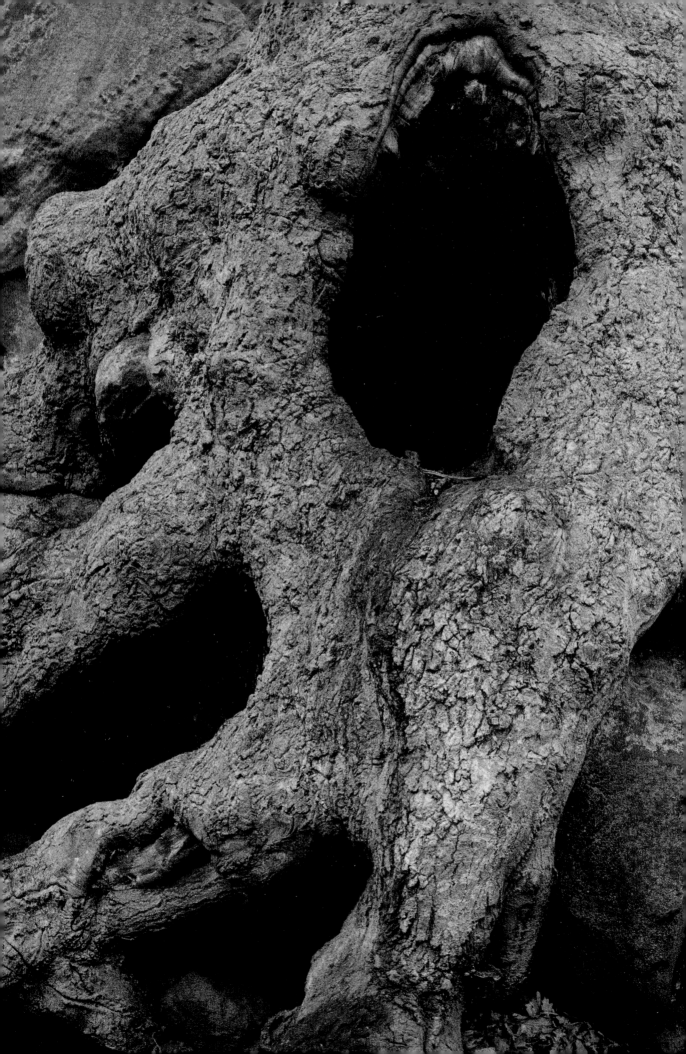

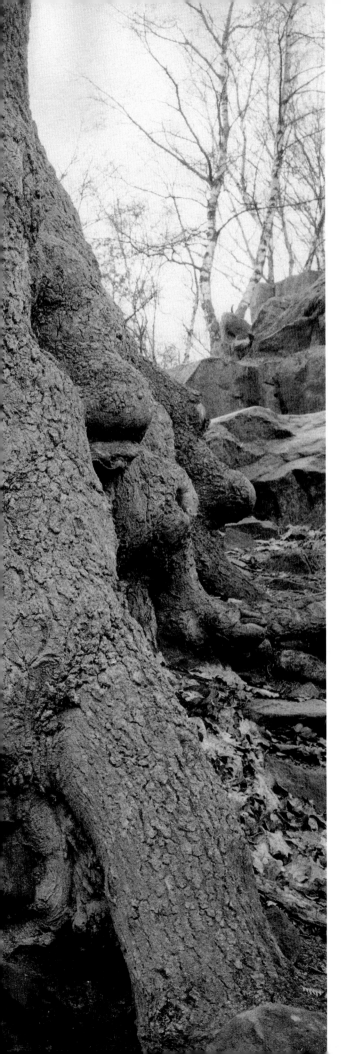

There's a difference in nature between rough and smooth textures and this is a contrast I often use in the surfaces of my sculpture. Things that get handled get smooth. There's evidence of the handling of early sculpture by people, it makes it more human.

Touching with the hand is a part of sight. But, while touching some sculptures can give pleasure, touch itself is certainly not a criterion of good sculpture. A particular pebble or a marble egg may be delightful to feel or hold because it is very simple in shape and very smooth, whereas if it were the same shape but with a prickly or cold surface, you would not like touching it. Of course, you can tell the shape of something if you put your hands all round it but a simple symmetrical shape eventually loses its interest because it is understood too quickly. A sculpture, like any work of art, should have things about it you can go on discovering.

It is impossible to put into words what, as an artist, I am trying to do. If one wanted to explain one's development, one would have to show an early work and then a later one and explain the differences. But then it would all be from the mind and, if they didn't feel it, if it didn't mean something to them, if they weren't following you in emotional terms, then it would mean nothing. It's like the fact that you can't explain love to somebody. It's more than in the mind, it's in the whole body. It's everything.

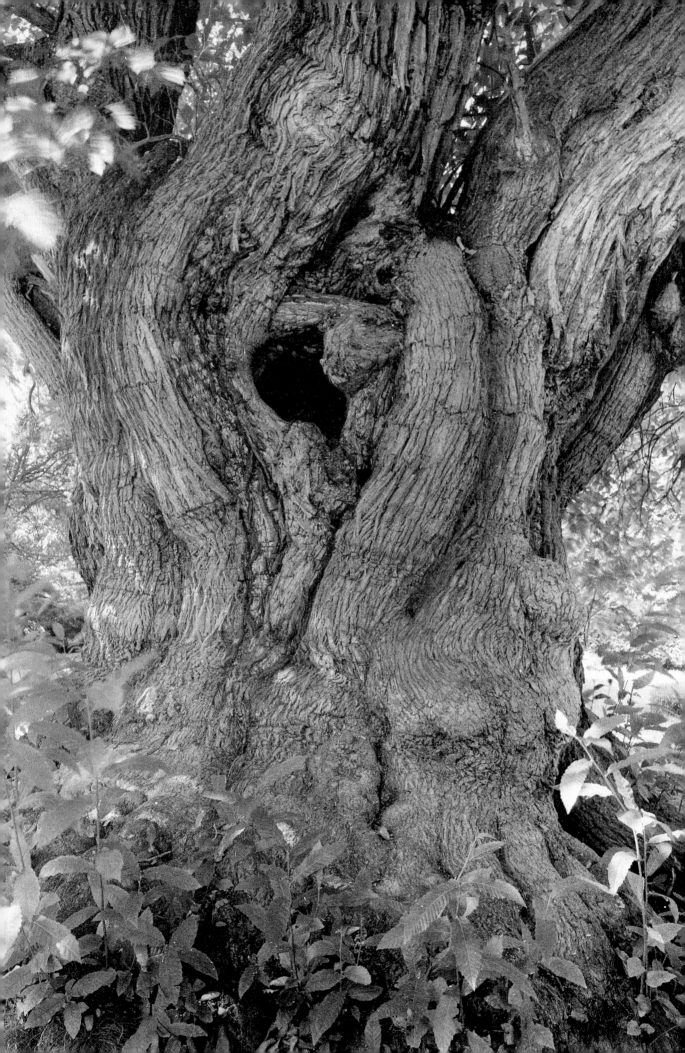

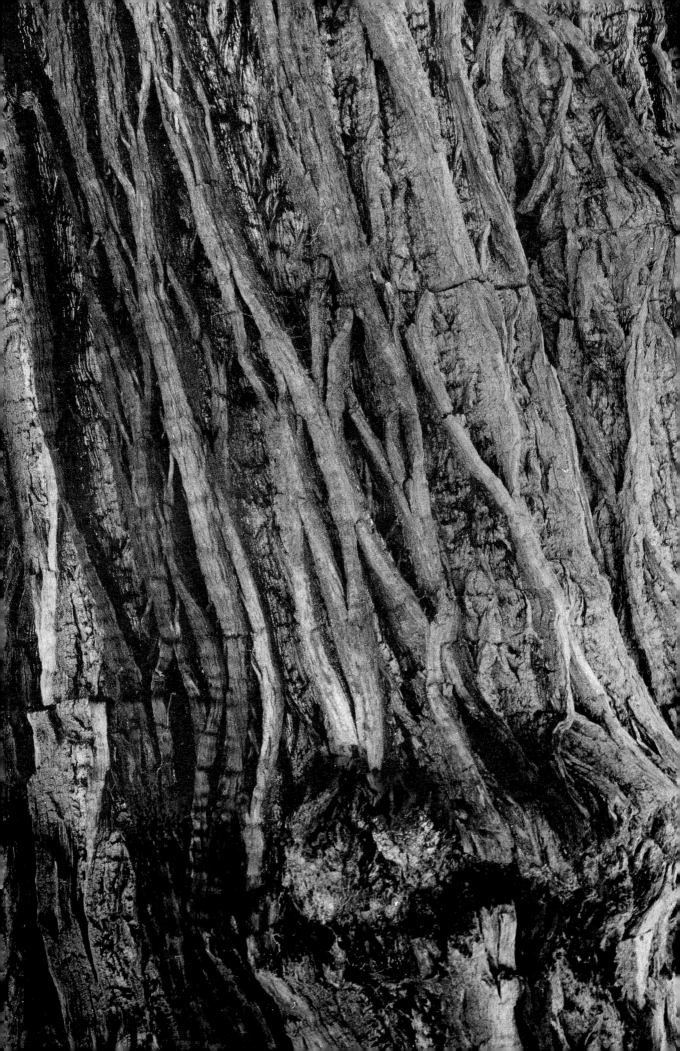

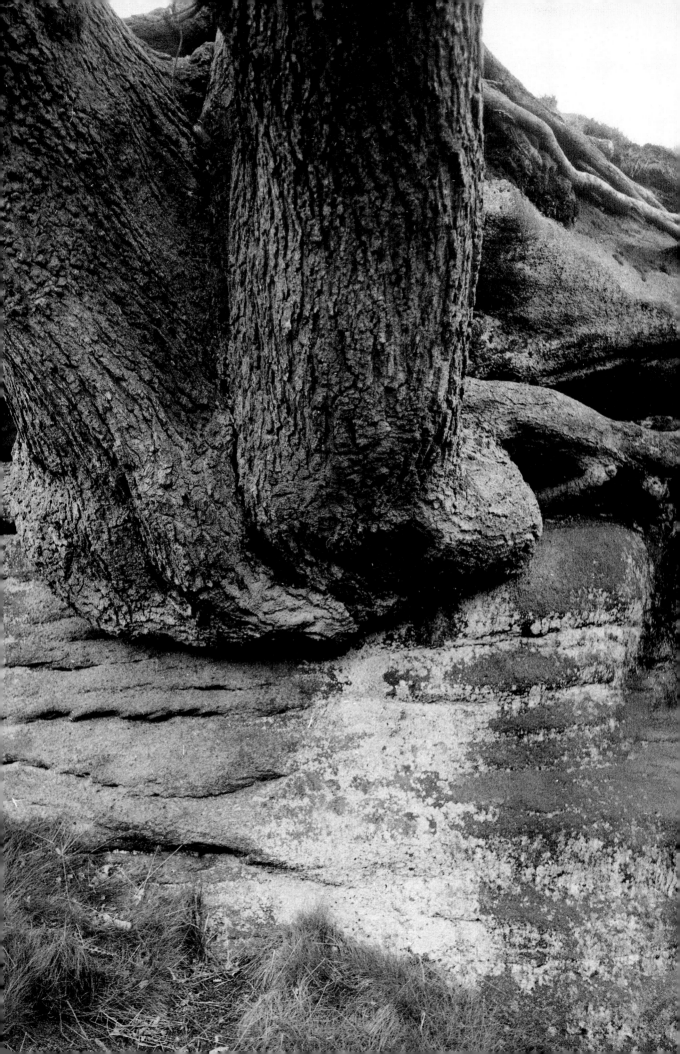

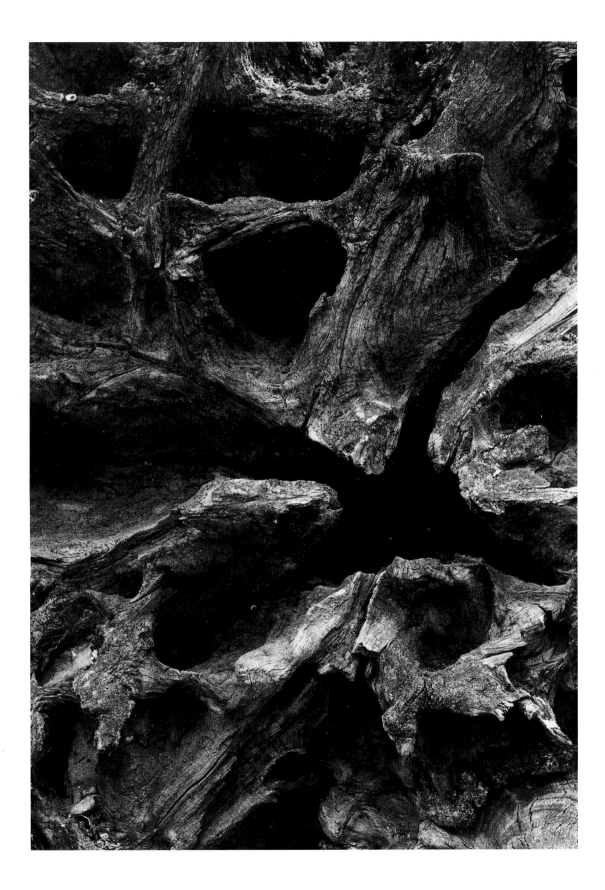

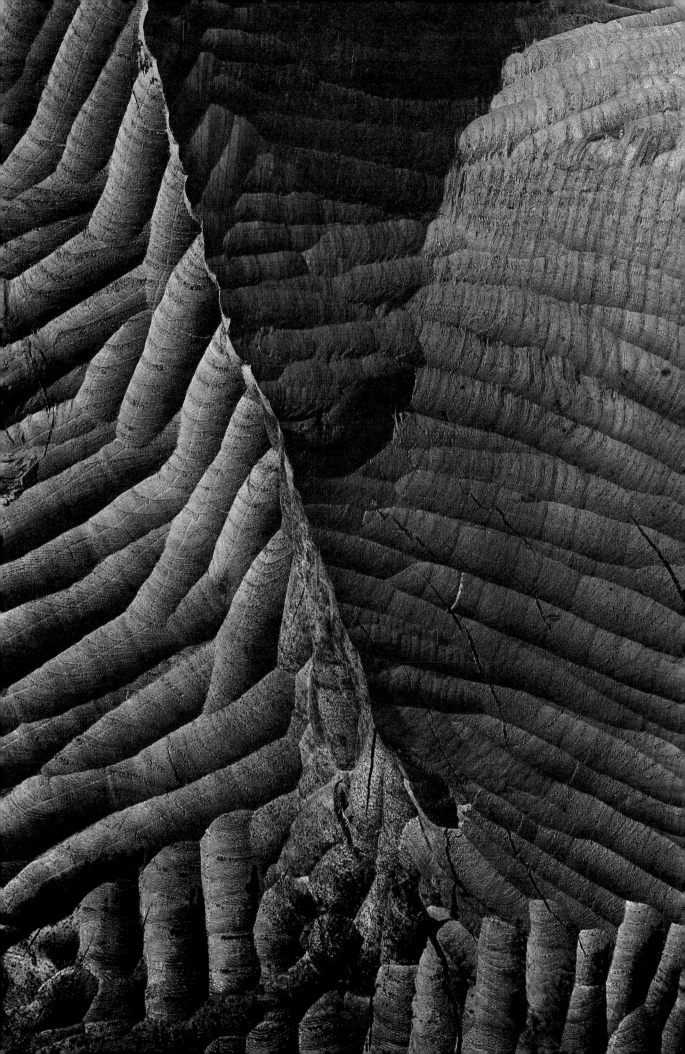

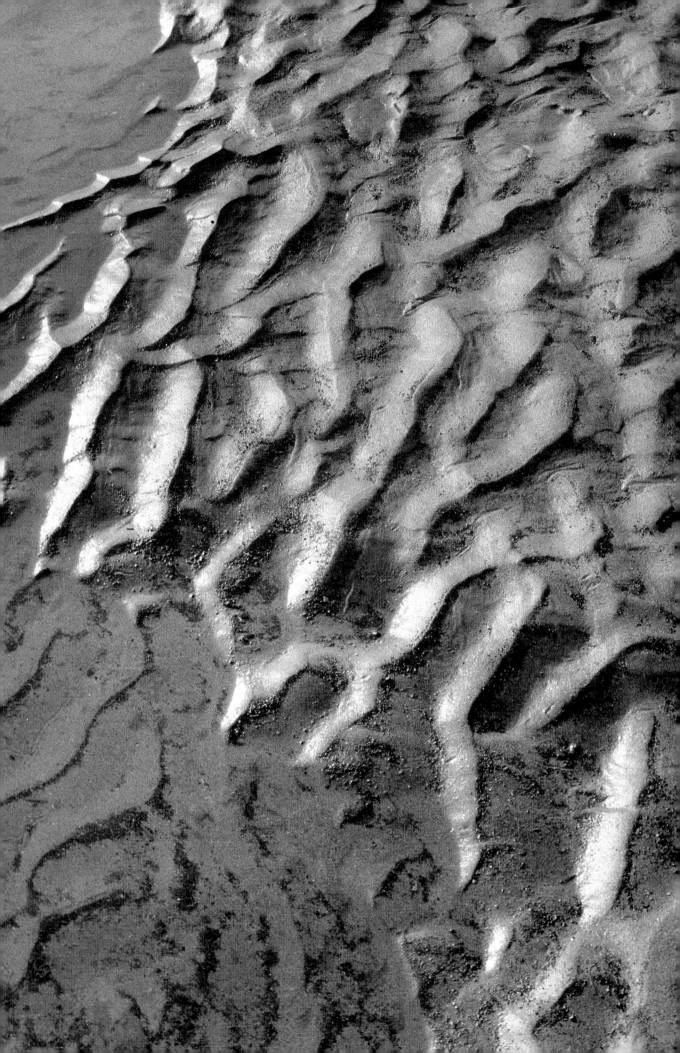

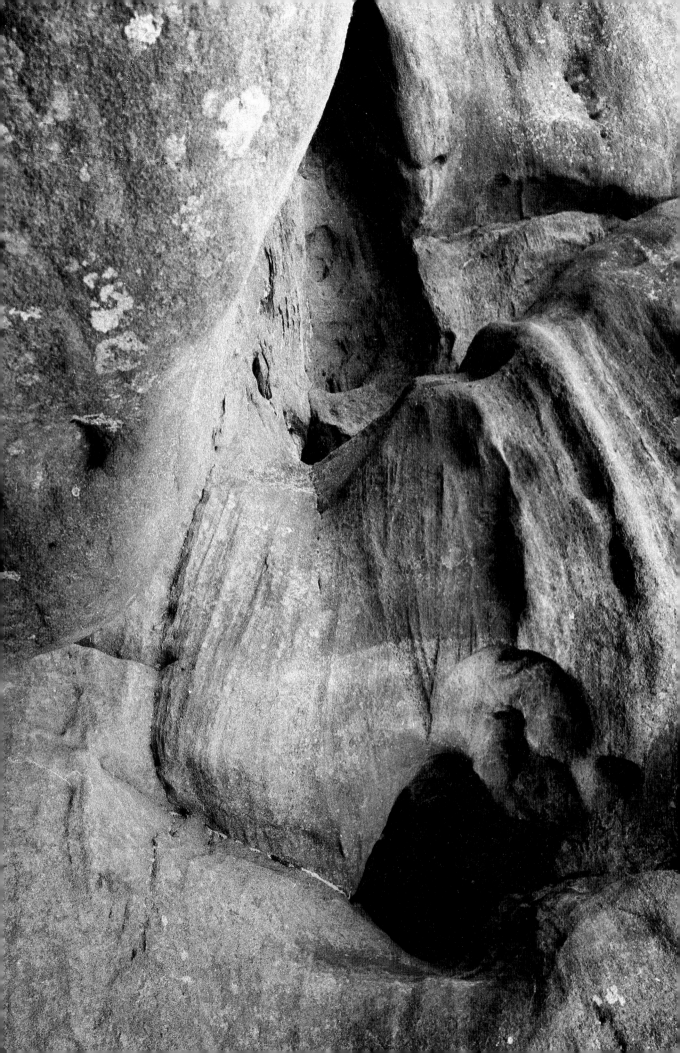

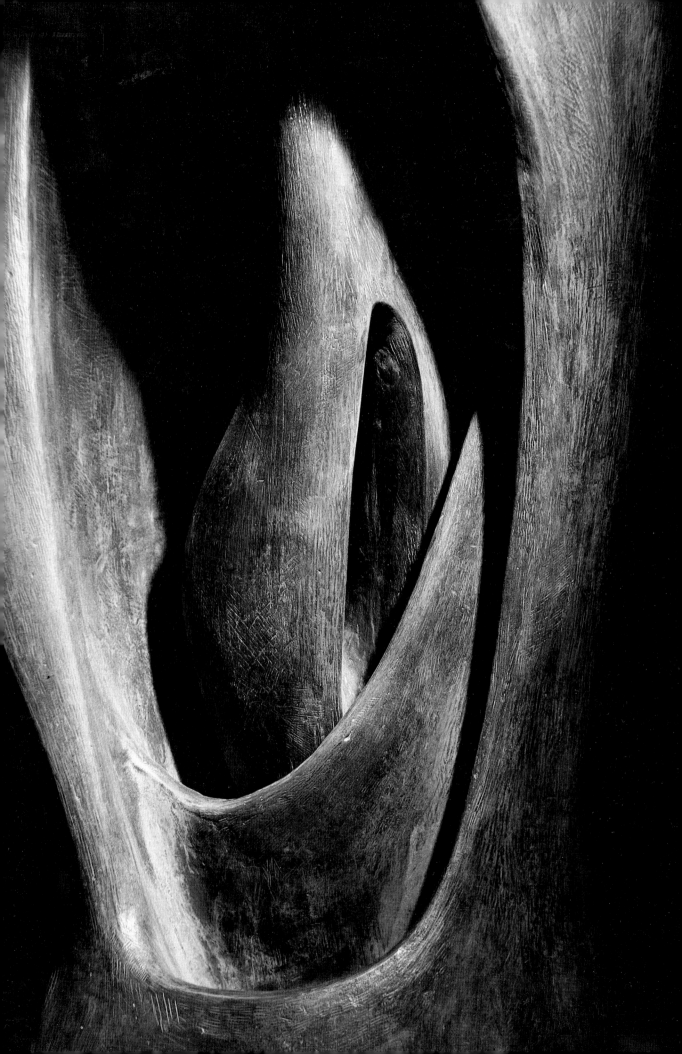

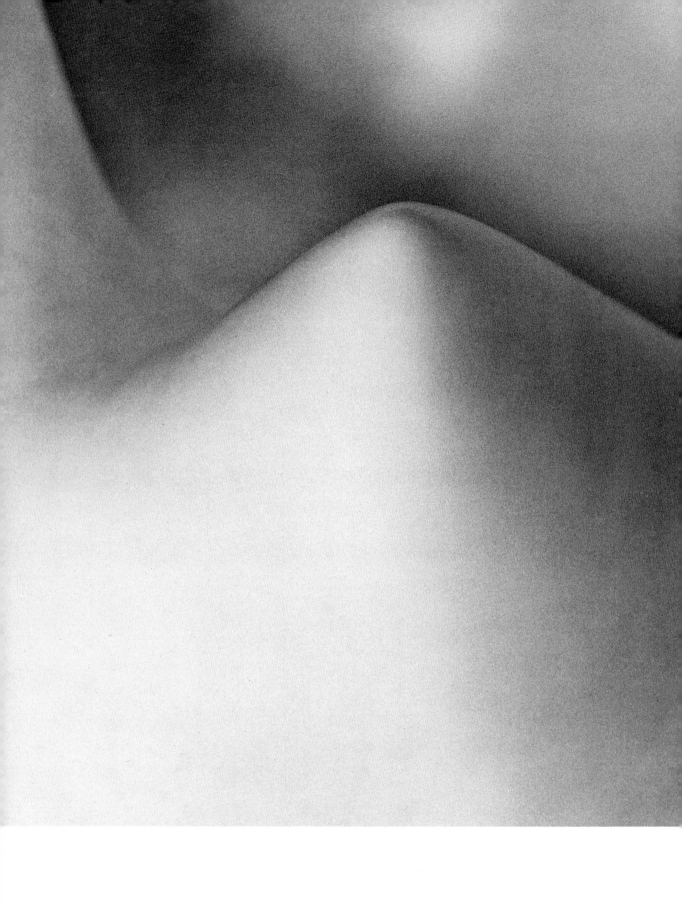

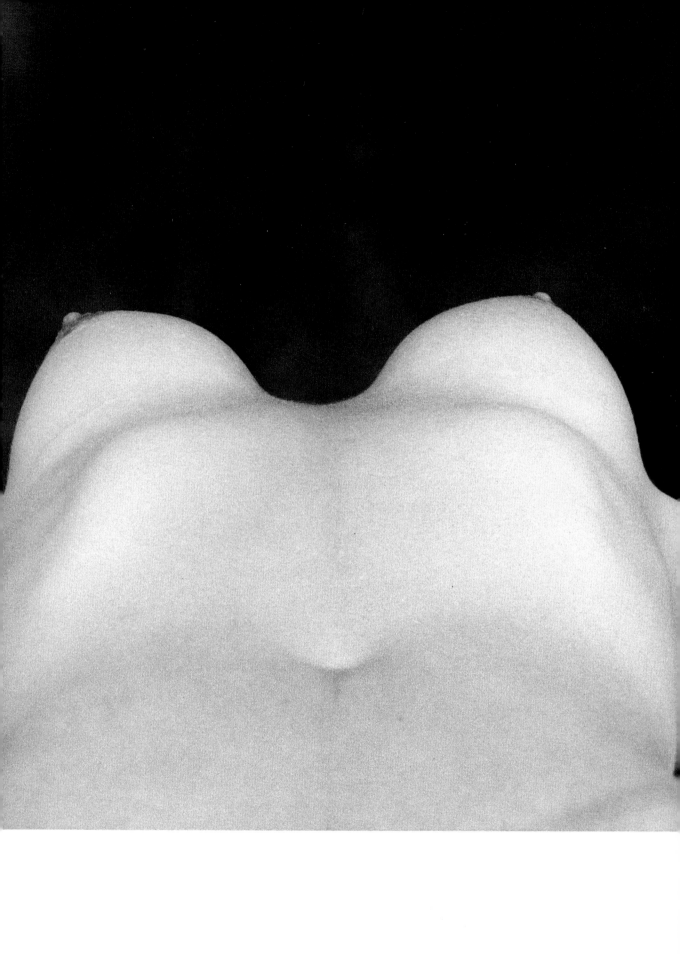

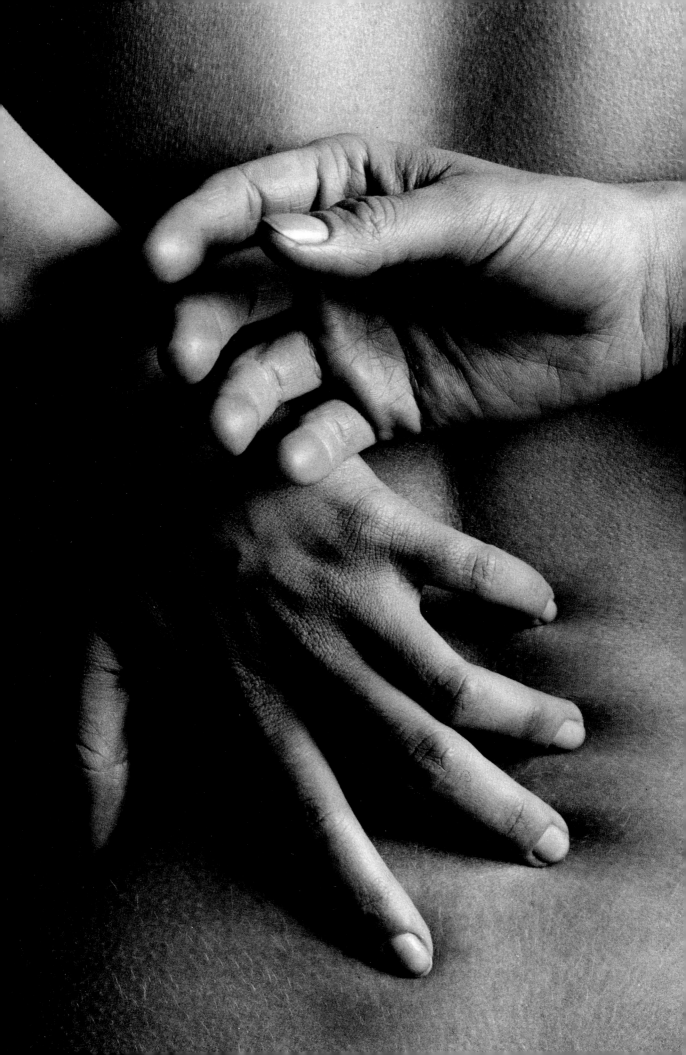

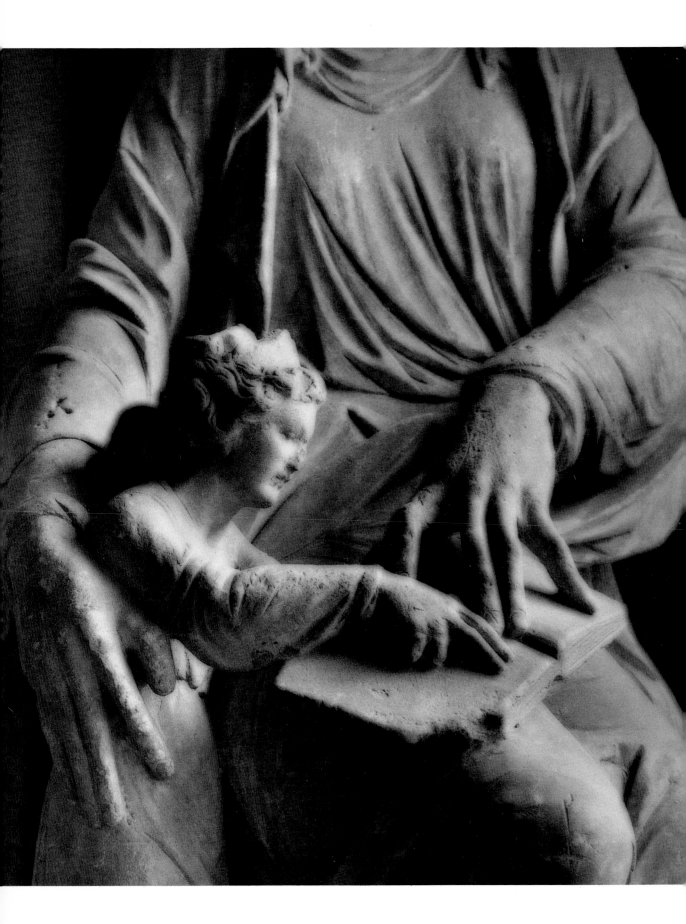

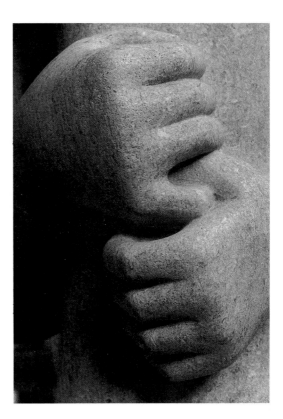

I have always loved hands, in common with most past sculptors. Rodin, for instance, made a very special study of hands. The first sculpture I did, or at least the sculpture that helped me to win a Royal Exhibition Scholarship to the R.C.A., was the modelling of a hand from life. Casts of this hand were later sent round to all the art schools as an example of how it should be done. I remember I enjoyed doing it quite enormously.

Hands, after the face, are the most obvious part of the human body for expressing emotion.

At the same time, how people sit and walk, the way they hold themselves, the pose of the head on the body all reveal part of their character. You can recognize a friend two hundred yards away solely by his proportions and by the way he moves and holds himself.

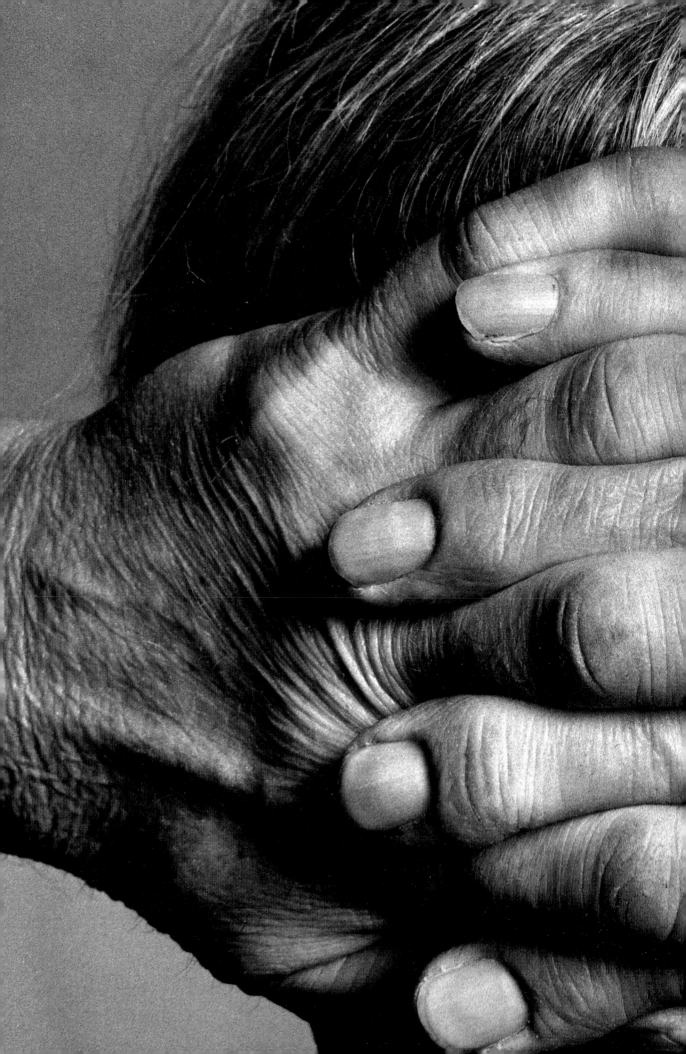

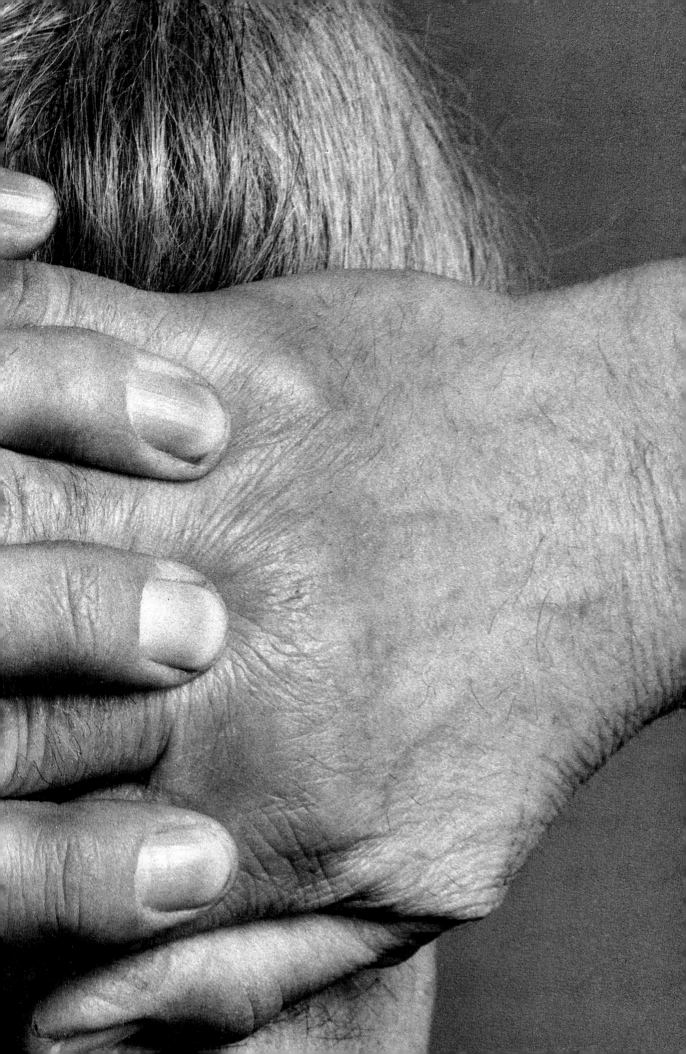

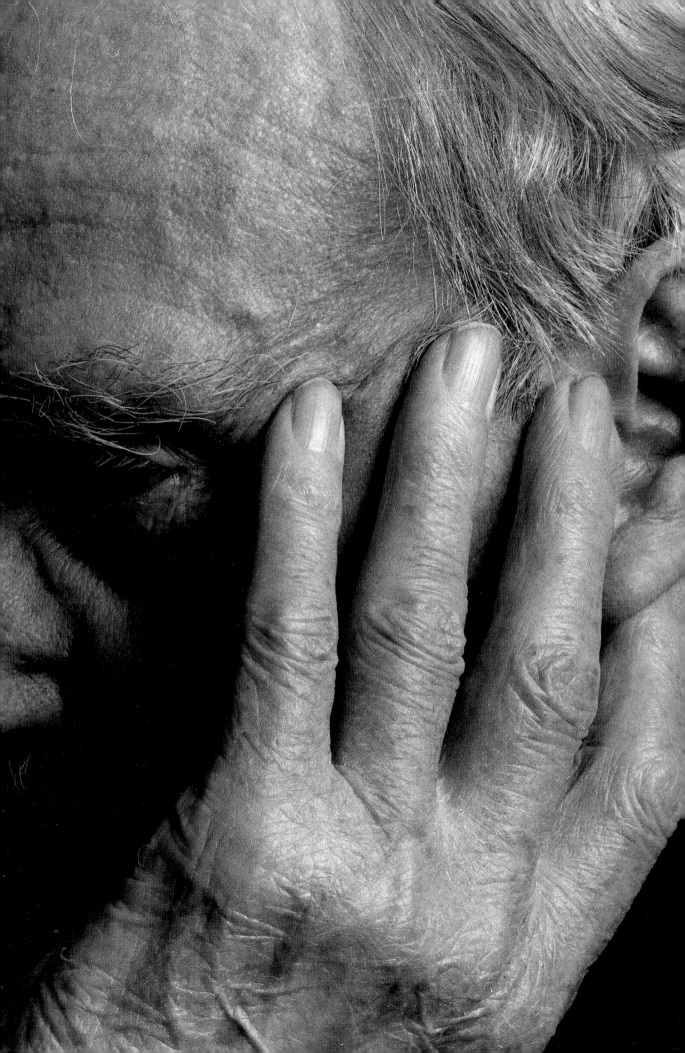

Great original talent cannot be quantified, although the question of heredity and environment must be involved.

This doesn't mean necessarily that someone in your family was a direct link and had shown a similar talent. But if it did, it doesn't have to be your father or your mother or your brother or your sister. It could have been your father's grandfather, or his grandfather's father, stretching back many centuries. And then it could have been a latent talent that had never been developed.

On the other hand, the environment in which you have been brought up, your experiences, the people who have encouraged you and helped to teach you the language of your discipline—these influences must play a major part in your understanding and in your aspirations, especially in your formative years.

The great artists that I admire have a life-giving power in their work that extends beliefs and understanding beyond normal perceptions. Michelangelo, Tintoretto, Rembrandt, Rubens, Cézanne, Rodin and some others have this quality in their work. I would like to think that in my own work some of this vital force has been imprisoned, independently from the object it represents, so that other people can be aware and sense it. But how it gets there would be impossible to explain. Nor should it need explanation. It is enough that our senses are enriched.

There are only three or four artists in any century who have any great original talent and in this category I include poets, writers, philosophers, painters and sculptors. There will be many who in their lifetimes will be considered successful and great artists. But in my view this is more often to do with public acclaim. It doesn't give them the special vision and talent that enlarges and enriches one's perception.

Michelangelo has the biggest reputation of practically any artist there has ever been. I don't know of any since him who touch on that true greatness. He wasn't, of course, recognized as the great man that he was until some long time after his death.

The unfinished sculptures impressed me most of all. They taught me what happened in his mind. When you see only the finished thing you don't know how it was arrived at. To see something that's not highly finished, or not had an enormous amount of time spent on it, you learn more about the person's methods and thinking.

Sometimes, the impression of seeing something for the first time is immense. A great work, for instance Cézanne's *Bathers*, the big triangular bathers, will always stand out clearly in my memory. I went to Paris several times when I was a student, but the Cézanne was the big event. He brought painting back from straightforward copying of nature to picture making, into using the mind as well as just taste. I think photography was playing an important role at this time in that its ability to copy with accuracy freed the painter to explore other ideas.

Cézanne's figures had a monumentality about them that I liked. In his *Bathers*, the figures were very sculptural in the sense of being big blocks and not a lot of surface detail about them. They are indeed monumental but this doesn't mean fat. It is difficult to explain this difference but you can recognize a kind of strength. This is a quality which you see only if you are sensitive to it. It's to do with the full realization of the three-dimensional form; colour change comes into that too, but not so importantly as human perspective.

Bathers is an emotional painting but not in a sentimental way. Cézanne had an enormous influence on everyone in that period, there was a change in attitudes to art. People found him disturbing because

they didn't like their existing ideas being challenged and overturned. Cézanne was probably the key figure in my lifetime. We had a cottage at Forte dei Marmi in Italy and I had a studio there. Sixty years ago it was impossible to get any marble in England as there was no sculpture going on so I had to use local stone. Later on I naturally went to where the material, the Carrara marble, was. You could get technical help there, too.

Of course, we enjoyed the place as well for the sea and the climate and to see the early sculptures there was tremendously exciting. It was very important to me as a sculptor—it enlarged my vision.

I first went to Querceta, near Forte dei Marmi in Italy, in connection with the Unesco sculpture. Querceta is a little village beneath the Carrara mountains. Altissimo is for me a most fascinating and exciting place. It is where Michelangelo spent two years of his life quarrying marble. Altissimo is owned by a firm called Henraux, who deal in stone from all over the world. It was they who supplied the Roman travertine which was used on the Unesco building in Paris and, when I decided that the Unesco sculpture was to be a carving and not a bronze, it seemed right to use the same stone. The Unesco sculpture was to be so big that the cost of sending the stone to England would have swallowed up the whole of my fee. Therefore I went to the mountain, instead of the mountain being sent to me. To do the Unesco sculpture meant that I was in Italy intermittently for nearly a year. I would go over for three or four weeks, work on the stone and, because I hated being away from home and from Irina and Mary, who was then only a child, I would come home for a month and then go back again. Whilst I was in England, I would leave the straightforward roughing out of the stone to two of Henraux's stonemasons.

I first saw Irina when I was a student at the Royal College—she was a student, too—and I saw her coming across from the Common Room where we used to have lunch at ninepence a time. I met her at a dance at the College and more or less took her out for the evening, not realizing she was at that time unofficially engaged. Lesley, her fiancé, was sitting there and I didn't realize he was anything to do with her and ignored him. Afterwards, I walked her back to Kensington Station and poor old Lesley came with us—Irina and I walking together on the pavement, Lesley dragging his feet in the gutter.

Irina has always been a tremendous inspiration, my most valuable constructive critic. Of course, it made a difference, the fact that I married a painter, Irina was trying to do the very same thing that I was and so she knew the problems I was faced with.

Irina knows what she likes of what I do, and she tells me. I take notice of it, too. She has kept my feet on the ground, she has made the reality of life easier for me. It's to do with sympathy, joining in, being interested. She even moved the stones with me.

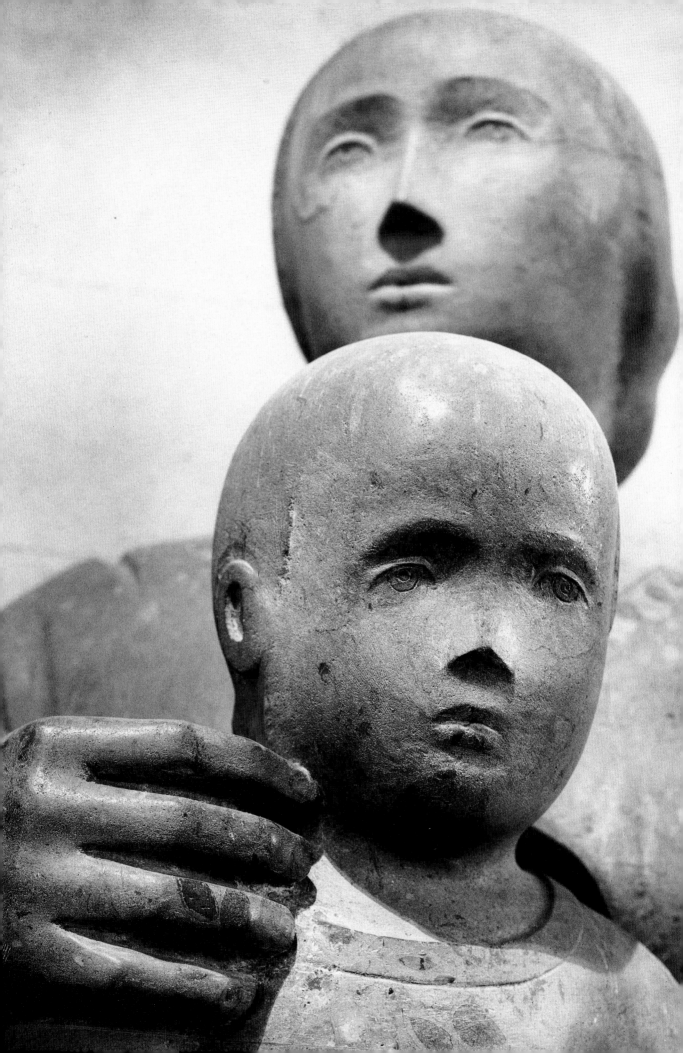

Religious art has been the inspiration for the greatest works of art in the world because the church at one time was the greatest patron and gathered up all the artistic talent—perhaps not so much so in England, but certainly in Italy. A lot of English church art, some of which is quite good, was done by the local stonemasons. They were brought up to do it from childhood, from being apprenticed at, say thirteen or fourteen. And they'd learn the style or the tricks, the fashion that they were in. They were taught to imitate, there was very little invention or change of style. This is a rare occurrence at any time. If there are rules and regulations, people without much original vision can work—though there is quite a lot of originality in some of the gargoyles and effigies, which were carried out in a slightly freer style.

When I came to do my *Madonna and Child*, I spent a lot of time and thought on it. It was different in a way from the Mother and Child work I'd done before though, of course, there were many similarities, too. You have to have a big form protecting a little form. From very early on I had had an obsession with the Mother and Child theme—it has been a universal theme from the beginning of time and some of the earliest sculptures we've found from the Neolithic Age are of a mother and child. I discovered, when drawing, I could turn every little scribble, blot or smudge into a Mother and Child. (Later on I did the same with the Reclining Figure theme!) But, with the *Madonna and Child*, there was the religious element too, it was to strengthen religious beliefs. Nor did I want to create something which the average person would find dreadful or wrong. I tried to fit in with the accepted faith. It was a real worry, and gave me many problems. One lay in trying to make the child an intellectual-looking child, that you could believe might be more than just an ordinary baby. The Madonna's face has a certain aloof mystery.

I'm not sure what people mean by religious art. If you believe that life is something wonderful, that it is worth living, that's religious. It's a belief in life.

The King and Queen have got a regal feeling, a confident poise about them. They became a King and Queen in the making. I couldn't do it again. I could do something, but it wouldn't be so intricate. There are certain things you wonder about, you wonder how you did them and you know you couldn't repeat them. It's a good thing really.

It was a big subject, *The King and Queen*. When I was working on them, I was reminded of an Egyptian sculpture in the British Museum that I had seen many times of a seated figure of an official and his wife. But somehow the sculptor had raised them above this status and had given them greater dignity and self-assurance, almost a nobility of purpose to make them appear above normal life. I've tried to infect some of this feeling into my sculpture.

Tony Keswick had seen my work and liked it, so I went up to his estate in Scotland which is the most perfect setting for sculpture with nature. The landscape is so bleak and impressive, so lacking in frilly bits of detail, so monumental. The first visit to Glenkiln was a staggering experience. As soon as I saw it, I was so very impressed and inspired by it; the light is always changing, too. I think Tony rather likes the idea of the King and Queen looking from Scotland across to England.

I'd sooner have my sculptures surrounded by natural landscape if I could choose, rather than with man-made architecture. The open air dwarfs everything because you relate it to the sky which is fathomless, endless, and to distance which can be enormous.

The King and Queen is rather strange. Like many of my sculptures, I can't explain exactly how it evolved. Anything

can start me off on a sculpture idea, and in this case it was playing with a small piece of modelling wax. It was at a time when I was thinking of starting my own brass foundry. I decided to cut out the first stage, which would have meant making a plaster cast, and to model directly in wax. Whilst manipulating a piece of this wax, it began to look like a horned, Pan-like, bearded head. Then it grew a crown and I recognized it immediately as the head of a king. I continued, and gave it a body. When wax hardens, it is almost as strong as metal. I used this special strength to repeat in the body the aristocratic refinement I found in the head. Then I added a second figure to it and it became a King and Queen. I realise now that it was because I was reading stories to Mary, my six-year-old daughter, every night, and most of them were about kings and queens and princesses.

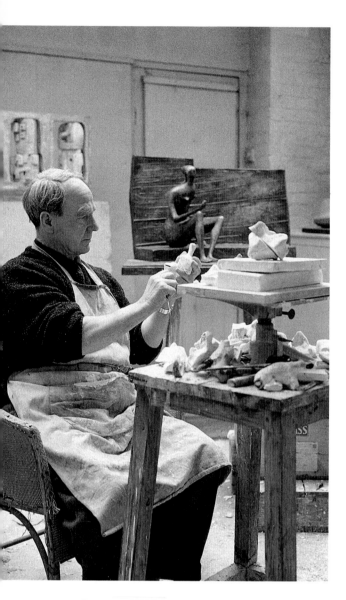

The general public is very slow to accept new trends in art because it can't understand them. After a certain age, people don't like making an effort either. If you think you know something, you stop learning any more about it. That would be impossible with drawing and sculpture and painting. You'd stop achieving anything. Every sculpture should have its different problems. They may not be technical ones, they may well be human problems—trying to understand some part of human nature that previously you didn't.

All good art demands an effort from the observer. You shouldn't think that a piece of art explains itself entirely without putting a mind to it at all. The more time and effort it costs the more you enjoy it. Anything that comes easily is less appreciated. In fact, all art should have some more mystery meaning to it than is apparent to a quick observer. In my sculpture, explanations often come afterwards. I do not make a sculpture to a programme or because I have a particular idea I am trying to express. While working, I change parts because I do not like them not because of a kind of literary logic, but because I am not satisfied with form. Afterwards, I can explain or find reasons for it but that is rationalization after the event and the explanations were not at all in my mind at the time—not consciously anyway.

People should not be impressed by things they do not comprehend, and should certainly not permit themselves to be belittled by them. Obscurity for its own sake only impresses fools.

My work has become familiar to people now, no longer comic or frightening. *The Knife Edge* stands outside the House of Lords and, whenever you see a politician being interviewed on television, the sculpture is there in the background. Millions of people must have passed it now. People pass things and don't notice, though. We pass trees hundreds of times, but ask someone to draw a tree—how much have they seen? Generally, my sculptures have begun with a small maquette taken from a preliminary drawing. Drawing is a way of developing ideas more quickly than making something in three dimensions. You can draw a standing figure in two minutes, whereas to make it, it would take you at least an hour or two. Even a small carving would take a week. When my sculpture was mainly carving I would get rid of ideas, as it were, by drawing them to prevent them from blocking each other up. So, if a drawing interests me, I make it into a small maquette so that I can view it

from every angle with ease simply by turning it in my hands. From this maquette, I would then decide whether to do a larger version which would entail some further alterations, because although a sculpture might work in a small size, as you enlarge it, it is necessary to change it again in order to get the scale, the proportion right. It's a practical consideration. You don't think about it, you just make it look more right. I might then carve it in wood or in stone, or make a working model by building an armature and then have it cast bronze.

When working in plaster for bronze I need to visualize it as a bronze, because on white plaster the light and shade acts quite differently, throwing back a reflected light on itself and making the forms softer, less powerful ... even weightless.

At first I used to have a tremendous shock going from the white plaster model to the finished bronze sculpture. But after forty years of working in plaster for bronze I can now visualize what is going to happen. The main difference is that bronze takes on a density and weight altogether unlike white plaster. Plaster has a ghost-like unreality in contrast to the solid strength of the bronze. If I am not absolutely sure of what is going to happen when the white plaster model is cast into bronze, I paint it to make it look like bronze. After a sculpture is cast it's too late, of course, to make any big alterations.

Man, who sits alone at the end of my garden, began as a detail from the Tate *Family Group*. Later, after making a few alterations, I used him as an experiment in casting in concrete. I found the material rather unsympathetic and so I faked him to look like bronze. The only people who were taken in were some local gypsies, who one night rolled all fifteen hundredweight of him a good hundred yards to the fence before one, more suspicious than the rest, struck him with a hammer and discovered not scrap metal but concrete. As I have said so often you should never judge sculpture at first sight.

At one time I became very interested in doing my own bronze casting. I had an assistant then who was ambitious to be a bronze caster rather than a sculptor. So I built a little foundry at the bottom of the garden. And I am very glad I did, because I learnt much about the characteristics of bronze which has been very helpful to me ever since. However, after a year of doing my own casting, I found the amount of time being taken up doing technical jobs was preventing me from doing as much sculpture as I wanted. Besides, professional bronze casters could do the job better than I. Now I send all my sculpture away to be cast and visit the foundry if necessary.

I use a foundry in London for the medium- and life-size sculptures, but I now go to Noack in Berlin for the really big ones. I like a bronze to come back from the foundry clean and bright like a new penny. From then on it is possible, by the use of various chemicals, to give it a patina which helps its sculptural form. Bronze is a material which can be changed to any colour as well as being able to be highly polished. Clean air will turn it green, as seen on country church roofs. Nearer the sea the salt makes it greener still. In cities the smoke and carbon dioxide tend to make it black. If a sculpture is going to an exhibition, dealers will often ask you to make several casts. Gradually, as I became more successful, I made bigger editions of my sculptures—after all, it enabled me to go on working. But one has to know where to draw the line. If you make a mould and it can be cast into bronze you could make thirty—even a hundred—casts and they would all be as good as each other. There's nothing wrong in that, it's just that numbers make something less valuable, less unique, so I've always tried to keep these numbers down to below ten.

I have rather enjoyed all the hundreds of thousands of visitors I've had over the years, busloads of schoolchildren. I've never minded being interrupted. In fact, I'd have hated to be isolated from other people. If a little child comes to you and says something, of course it's worth taking seriously—it only shows they're interested and everyone is worth considering. I've always tried to give serious answers to questions about my work to whomever might want to ask. I can understand why people come to ask why are my women always fat ones, never thin or why they have holes in them.

At one time I used wire netting in making the armature, but this caused immense trouble when I made alterations which are always necessary in enlarging the maquette into a full size sculpture. Now for the armature I use polystyrene and plaster.

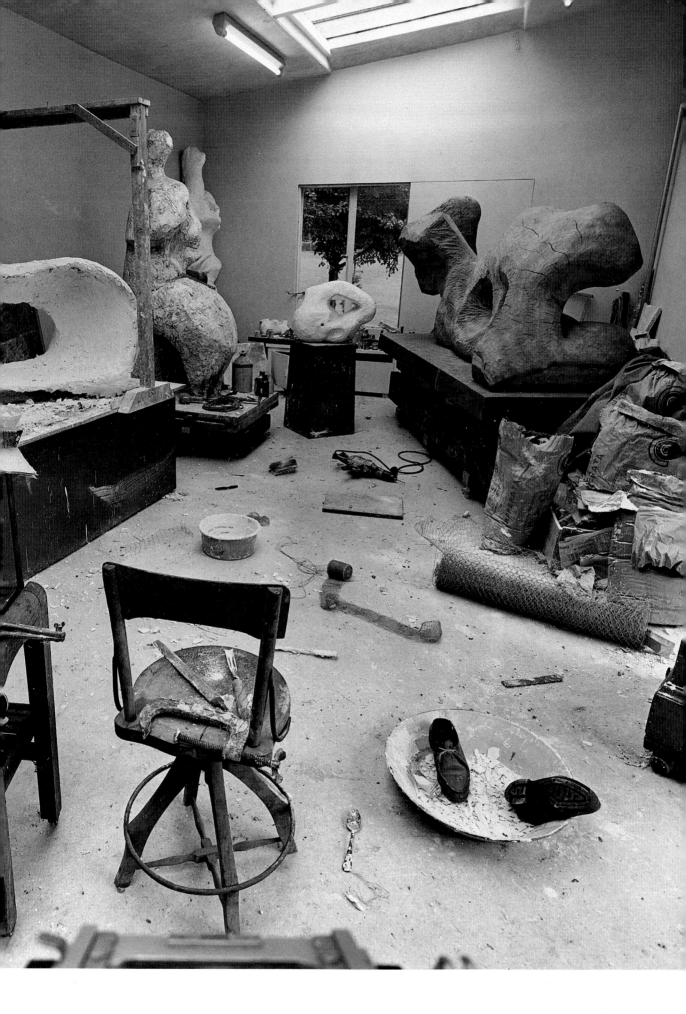

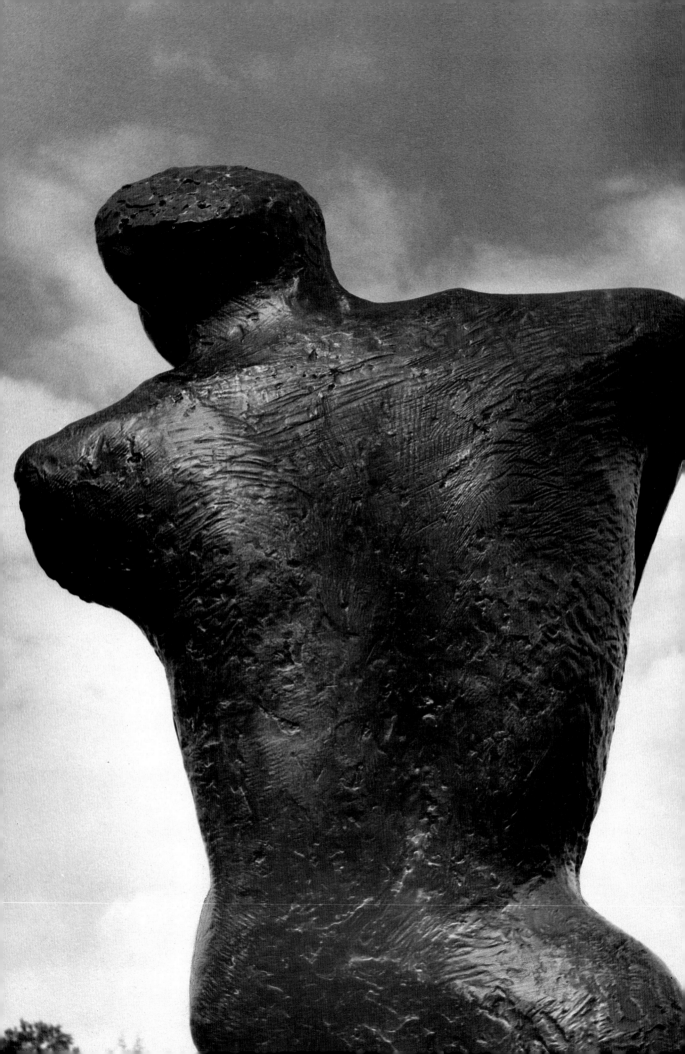

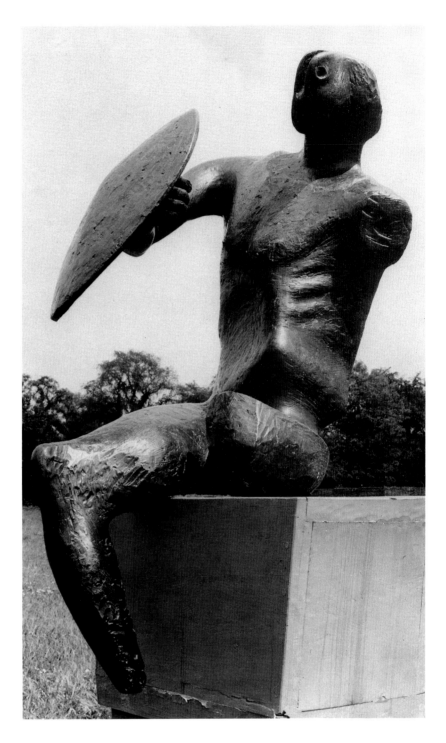

The idea for the Arnhem warrior came to
me in 1952 or 1953 and it evolved from a
pebble I found on the sea-shore. It
reminded me of a stump of a leg am-
putated at the hip. Just as Leonardo says in
his notebooks that the painter can find a
battle scene in lichen on the wall, so this
gave me the idea for my warrior, a figure
which, though wounded, is still defiant.

It is often said by philistines that art is an escape from life, while others say that an artist is a product of his society and can't escape from everyday conditions. But an artist is the same as everyone else, he stands on two legs and thin ankles. Writers and artists are simply trying to put a point of view about life and an attitude towards life, which their own sensitivity determines as out of the ordinary. If this were not so, it wouldn't be much good them doing it. If somebody were just repeating what the ordinary person wants, and the ordinary person wants something that has already been done, then public approval is valueless.

There is a difference between literary criticism and art criticism in the sense that literary critics are working in their own medium. In their literary criticism, Baudelaire, Coleridge and Eliot really knew what they were about because they were poets, whereas very few art critics are practising artists. Therefore they are more inclined to make stupid errors.

An artist should not be controlled by the opinions of critics. With friends it may be different. For example, I ask Irina whether she thinks certain drawings or sculptures should be sent to one exhibition or another. Again, I might have asked friends such as Herbert Read or Kenneth Clark which idea out of several drawings they think is better for a certain project. But I wouldn't ask anyone whether he thinks I should follow a certain direction or not, or how I should do a certain sculpture. A painter might ask his framer for advice on the framing of a picture, but he would never ask how to paint the picture.

Too much art criticism is advice to change the work of art in the direction the critic recommends. I don't say that an artist should not listen to other people's opinions, only that he doesn't have to take any notice of it.

The whole of my development as a sculptor is an attempt to understand and realize more completely what form and shape are about, and to react to form in life, in the human figure, and in past sculpture. This is something that can't be learnt in a day, for sculpture is a never-ending discovery.

When Michelangelo said that sculpture could express everything, he did not mean that sculpture could replace the functions of all the other arts, or that sculpture could play a banjo! He meant that it can express so much that you don't need to worry about what it can't do. In that sense it was enough for him . . . it is enough for twenty lifetimes.

The more you know about something, the more ambitious you become. At the age of twenty-seven or twenty-eight, one doesn't want to do an over-life size sculpture. But it satisfies the ego more if you're doing something big, a good big'un was better than a good little'un. There was a size that was practical. I mean I couldn't do over-life size — I didn't have a studio, I couldn't handle it, I couldn't import it, I couldn't afford the material — so a lot of things were controlled by circumstances.

In a figurative sculpture, the head is, for me, the vital unit. It gives scale to the rest of the sculpture and, apart from its features, its poise on the neck has tremendous significance. Michelangelo's faces are probably the least dominating part of his sculpture, for he was not a portraitist.

In my opinion, individual features are not of the utmost importance in sculpture, whilst their proportion and placing in the head can have enormous meaning.

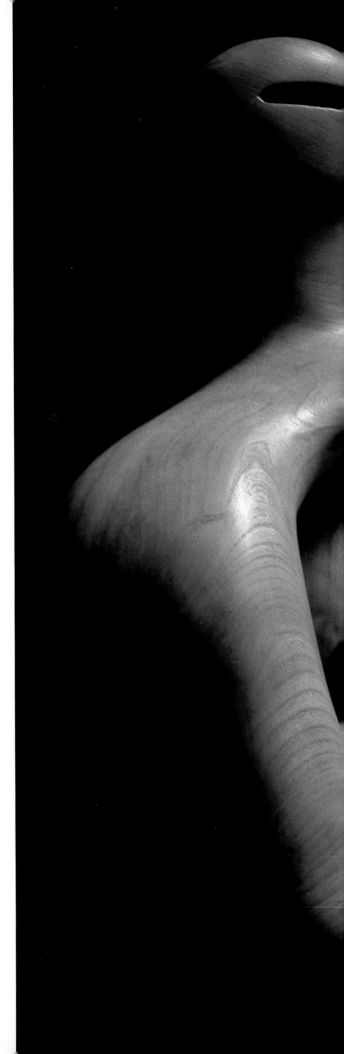

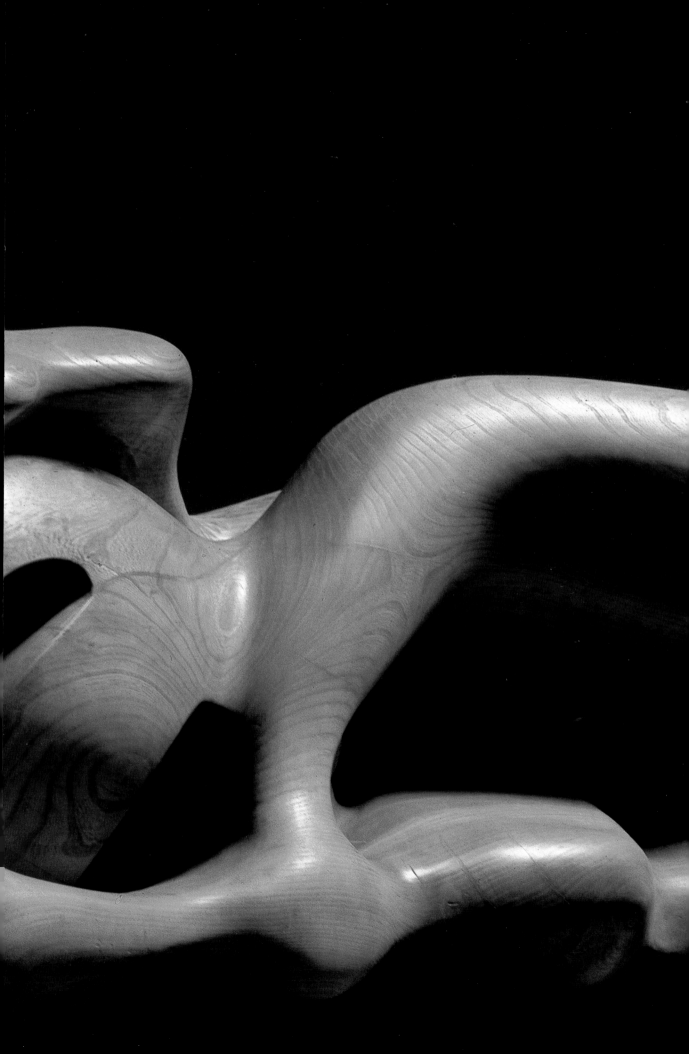

I'm not really colour conscious at all. I think it wouldn't hurt for a sculptor to be completely colour blind. In fact, it would make him better, more able to concentrate on form and light without being intrigued or distracted by colour.

I've tried to make my sculpture have life—it's not just decoration. Working from nature, one was against symmetry. Nature may appear symmetrical sometimes, but it never is. Everybody's face, for instance, is asymmetrical. If you took the two halves of a person's face and reversed them, you'd get a different person. All living forms have their character and I hope I have been able to give that sense of life of my work. It isn't just a dead set of lines, life can't be explained entirely, thank goodness.

We first moved to Much Hadham during the war after the London studio had been bombed. We discovered that we could lease half of a house called Hoglands. The owner was away at the war and his wife and children were living in the other half. A month or so later the wife decided to go and live with her mother and offered to sell us Hoglands. I had just been offered £300 by Gordon Onslow-Ford for the 1939 elmwood *Reclining Figure* and this happened to be exactly the deposit required on the house. We have lived at Hoglands ever since.

I returned to London two days a week spending the nights in the Underground where I was filling a sketch book with the shelter drawings.

The people had taken over the Underground to escape the bombing. It wasn't only on the platforms, it was in an empty tunnel, too, where they were excavating to put a new line in. Of course, I couldn't do the drawings on the spot—it would have been like drawing in the hold of a slave ship. I might have made a note—to remember the line of someone's legs, say—but I had to do them from memory.

I had never seen so many reclining figures and even the train tunnels seemed to be like the holes in my sculpture. And, amid the grim tension, I noticed groups of strangers formed together in intimate groups and children asleep within feet of passing trains.

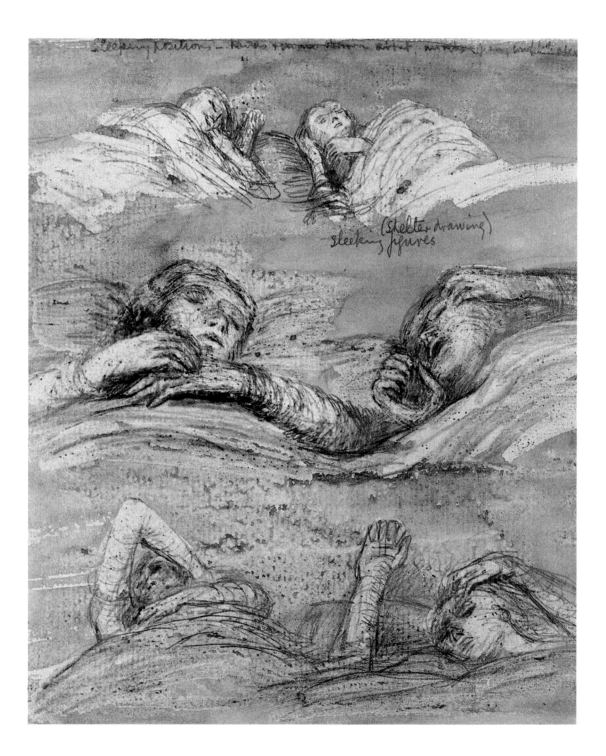

Early in 1941 the authorities started to provide bunks and canteens in the shelters and to lay on sanitary arrangements. With them the drama and strangeness of the early months in the Underground began to recede both for me and for the people themselves. Mentioning this to Herbert Read one day he suggested that, with my background, coal-mining, being an industry of great national importance, would make a good subject.

I spent two weeks in a coal-mine and these sketches provided me with enough material for about three months of drawing.

After this I told Kenneth Clark, Chairman of the War Artists Committee, that I did not want to undertake any more commissions and I began work once again on drawings for sculpture. Towards the end of 1942, I held an exhibition of fifty new drawings at Curt Valentin's Gallery in New York, which did not include any shelter or coal-mine drawings.

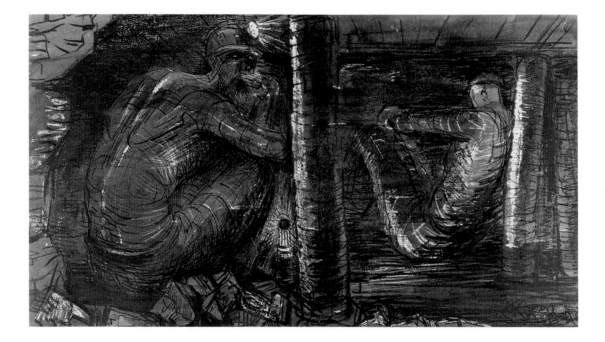

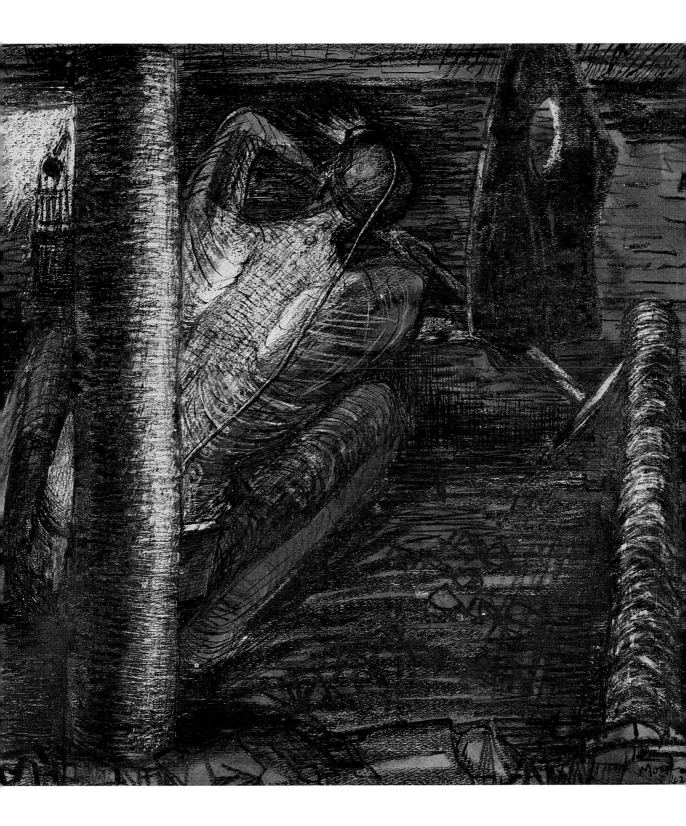

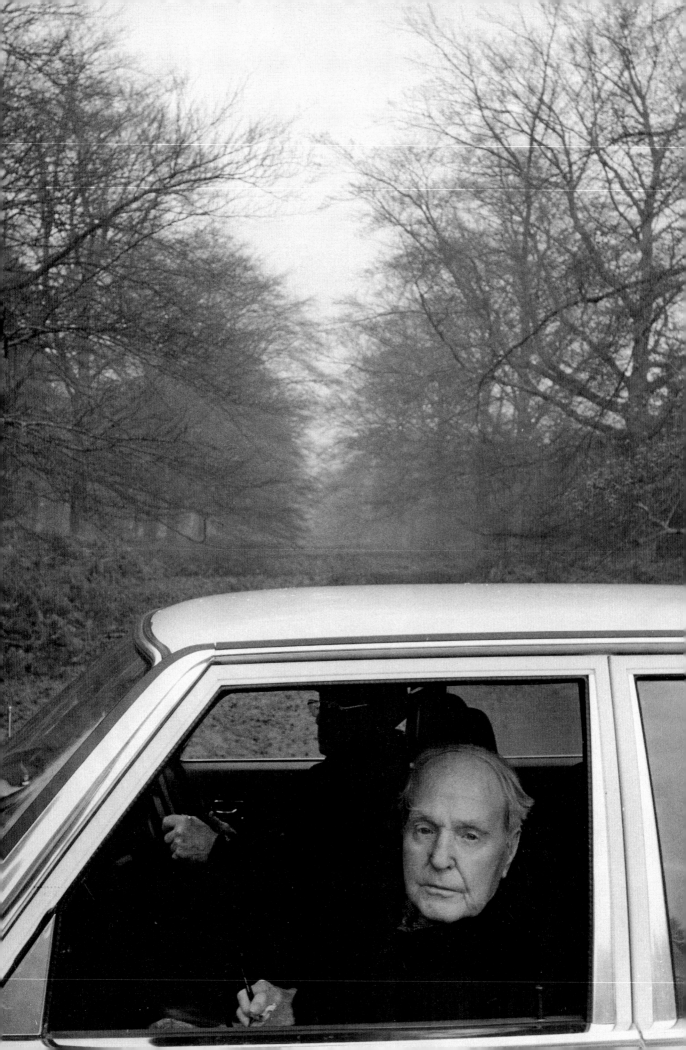

I cannot draw while I'm looking. I just let my eyes take in what is in front of them. I store it all up in my memory; this has always been so. I then will draw for several days, not copying, but creating from my imagination, perhaps relating to many experiences in the one drawing. I will then attempt to bring a three-dimensional solidity, showing the shape of an object by means of light and shade. I might use sketches, notes I made at the time, or even photographs, but most of it comes from my remembered experience of what I have seen and felt.

Happiness is to be fully engaged in the activity that you believe in and, if you are very good at it, well that's a bonus. An artist's raw material is what he has seen and done so I still have to refresh my eyes every day. It is not enough to sit in my comfortable chair surrounded by outstanding examples of fine art. Although it is difficult, I have to go out every day for a drive, to see nature, the countryside, the trees, the sky, to be renewed and refreshed. The drawings I make reflect my love of nature.

Even now, at the age of 87, it is necessary to go out for a drive each afternoon because it refreshes my vision.

An artist lives through his eyes, as a musician lives through his ears. One can't go on living on the same material. One's memory is one thing, and very valuable it is too, but it has to be refreshed. I enjoy my afternoon drives enormously, I see different things, even if I go the same route, because the light is always different.

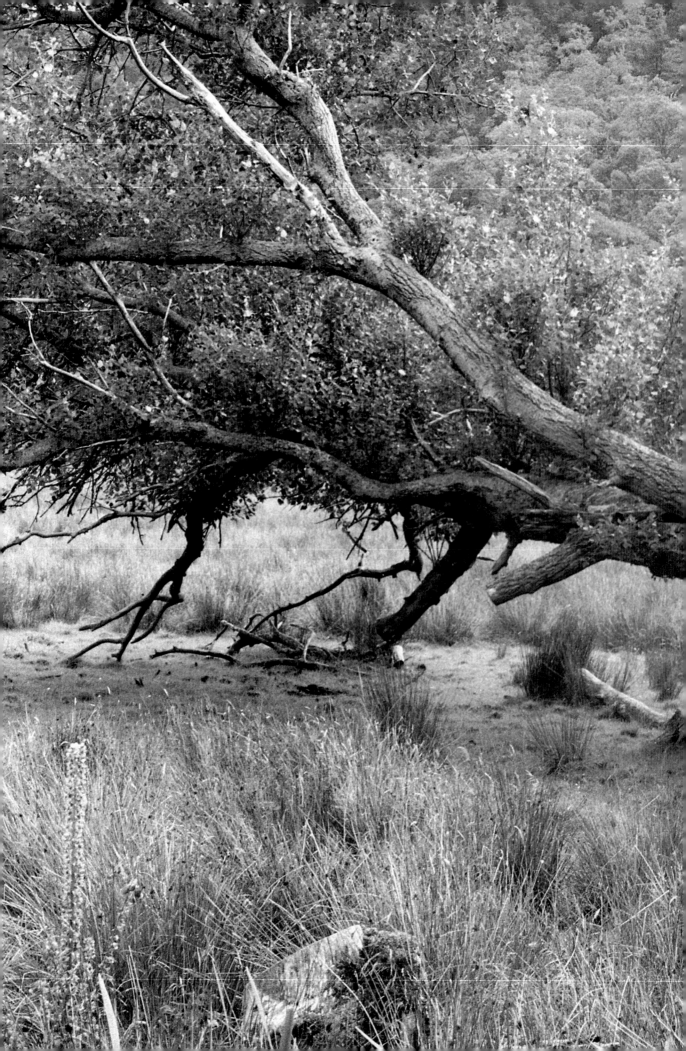

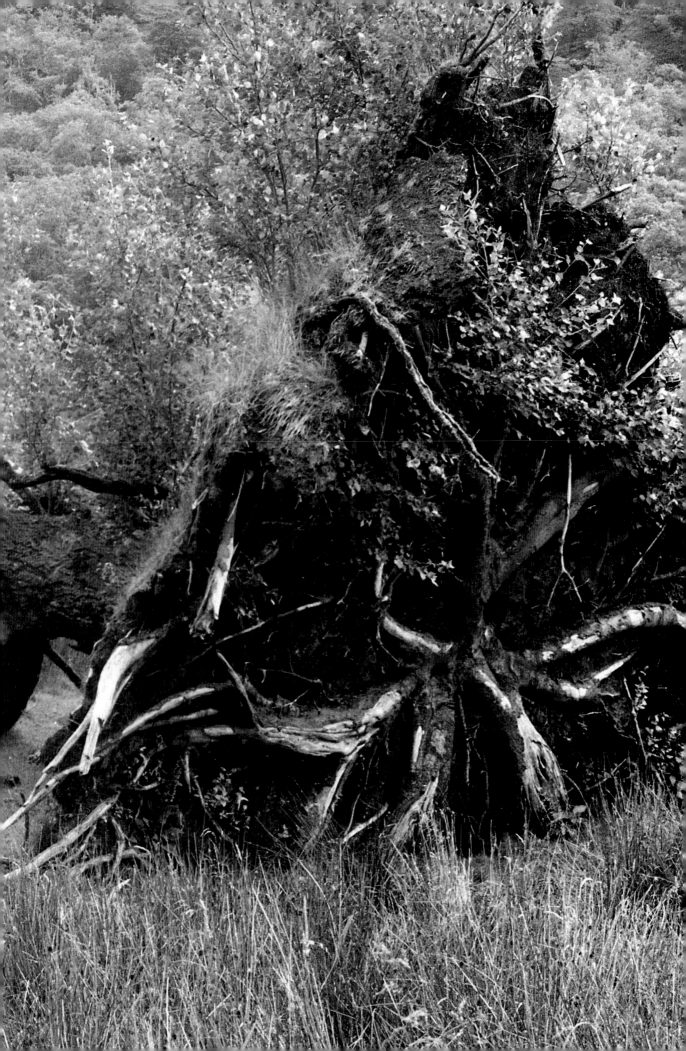

It is impossible to turn to a single
influence in any work of art, it can only
come by the development and experience
of a lifetime combined with all these
influences. And then it is only the truly
great artists who can emerge to create
their own individual style. Then with the
artist's own ideas and abilities one hopes
that an added vitality will be embraced
within the work he produces. But nobody
can say where that added force comes
from other than that it comes from
within the artist himself.

When I've finished a sculpture and
through it expressed my ideas, emotions
and feelings, then I can look and
philosophize about the reason for doing a
particular piece. But it would never be
exact. Who is to tell if an experience
which occurred yesterday, or ten years
ago, or a lifetime ago was an influence or
not? I can't.

I can't remember whether I was asked to do the sheep or whether I just thought of it for myself. They were all around the studio and I began to really look at them for the first time. Before, I used to think a sheep was just wool with four legs, an animal shape. But later, as I came to look, I found that there were different sheep, some were thin and elegant and some were fat and lazy and they began to become individuals. So I used to draw in a sketch book and it just went on. I loved doing it. Sheep have an entirely different feeling from, say, horses or cats or dogs. The sheep used to come right up to my studio, very close, about nine or ten feet away almost as if they were in the room with you or you with them. As I progressed with the drawings, I began to go into the field and see them in their natural surroundings, so they were all drawn from life. I began to recognize the individual sheep over a time, I would know that I'd drawn that one already and that one I hadn't. I suppose there were a good fifty or more in the field.

Just because throughout my sculpture
I've been interested in the same subjects,
mother and child, reclining figures, seated
figures and so on doesn't mean I was
obsessed with these themes. It just means I
haven't exhausted them and, if I were to
live another hundred years, I would still
find satisfaction in these subjects. I could
never get tired of them, I can always
discover new thoughts and ideas based on
the human figure, it is inexhaustible.

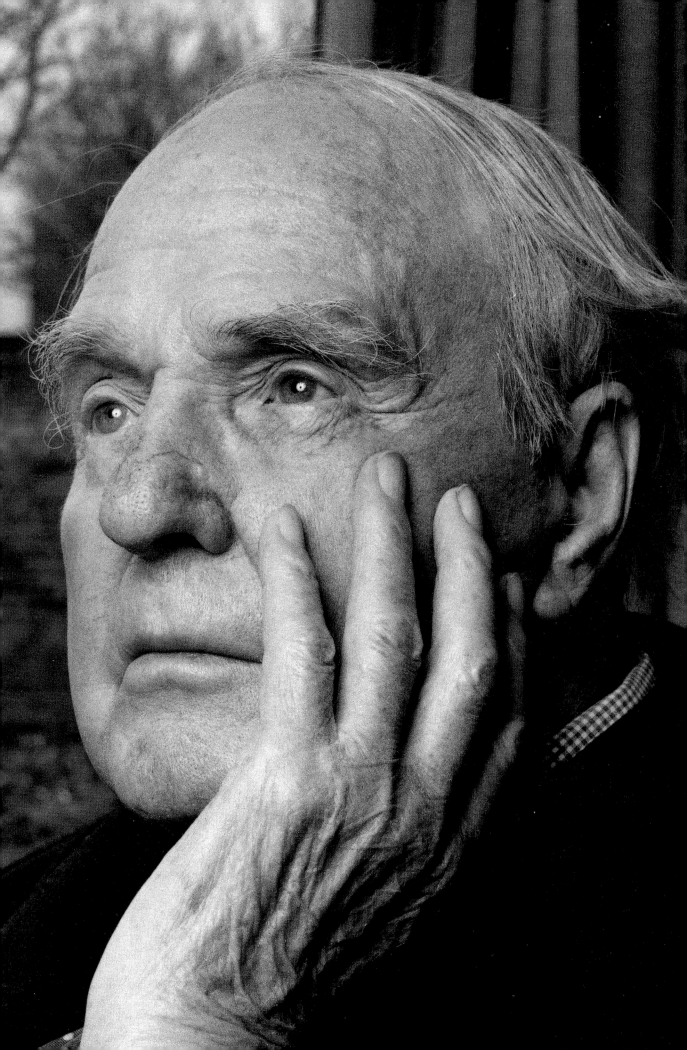

GALLERY
OF SCULPTURE

The gallery in the following pages
represents a selection of Henry Moore's
major sculptures from 1928 to the present day,
and shows the way he developed
recurrent themes over the years.

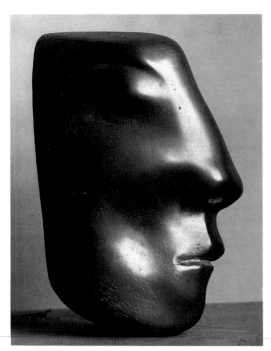

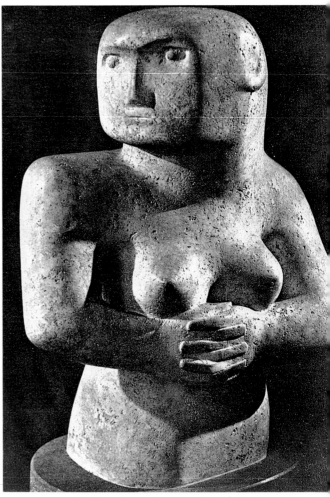

1 Mask, 1929, Lead, Height 8½ in/21.75 cm.

2 Figure with Clasped Hands, 1929, Travertine Marble, Height 18 in/45.5 cm.

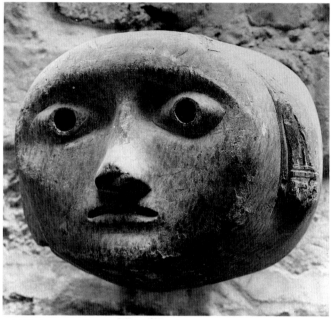

3 Mask, 1929, Stone, Height 5 in/12.5 cm.

4 West Wind, 1928,
Portland Stone,
Length 96 in/244.5 cm.

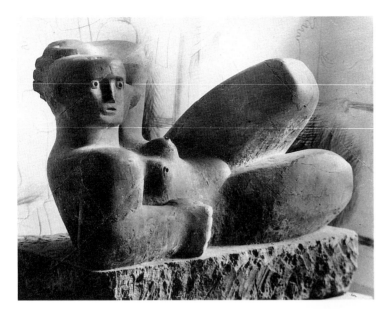

5 Reclining Figure, 1929,
Brown Hornton Stone,
Length 33 in/84 cm.

6 Girl, 1931, Ancaster Stone,
Height 29 in/74 cm.

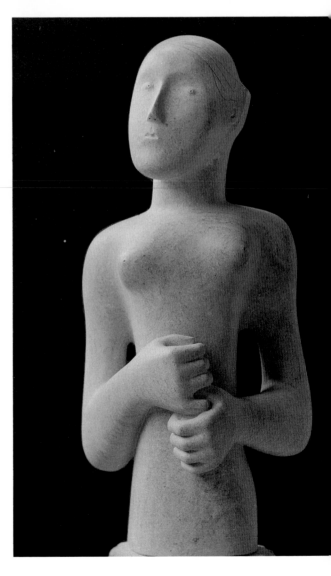

7 Mother and Child, 1931, Sycamore Wood,
Height 30 in/75 cm.

8 Mother and Child, 1932, Green Hornton Stone,
Height 35 in/89 cm.

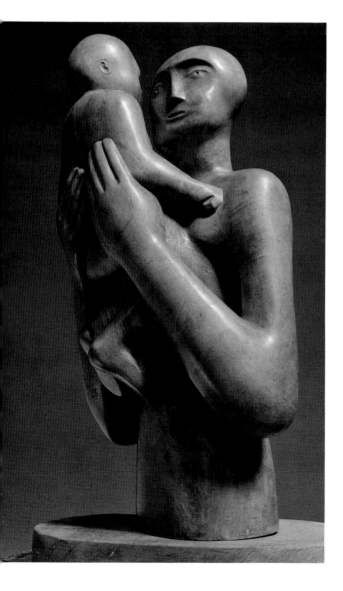

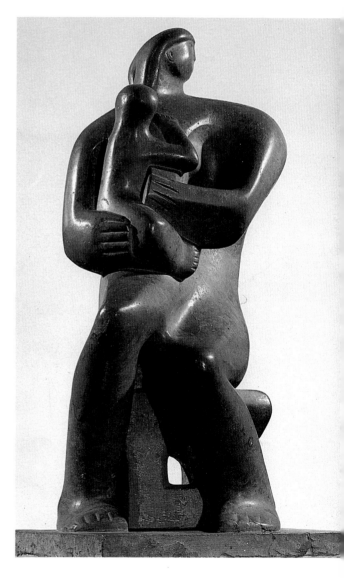

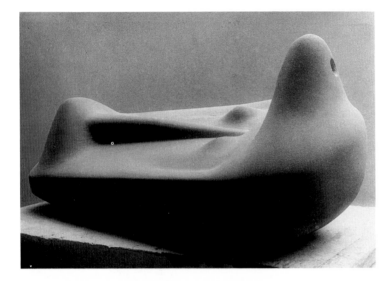

9 Reclining Figure, 1934–5,
Corsehill Stone,
Length 24½ in/62.25 cm.

11 Mother and Child, 1936,
Green Hornton Stone,
Height 45 in/104.5 cm.

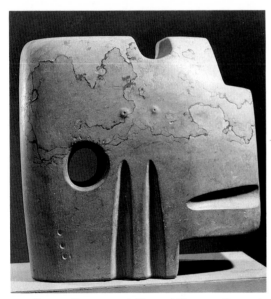

10 Square Form, 1936, Brown Hornton Stone,
Length 21 in/53.5 cm.

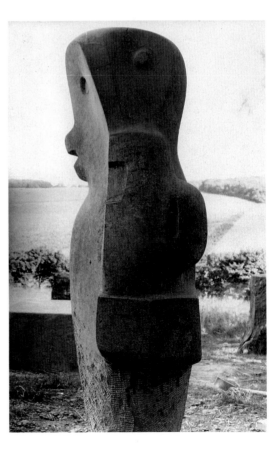

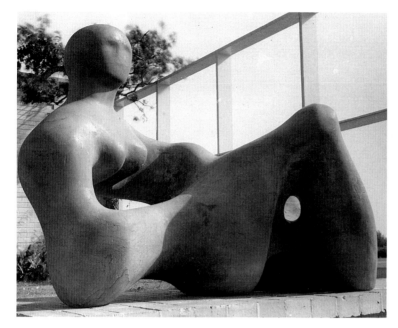

12 Recumbent Figure, 1938,
Green Hornton Stone,
Length 55 in/129.5 cm.

13 Reclining Figure, 1939,
Elm Wood,
Length 81 in/202.5 cm.

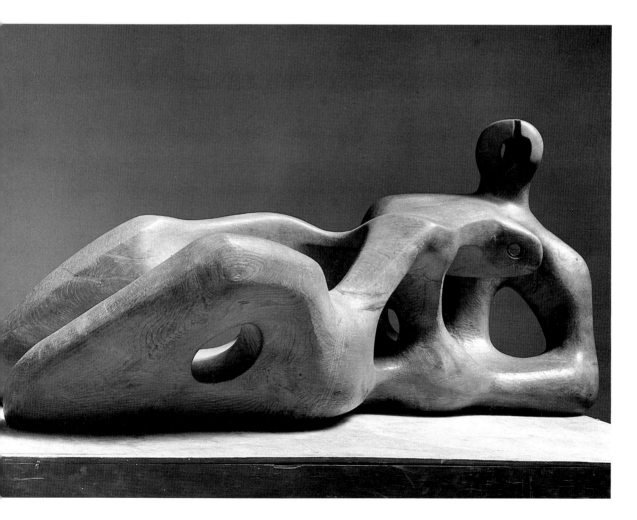

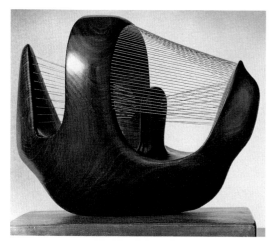

14 Bird Basket, 1939, Lignum Vitae and String,
Length 16½ in/41.75 cm.

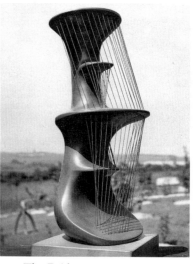

15 The Bride, 1939–40,
Lead and Wire, Height 9⅜ in/24.25 cm.

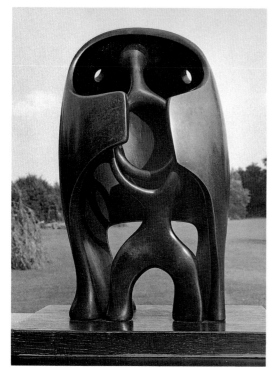

16 The Helmet, 1939–40, Bronze,
Height 11½ in/29.25 cm.

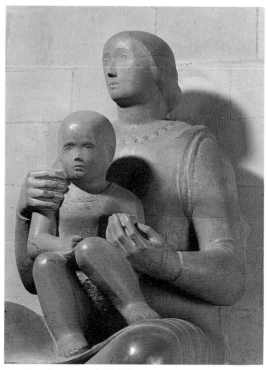

17 Madonna and Child, 1943–4, Hornton Stone,
Height 59 in/150.5 cm.

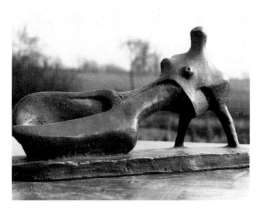

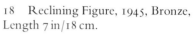
18 Reclining Figure, 1945, Bronze,
Length 7 in/18 cm.

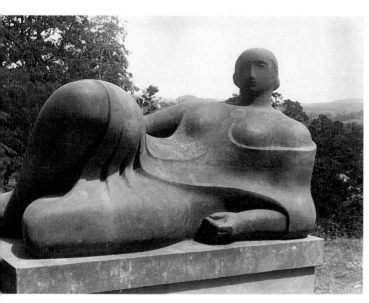

20 Memorial Figure, 1945–6, Hornton Stone,
Length 56 in/142.5 cm.

19 Reclining Figure, 1945, Elm Wood,
Length 75 in/191 cm.

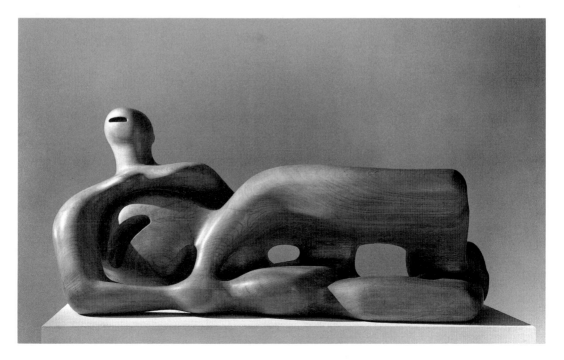

21 Claydon Madonna and Child, 1948–9,
Hornton Stone, Height 48 in in/122.5 cm.

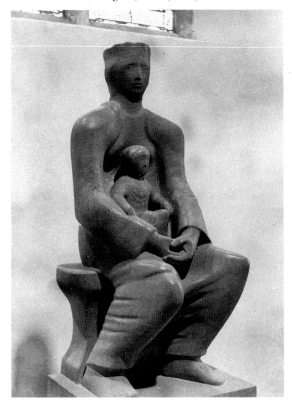

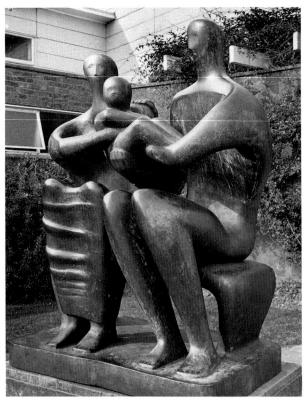

23 Family Group, 1948–9, Bronze,
Height 60 in/153 cm.

22 Three Standing Figures, 1947–8,
Darley Dale Stone, Height 84 in/214 cm.

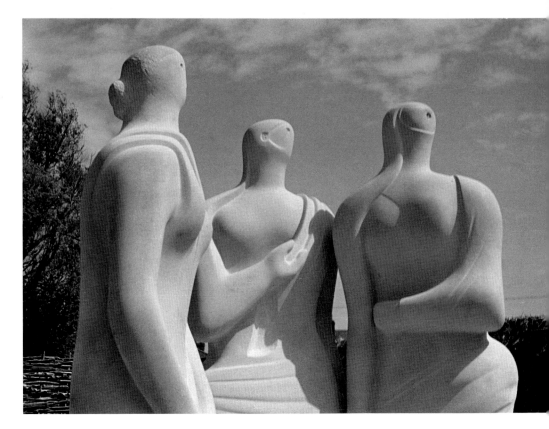

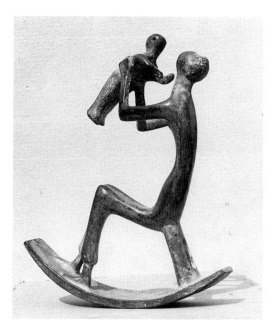

24 Rocking Chair No. 1, 1950, Bronze,
Height 13 in/33 cm.

25 Helmet Head No. 2, 1950, Lead and Bronze,
Height, 13½ in/34.25 cm.

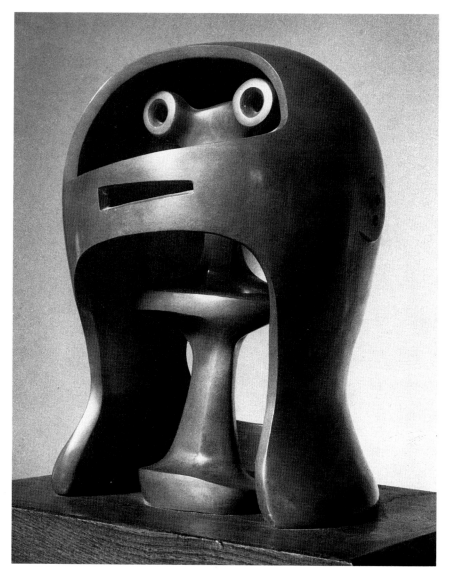

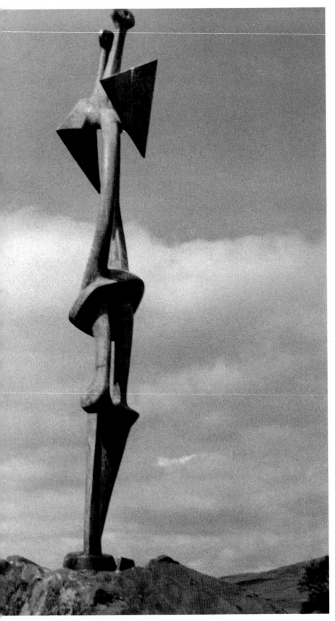

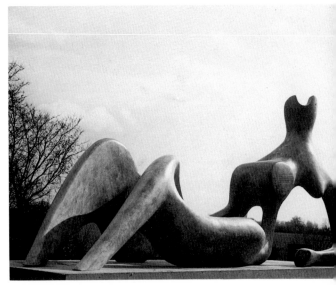

27 Reclining Figure, 1951, Bronze,
Length 90 in/221.5 cm.

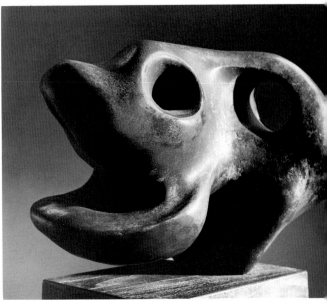

26 Standing Figure, 1950, Bronze,
Height 87 in/222 cm.

28 Animal Head, 1951, Bronze,
Length 12 in/30.5 cm.

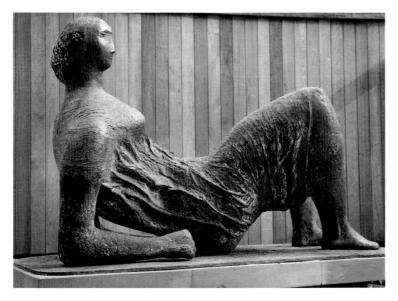

29 Draped Reclining Figure,
1952–3, Bronze,
Length 62 in/158 cm.

30 Time/Life Screen, 1952–3,
Portland Stone, Length 318 in/810.5 cm.

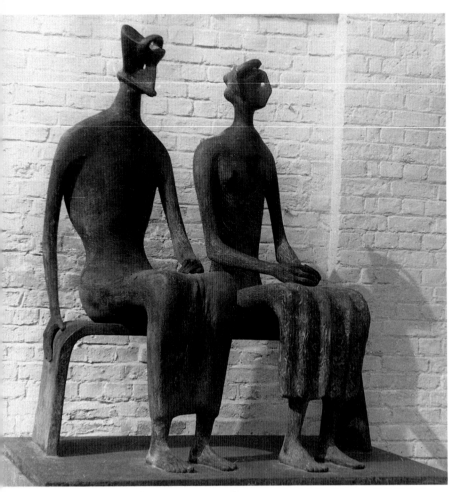

31 King and Queen, 1952–3, Bronze,
Height 120 in/306 cm.

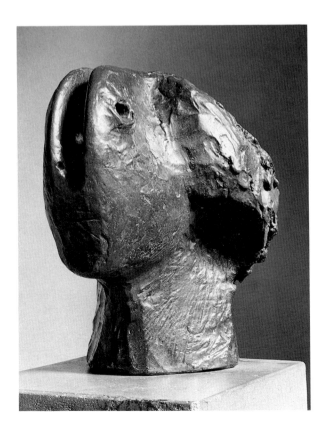

32 Warrior's Head, 1953, Bronze,
Height 10 in/25.5 cm.

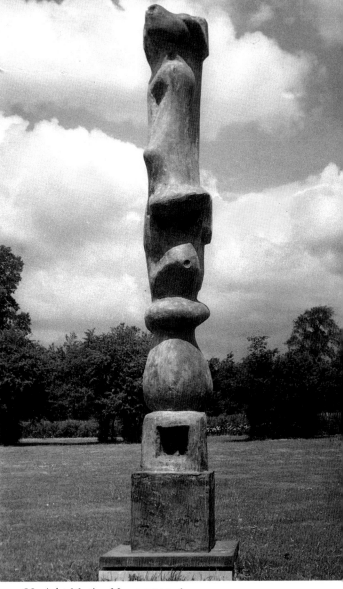

33 Internal and External Forms, 1953–4,
Elm Wood, Height 103 in/262.5 cm.

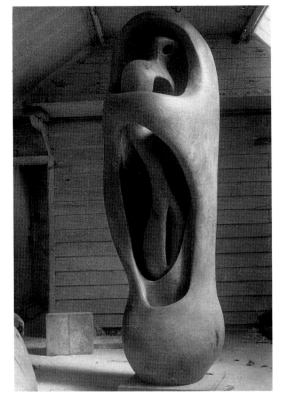

34 Upright Motive No. 2, 1955–6,
Bronze, Height 126 in/321 cm.

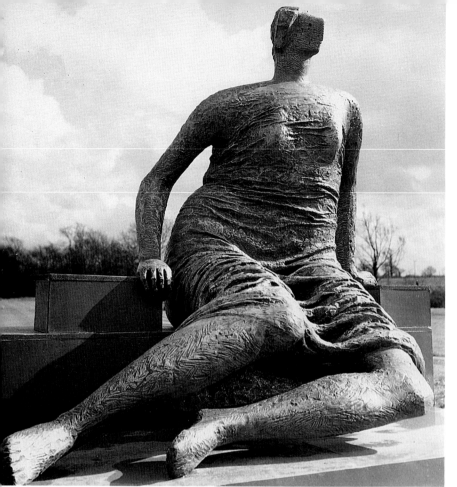

35 Draped Seated Woman,
1957–8, Bronze,
Height 73 in/186 cm.

37 Two Piece Reclining
Figure No. 1, 1959, Bronze,
Length 76 in/193.5 cm.
Height 51 in/130 cm.

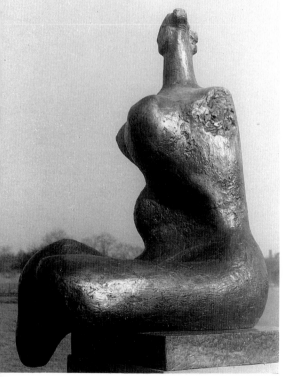

36 Woman, 1957–8, Bronze,
Height 60 in/153 cm.

38 Square Head, 1960, Bronze, Height 11 in/28 cm.

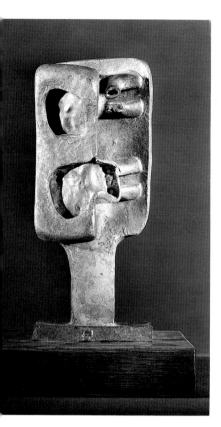

39 Reclining Mother and Child,
1960–1, Bronze, Length 86½ in/220.25 cm,
Height 33 in/84 cm.

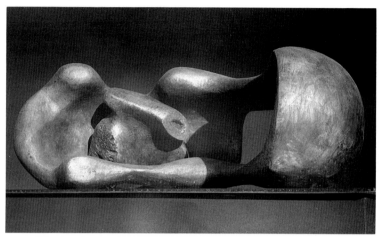

40 Seated Woman: Thin Neck, 1961, Bronze,
Height 64 in/163 cm.

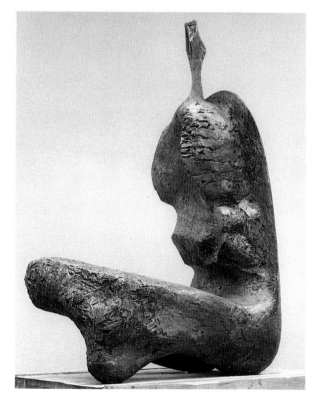

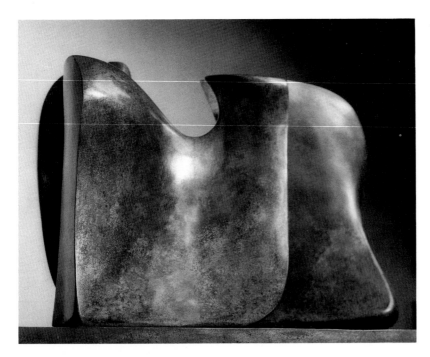

41 Knife-edge Two Piece,
1962, Bronze,
Length 28 in/71 cm.

43 Large Torso: Arch,
1962–3, Bronze,
Height 78½ in/200.25 cm.

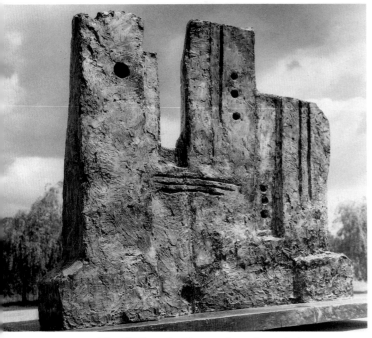

42 The Wall, 1962, Bronze, Length 100 in/255 cm,
Height 84 in/214 cm.

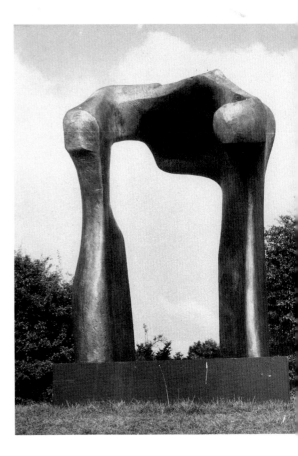

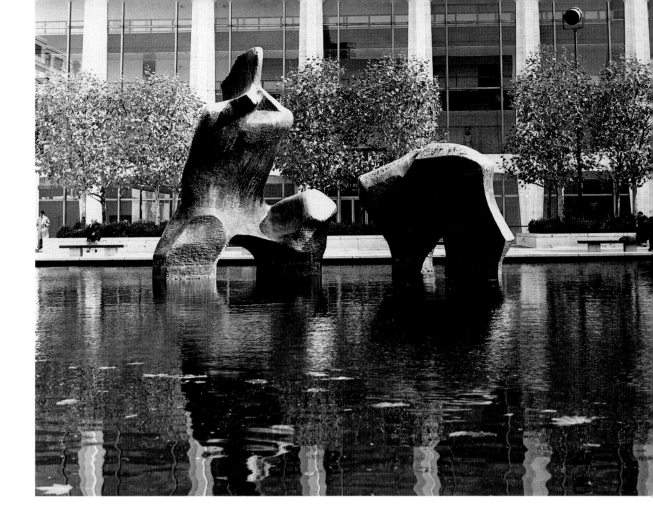

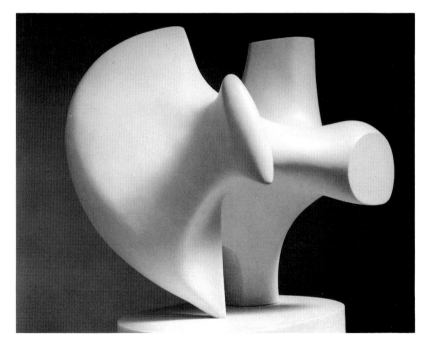

44 Reclining Figure,
1963–5, Bronze,
Length 316 in/805.5 cm.

45 Archer, 1965,
White Marble,
Height $31\frac{1}{2}$ in/80.25 cm.

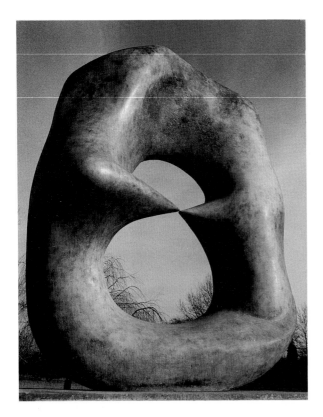

46 Oval with points, 1968–70, Bronze, Height 130½ in/332.75 cm.

47 Working Model for Square Form With Cut, 1969, Fibreglass, Length 55 in/140 cm.

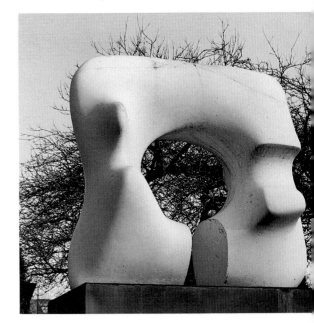

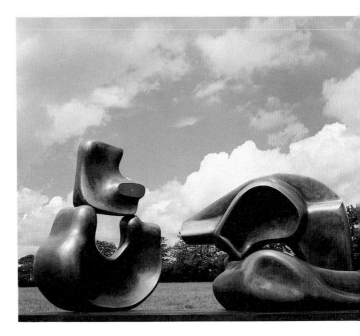

48 Large Four Piece Reclining Figure, 1972–3, Bronze, Length 158½ in/404.25 cm.

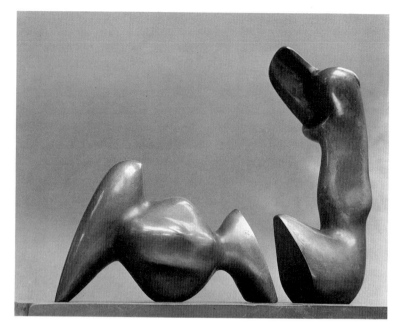

49 Architecture Prize, 1979,
Bronze, Length 13 in/42 cm.

50 Reclining Figure: Hand,
1979, Bronze,
Length 87 in/222 cm.

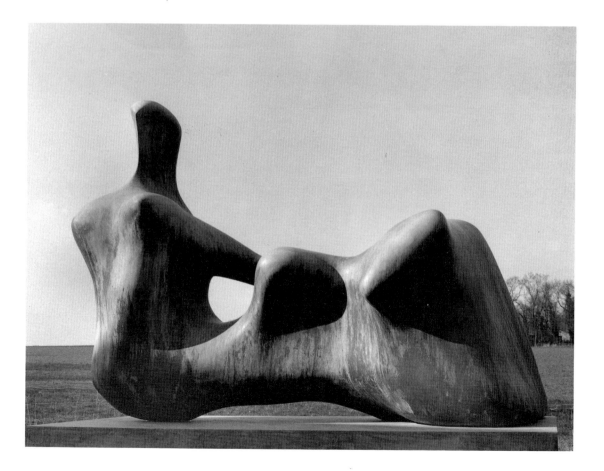

The Photographs